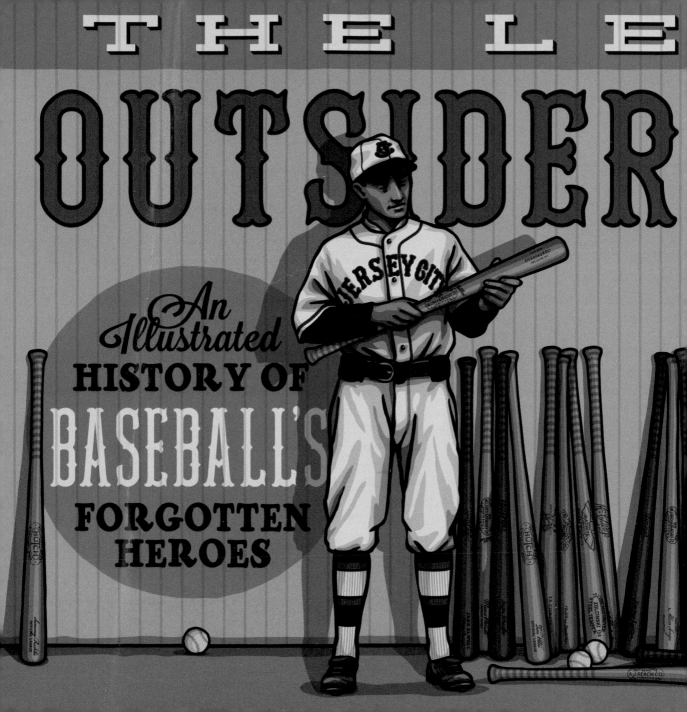

AGUE OF

BASEBALL

Written &
Illustrated by

GARY JOSEPH
CIERADKOWSKI

TOUCHSTONE

NEW YORK LONDON
TORONTO SYDNEY
NEW DELHI

Touchstone
An Imprint of Simon & Schuster, Inc.
1230 Avenue of the Americas
New York, NY 10020

First Touchstone hardcover edition May 2015

TOUCHSTONE and colophon are registered trademarks of Simon & Schuster, Inc.

For information about special discounts for bulk purchases, please contact Simon & Schuster Special Sales at 1-866-506-1949 or business@simonandschuster.com.

The Simon & Schuster Speakers Bureau can bring authors to your live event. For more information or to book an event, contact the Simon & Schuster Speakers Bureau at 1-866-248-3049 or visit our website at www.simonspeakers.com.

Interior design by Gary Joseph Cieradkowski

Manufactured in the United States of America

10 9 8 7 6 5 4 3 2 1

Library of Congress Cataloging-in-Publication Data is available.

ISBN 978-1-4767-7523-4
ISBN 978-1-4767-7525-8 (ebook)

The LEAGUE OF OUTSIDER BASEBALL

Within these pages you will find a league of ballplayers stocked with some of the most interesting men and women to have played the game of baseball.

The idea behind "The Outsider Baseball League" starts with my dad. When I was a kid growing up in New Jersey, I was a Mets fan; it was predestined that I wind up that way. My father's father was a die-hard Brooklyn Dodgers fan and having a Cieradkowski root for the Yankees was out of the question. So all I had was the Mets. This was the 1970s—not the giddy, pennant-winning Mets of the early 1970s, but the stinky, bottom-of-the-barrel Metropolitans of the late 1970s. Because my team was so awful, talking about them just wound up turning into angry complaining sessions. Because of a lack of quality Mets topics to discuss, talks with my dad often turned into me asking the Old Man about baseball when he was my age, kindling my interest in baseball history.

When I went away to art school, my dad and I enjoyed a long-distance friendship that revolved around the game of baseball. Just as we had tossed a ball back and forth many years before, as adults we tossed bits of baseball trivia at each other. This eventually evolved into a spirited trivia showdown that had no winners, losers, or end, just pure fun.

No matter where my career as a graphic artist took me—Baltimore, Chicago, Cincinnati, Boulder, Hollywood—three or five times a week would find my dad and me on the phone trading stories of obscure baseball players. And not just famous players, we liked the ones who played "outsider baseball"—a phrase coined by baseball historian Scott Simkus to describe the game played beyond the parameters of "organized" ball—Negro Leagues, town teams, foreign leagues, the low minors, and so on—the stuff you rarely hear or read about. For many years it was great fun learning

from and teaching my dad about players we found.

And then, just like that, he was gone.

A brain aneurysm took him from me just before the start of the 2009 World Series. Besides losing my dad, I lost my baseball pal. For the first time since I was a kid, I had no one to discuss baseball history with. It was my way of dealing with that loss that began the journey leading to the book you now hold in your hands.

In the winter of 2009 I drew a small baseball card–style illustration of Negro Leagues great Leon Day and posted it on a blog I had started. I wasn't then and am still not a tech-savvy blogger; it was just myself alone, missing my dad, looking for an outlet.

As an artist, I have always drawn ballplayers, but not until then did I seriously start illustrating them with any purpose. I had no goal in mind, only to continue the conversations I used to have with my dad about interesting and forgotten ballplayers.

Within weeks my blog had attracted hundreds of visitors through word of mouth. To my surprise, many others interested in the same obscure corners of baseball had been looking for exactly what I was trying to do. Before long I was receiving a constant flow of "fan letters" giving me encouragement

and suggesting their own favorite obscure players. Within a month of starting my blog I had found a semblance of what I once shared with my dad, only it was with hundreds of strangers I'd never met!

When I first started, I wanted to create a style that would be visually striking yet fairly easy for me to execute. I chose to avoid the 2½-inch by 3½-inch trading card size that has become standard since the 1950s. Instead, I wanted to pay homage to the beautiful old tobacco cards that were manufactured at the turn of the century. These narrow pieces of cardboard had always fascinated me since I first laid eyes on them as a kid, and to me they represented a mythical time when the game and the world seemed to be a whole lot simpler. As an artist, I always enjoyed the cards that used illustrations rather than photographs because they seemed more creative; instead of simply documenting what a player looked like, as in a photo, an illustration seemed to portray what you wanted a player to look like. That is exactly what I wanted my drawings to be.

Instead of simply copying an existing photograph, I decided to put to use all the knowledge I had accumulated over the years regarding a player's batting stance

or pitching motion. This makes my illustrations one-of-a-kind original poses, which is especially important when it comes to some of the more obscure players of whom few photographs were taken. How many times do you see the same pose of Satchel Paige? *The League of Outsider Baseball* portrays these forgotten players as they should be, rendered with the same care and respect as would befit Ted Williams or Babe Ruth.

The main reason for this book's existence is fun. I wanted to share that great joy the game of baseball and its history have given my father and me over the years. Today it's easy to get distracted by the petty controversies, salary disputes, and silly correctness that sometimes take precedence over the game itself. Writing these stories and drawing the illustrations make me remember what the game was all about for me and my dad.

When you read this book I hope, at least for a little while, you can get that feeling again of what it's like to throw the ball around with your dad, recall once more the sounds and smells of your first time at a ballpark and that feeling of zipping down a country road with the windows open, listening to the broadcast of a faraway baseball game.

But for now, the batting cage is being wheeled away and the players are beginning to take the field. *The League of Outsider Baseball* is about to start.

CHAPTER 1
THE BUSH LEAGUERS

Everyone starts somewhere.

Since the earliest days of organized baseball there has been a hierarchy of leagues, organized by their level of talent, all leading up to the major leagues. Today there is a very rigid and regulated system and each big league club has an allotted number of teams at each level that they can have control over.

Up until the 1950s this was not the norm. Some teams like the Cardinals and Dodgers had vast farm systems with outposts in almost every state. There was even a saying that went something like "it ain't a town unless it's got a Cardinals farm team in it." These forgotten little towns and the teams that once played there are where the term *bush league* comes from, meaning far away from the bright lights of the major league cities.

While the Cardinals and Dodgers had a continuous flow of new talent to fill their rosters, other teams were shortsighted or too cash-poor to have much of a farm system. The St. Louis Browns and Washington Senators fell into this category and their inability to develop fresh talent reflected in the two trading the position of last place in the American League year after year.

It's always staggering to think that of the millions of players who pass through the ranks of the minor leagues, only a select few make it all the way to the big leagues. Take, for example, the year 1930: The National and American Leagues both consisted of eight teams each with 25 players on the roster. That's just 400 jobs available at the top level of the game. Now consider that every summer day in 1930 an estimated 4,000 players were playing their hearts out on 160 minor league teams, trying to make the big leagues. For every Hank Greenberg making a name for himself that year there were thousands of guys named Buckshot May and Pinky Pittenger toiling in obscurity for teams like the Des Moines Demons and Jersey City Skeeters.

Everyone starts somewhere, and this chapter will show you how a few rose up from the anonymous thousands to become legends of the game.

SANDY KOUFAX

The Coney Island Bonus Baby

When Sandy Koufax enrolled at the University of Cincinnati in 1953 it was not to play college baseball for the Bearcats, but to become an architect.

At a time when a major league baseball player was the thing most kids wanted to be, the career of an architect was Koufax's dream. Then as now, UC was one of the world's finest architecture schools, and just being admitted to the program was considered an achievement.

Back in Brooklyn Koufax had excelled at basketball, and he made the university's varsity team as a freshman walk-on. After a successful season on the college boards, Koufax mentioned to coach Ed Junker that he could pitch.

Koufax made the varsity Bearcat baseball squad in the spring of 1954. He had a blazing fastball but was dangerously wild. The regular catcher refused to catch him, and legend has it the coach would have Sandy warm up on the sideline just to terrorize the opposing team with his 100-mile-per-hour fastball, which he had no control over.

> *The coach had him warm up on the sideline to terrorize the opposing team*

In his only year of college competition he averaged one walk per inning but struck out at least two per frame, and by the end of the season the Brooklyn Dodgers had signed Sandy Koufax to a lucrative contract.

The Dodgers had apparently had their eye on him when he was in high school, but in what has to be one of the worst clerical errors in baseball history, the scouting report was misfiled. At the time he could have been signed for a song, but now other teams began to take notice and Koufax skillfully negotiated a bonus large enough to cover the rest of his architecture school tuition if baseball did not pan out.

Due to the large bonus, Major League Baseball rules at the time dictated that he be sent directly to the majors and not farmed out to a minor league team for seasoning. To make room for the young fireballer, the Dodgers looked over their roster and sent their least effective pitcher down to the minors. That pitcher's name was Tommy Lasorda.

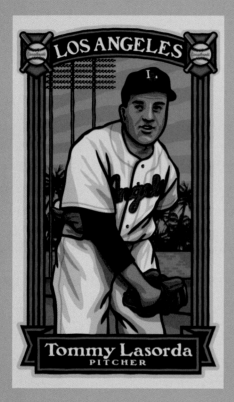

LOS ANGELES

Tommy Lasorda
PITCHER

After six seasons with the Montreal Royals, during which time he became the winningest pitcher in the history of the team, Brooklyn Dodgers farmhand Tommy Lasorda finally made the big league club. His career as a Dodgers player lasted just four games spread out over the 1954 and 1955 seasons. After he tied the major league record for three wild pitches in one inning, he was sent back to the minors to make room for bonus-baby Sandy Koufax.

In 1957 Lasorda found himself with the Los Angeles Angels of the Pacific Coast League. Formerly the Chicago Cubs' top farm club, the Angels were now property of the Brooklyn Dodgers, who needed to buy the franchise in order to move their team west for the 1958 season. Stocked with Brooklyn Dodger castoffs, the highlight of the season was an epic on-field fight against their longtime rivals, the Hollywood Stars.

After giving up a homer to the Stars' pitcher, Lasorda threw a high and tight fastball that sent the next batter, Spook Jacobs, diving for his life. Jacobs retaliated by bunting the next pitch back to Lasorda with the idea of spiking the pitcher as he covered first. Lasorda skipped fielding the ball and instead charged Jacobs, hitting him from behind. The ensuing fight, broadcast live on TV, lasted 35 minutes and went down in Pacific Coast League lore as "The Fight of '57."

Though his playing career was fading fast, Lasorda discovered he was a natural leader and had a knack for working with young players. Though he never made it back to the Dodgers as a player, his 20 years as the team's fiery manager earned him a spot in the Hall of Fame.

Walter Johnson's father was the first to notice that his boy threw fast and encouraged him to pitch. From the start the kid had a well-oiled, effortless motion, bringing his right arm back like a whip and releasing the ball from an almost sidearm position.

Johnson got his start with the Olinda Oil Wells in 1905. Even fresh out of high school he dominated the Southern California semipro leagues, averaging more than 10 strikeouts per game that first season. The young right-hander and his teammates were paid from whatever change the fans put into a hat, usually yielding about 50 or 75 cents per man, not bad for a day's work at the turn of the century.

Bolstered by his local success in Orange County, Johnson ventured to Washington State to join the Tacoma Tigers of the California League but was released after just one game. Refusing to give up his hopes for a baseball career, Johnson traveled to Idaho and joined the Weiser Wonders. After a 7-1 season he returned to California and rejoined the Oil Wells, now based in Anaheim. He struck out 15, 17, then 21 batters in games throughout the winter season. In the spring he went back to Weiser, where he pitched a record 57 straight scoreless innings, earning the nickname "The Weiser Wonder."

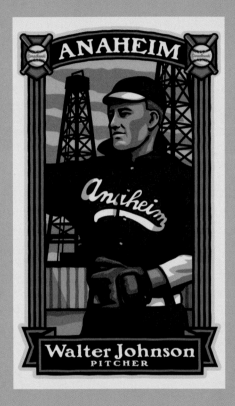

ANAHEIM

Anaheim

Walter Johnson
PITCHER

Initially he was disregarded as a big league prospect because of the way he brought back his pitching arm, revealing what he was about to throw. Fortunately for Johnson, he was so fast that knowing what pitch was coming really didn't matter, because no one could seem to hit it, and he'd go on to win 417 games in his 20-year career.

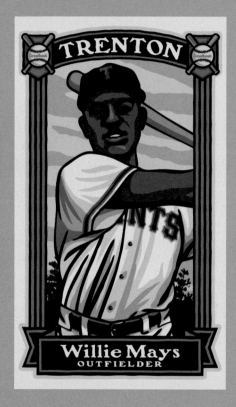

TRENTON

Willie Mays
OUTFIELDER

The 20-year-old kid who joined the Class B Trenton Giants in the spring of 1950 was already a seasoned veteran. He'd put in two solid seasons with Birmingham, including their 1948 championship year, and was as solid a prospect as you could get. The New York Giants knew they were lucky to have scored such a talent. He was fast, smart, and aggressive on the base paths, a solid hitter, and his fielding was just inspiring to watch. This kid had it all and then some.

The Giants would have liked to start him a little higher up their minor league food chain except for one problem—this particular player was black. In 1950 there weren't a whole lot of minor leagues that wanted to be at the forefront of integration, even if the player was to become one of the greatest center fielders the game has ever known—Willie Mays.

Because of his youth the Giants didn't want to start him at the top, so Jersey City and Minneapolis were off the table. Sioux City was the next choice, but that city had just had an anti–Native American riot and wasn't the right atmosphere in which to introduce the team's first black player. Jacksonville of the Southern League was, well, the Southern League, and that was out of the question. One rung below was the Interstate League Trenton Giants. Most of the league teams were in places thought to be more tolerant; the only rub was that it was Class B ball, a much lower level than Mays's former team, the Birmingham Black Barons. It was an unintended insult, but there really weren't any other options. Trenton it was.

Mays joined the club on the road in Hagerstown, Maryland. The Giants were in the late

innings of a game when he introduced himself to manager "Chick" Genovese and his new teammates in the dugout. Afterward, Mays was told that he was to stay at a hotel in Hagerstown's colored neighborhood, away from his white teammates.

Although he'd stayed at segregated hotels while with the Black Barons, the team always stayed together. Lodging with your teammates helped create a bond between players that showed on the field. Now here on his first day Willie was isolated from his new team.

Mays checked into a third-floor room and unpacked. Unknown to him, the rest of the Giants were pissed. Having a black player thrust onto their team brought out deep emotions, and as the evening wore on, the simmering anger boiled over into action. At midnight five of his teammates trekked into Hagerstown's colored neighborhood. Fueled by anger, they climbed the hotel's fire escape and huddled in the darkness outside Mays's room.

Willie Mays said later the midnight visitors wanted "to check whether I was okay." See, his Trenton teammates weren't angry about Mays's skin color, they were angered by the way he was forced to accept different accommodations from the rest of the club. To these young players they were all ballplayers now, teammates. After being reassured the new guy was indeed okay, three of the players spent the night sacked out on the floor, returning to the team's white hotel in the morning.

It was this unexpected act of solidarity that instantly made Mays feel accepted as part of his new team and enabled him to endure all the sick, racist heckling he would face in the coming months. Whether the opposition liked it or not, Willie Mays was a member of the Trenton Giants now.

Mays was right in thinking the Interstate League was below his level of play—he clipped the league's pitching for a .353 average. Mays was already an amazing outfielder when Chick Genovese taught him the basket catch that he would soon make his trademark, and Willie Mays was off to a long career that would see him become one of the most revered stars of the game as well as one of the great pioneering players who integrated the game.

Fueled by anger, they climbed the hotel's fire escape and huddled in the darkness

JACKIE ROBINSON

A Great Day in Jersey City

When Jackie Robinson took the field at Jersey City's Roosevelt Stadium on April 18, 1946, he became the first black ballplayer in organized baseball since 1899.

It wasn't chance or luck that led to Robinson's donning a Montreal Royals uniform that day and making baseball history. Jackie's fame as a college athlete, his university education, and his experience as an army officer made him the perfect man carefully chosen by Branch Rickey for a very difficult job.

Many of the Negro League ballplayers he played with in 1945 vocally expressed disappointment that he was to be the first to integrate the game. His manager with Montreal questioned whether a black man was even human. Bob Feller, who had pitched against Robinson in 1945, thought so little of his talent that he told reporters, "If he were a white man, I doubt if they would even consider him big league material, except perhaps as a bat boy."

Robinson faced it all with quiet dignity and strength. In that first game in Jersey City he went four for five, including a three-run homer, scored four runs, drove in three, and stole two bases. Overcoming immense racial pressure, Jackie won over his teammates and fans with his natural physical ability and intense drive to win. He led the International League both in batting, with a .349 average, and in runs scored, with 113.

His intense drive to win and natural ability won over his teammates and fans

Sparked by his play, the Royals won the Little World Series of 1946, and when fans chased Robinson through the streets of Montreal to lift him up on their shoulders, sportswriter Sam Maltin was inspired to write, "It was probably the only day in history that a black man ran from a white mob with love instead of lynching on its mind." The next year he was playing for the Brooklyn Dodgers, where he was voted Major League Baseball's Rookie of the Year.

Through his sheer determination Jackie Robinson not only paved the way for the desegregation of the major leagues but also the modern civil rights movement.

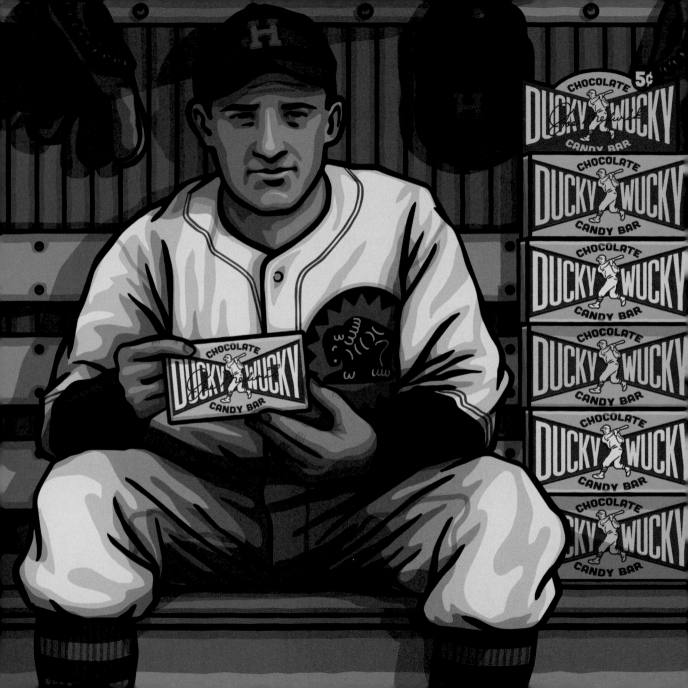

JOE MEDWICK

Knowing Your Value Is Half the Battle

From an early age, Joe Medwick knew he'd be a major leaguer. The kid starred on the football and baseball fields of Carteret, New Jersey. He got his first taste of rejection when the local Newark Bears, a Yankees farm team, took a look but considered him too much of a bad-ball hitter.

The kid did in fact chase balls outside the strike zone, but the thing was, he hit them a mile. While some kids would have been crushed to be turned down by the Yankees, Medwick was not. He had a self-assurance like no other teen and simply returned to high school to patiently wait for his chance. Medwick graduated Carteret High with football scholarship offers from Princeton, Duke, Notre Dame, and two dozen other programs. Those were flattering, but no one paid you to play college football. Medwick knew he was good enough to make a living playing big league baseball.

The 18-year-old played in no fewer than seven local semipro leagues and one afternoon a Cardinals scout approached the husky kid. This was 1930, the beginning of the Depression, and to many kids, a contract to play ball was a godsend. They'd sign no matter what. But Joe Medwick wasn't just any kid—he knew exactly how good he was.

Medwick had studied the *Sporting News* weekly and knew which teams offered the best chance of advancement. The Yankees, with veterans Ruth, Combs, and Chapman, left no room for a young outfielder. Likewise the A's, Cubs, and Giants. Medwick knew that, though they were pennant bound that year, the Cards had an aging outfield with Chick Hafey, Taylor Douthit, and George Watkins all pushing 30. Here was a winning organization with a potential place for him.

To the surprise of the Cardinals, it took three days of negotiations to get the brash young kid to sign, and when all was said and done he'd done the impossible and squeezed a $500 signing bonus out of Cardinals business manager Branch Rickey.

The kid with the thick New Jersey accent was sent to Scottsdale, Pennsylvania, where

> *Joe Medwick wasn't just any kid—he knew exactly how good he was*

he beat up on the Class C Middle Atlantic League pitching for a .419 average. For 1931 the Cards bumped him up a few rungs to the Class A Houston Buffaloes.

Medwick joined a team that featured future Cardinals teammate and Hall of Famer Dizzy Dean (who tried unsuccessfully to room with the kid, as he had a stylish New Jersey wardrobe Diz hoped to dip into) and a dozen others who would make the big leagues.

The thick-accented Medwick became an exotic favorite of the Texans. While Dizzy Dean and his brother Paul brought both talent and entertainment to the ball club, Medwick remained a serious and surly young man. As was the custom in the minors, the older players would give the youngsters a hard time since they were trying to take their jobs away. Medwick was self-assured in his talent and used his fists to back it up when anyone got in his way. He adjusted to Texas League pitching by hitting .305 with 47 doubles and 19 home runs and leading the circuit in total bases.

As good as 1931 was, the next year was Medwick's breakout summer. With Dizzy Dean gone to the big club in St. Louis, Medwick emerged as the Buffs' lone star. Female fans began calling the handsome slugger "Ducky" because his gait on the field resembled the waddling of a duck. Medwick, who preferred to be called Mickey or Jersey Joe, hated the new name. While he tore up opposing pitching on the field, he found he was powerless to stop the hated nickname. It didn't get any better when it was modified to an excruciating "Ducky-Wucky."

When Houston's team president Fred Ankenman contracted with a local candy company to produce a Ducky-Wucky Bar to be sold at Buffs home games, Medwick took charge. If he had to endure the lousy name then he was getting a big slice of the profits from the snack named for him. The local newspapers reported that it was a surprise the slugger could demand a cut of the proceeds as he was property of the Houston club. To Joe Medwick, if anyone was going to profit from him, even if it meant capitalizing on a dreaded nickname like Ducky-Wucky, it was him.

It didn't get any better when the nickname was modified to "Ducky-Wucky"

At 19 years old, Joe Medwick, the cocky kid from North Jersey, had what only Babe Ruth and Charles Lindbergh had—a chocolate treat named in his honor.

Medwick's hitting dominated the Texas League that summer. His .354 was second best in the loop and he banged out 48 doubles, 10 triples, and 26 homers for a league-leading .611 slugging percentage. In late September, just as Medwick knew they would, the Cardinals sent for him.

In his last game several thousands of his fans showed up to say good-bye. In his final at-bat Medwick tipped his hat to the crowd then hit a shoulder-high fastball over the outfield wall. To most it would be a triumphant way to say so long to the minor leagues, but to Medwick it was a huge letdown. He was bitter that he wasn't given a travel bag, shotgun, or set of golf clubs,

Medwick, Babe Ruth, and Reggie Jackson share one rare distinction

the traditional farewell gift presented to big league–bound players. The angry Medwick received nothing but handshakes.

When the crowd dissipated the man who ran the Ducky-Wucky concession approached its namesake and asked if the team could continue to sell the treat. Medwick snapped back an emphatic "no" and proceeded to stand by and watch as the vendor removed all the Ducky-Wucky labels from the remaining stock of candy bars.

When he was finished, Medwick scooped up all the discarded labels, shoved them in a sack, and left to join the Cardinals. Medwick always knew his worth and he was not about to let anyone take advantage of him.

Medwick hit .329 in the remaining 26 games of the 1932 season and made the majors for good. Though not as revered as contemporaries Joe DiMaggio and Ted Williams, Medwick became one of the game's most feared hitters. He cemented his reputation as the game's greatest bad-ball aficionado when he clubbed a home run in the 1934 All-Star Game on a pitch that was reported to have been above his head. He accomplished baseball's greatest single-season hitting feat when he won the Triple Crown in 1937, the last National Leaguer to do so. A 10-time All-Star, he was the National League MVP in 1937 and has a plaque in Cooperstown with his mug on it. Yet there is one distinction, rarer than all the others but not listed in the *Baseball Encyclopedia*, that Medwick holds along with fellow Hall of Famers Babe Ruth and Reggie Jackson: All three have been immortalized by a candy bar named in their honor.

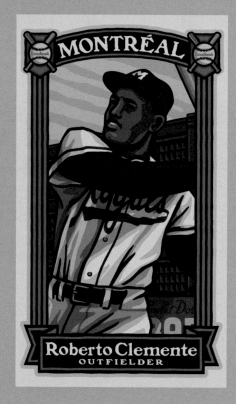

MONTRÉAL

Roberto Clemente
OUTFIELDER

In the Montreal Royals' 1954 home opener, a young Puerto Rican newcomer knocked a ball over the left field wall and completely out of Delorimier Stadium, one of three hits he registered that afternoon. Then the next day he was out of the lineup.

Sometimes stories are told so many times they become the truth, and over the years it's become accepted that the great Hall of Famer Roberto Clemente was kept hidden by the Dodgers to conceal his great talent from other ball clubs. The truth is actually quite different.

Clemente made a name for himself in his native Puerto Rico Winter League and the Brooklyn Dodgers were impressed enough to sign the 18-year-old for $15,000. The problem was that there was a rule stating that if a club signed a player for more than $4,000, that player had to go directly to the majors for two years or the player was open to being drafted at the end of the season by another team. On the surface it was a stupid rule, but it was meant to prohibit affluent teams like the Yankees and the Dodgers from hoarding all the good talent. Sandy Koufax was a victim of this rule and he spent several frustrating years sitting on the Brooklyn bench when he should have been learning to control his heater in the minors. The Dodgers took a huge risk by sending Clemente to Montreal, which meant any team was free to sign him after the season ended. That is where the conspiracy stories originate.

In the 154-game season Clemente had only 148 plate appearances. Why did the Royals use him so sparingly? Well, the Royals didn't need him, that's why.

Montreal in the International League and St. Paul in the American Association were Brooklyn's two top farm clubs. In 1954 the Royals had no fewer than 27 former or future major leaguers suit up for them. The International League was the premier minor league in the country and winning the IL pennant was the team's first priority, developing young players second. St. Paul was more of a development club than Montreal. Why Clemente was sent to the Royals is not known, but it may have been so that he would not have to deal with as much racism in the bigger East Coast IL cities as he would if he played in the midwestern American Association.

The story that the Dodgers tried to "hide" Clemente just isn't true

After Clemente's big home opener he was absent from the lineup for days at a time, fueling the stories of a conspiracy. If you look at the Royals roster, you can see the team was stocked with better outfielders. Gino Cimoli, Ken Wood, Dick Whitman, and Jack Cassini were seasoned vets batting .276 or better, and a youngster named Sandy Amoros hit .352 in 68 games. Though a promising prospect, Clemente managed just .257 and hit just one more homer all year. Montreal's manager, Max Macon, recalled that Clemente swung wildly at balls outside the strike zone. Authors Stew Thornley and David Speed have done stellar work dissecting Clemente's 1954 season and busting many of the myths surrounding his time in Montreal.

Clemente himself complained that he would hit well one game only to be benched for the next few games. This is used to demonstrate that the Dodgers higher-ups didn't want the young phenom making headlines that would attract attention. Thornley and Speed figured out that in reality Clemente was only played when a left-hander started for the opposing team, since he seemed to hit better against southpaws. No conspiracy, just good baseball by Max Macon.

Even if the evil Brooklyn management did conspire to "hide" Clemente, it didn't matter. Pirates scouts had seen the young outfielder sometime in June or July and made a note to sign him in the draft. By the spring of 1955 he was Pittsburgh's regular right fielder and on his way to the Hall of Fame.

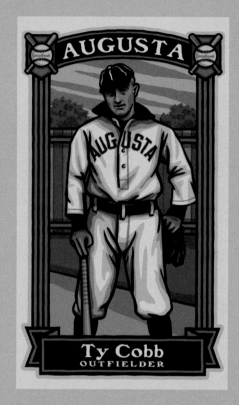

AUGUSTA

Ty Cobb
OUTFIELDER

With his father's words "Don't come home a failure!" fresh in his mind, 17-year-old Ty Cobb left his home in Georgia in the spring of 1904 to join the Augusta Tourists of the South Atlantic League.

His professional career almost ended as soon as it started when he was released after just two games. Refusing to slink home in failure, Cobb joined a semi-pro team in Anniston, Alabama, and began sending anonymous postcards to newspapers touting the talents of a kid named Cobb. Famed sportswriter Grantland Rice fell prey to Cobb's clever self-promotion and added "young fellow named Cobb seems to be showing an unusual lot of talent" into one of his *Atlanta Journal* articles.

Cobb's plan worked, and he finished the season with the Tourists. The next spring he impressed the visiting Detroit Tigers with his raw but aggressive style of play, and by the end of 1905 he was called up to the majors. But what should have been the high point of his life turned out to be bittersweet.

Just days before leaving for Detroit, Cobb's mother, alone late at night, shot and killed an intruder sneaking past her bedroom window. It appears that the elder Cobb believed his wife was having an affair and had tried to catch her in the act. Although the circumstances were a little fishy, a jury ruled it an act of self-defense and acquitted Cobb's mother.

Cobb joined the Tigers just a week after burying his father and played baseball with an aggression and passion never seen before or since. Years later he told biographer Al Stump, "I did it for my father. . . . I knew he was watching me and I never let him down."

HANK GREENBERG *A Pro Grows in Brooklyn*

In the summer of 1929 Hank Greenberg took the long subway ride from his home in the Bronx to Brooklyn for his first game as a professional ballplayer. The teenager got a spot on the Brooklyn Bay Parkways, an independent semipro team that played local Negro League and touring teams of barnstorming major leaguers.

When he didn't receive payment after his first game, he said he wasn't coming back. The startled manager said that he thought Greenberg was an amateur and did not want to accept money in order to preserve his eligibility to play collegiate sports. Hank said he didn't care about that. It took a long time to travel all the way to Brooklyn and he expected to be paid!

After he hit a heady .454 in 21 games, Yankees scout Paul Kritchell came knocking. While watching a game as a guest of the Yankees, Kritchell pointed to first base and declared that Lou Gehrig was all washed up and that if he signed, Hank would soon

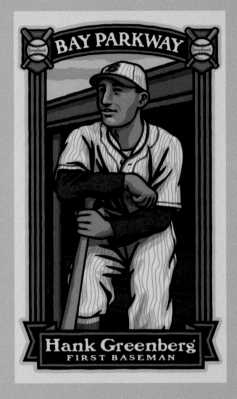

BAY PARKWAY

Hank Greenberg
FIRST BASEMAN

have his job. To be a Yankee was something all ballplayers dreamed of, but deep down Greenberg knew the 26-year-old Gehrig was far from washed up in 1929. If he signed with New York, there was a big likelihood he would be trapped in the minors for a long time, waiting for the Iron Horse to get injured or retire. As tempting as it was, he turned the Yankees down.

Soon the Detroit Tigers snatched him up, and by 1933 Greenberg would be their starting first baseman. It was a wise choice: Lou Gehrig, on his way to setting a record for playing in the most consecutive games, wouldn't give up his job at first until 1939.

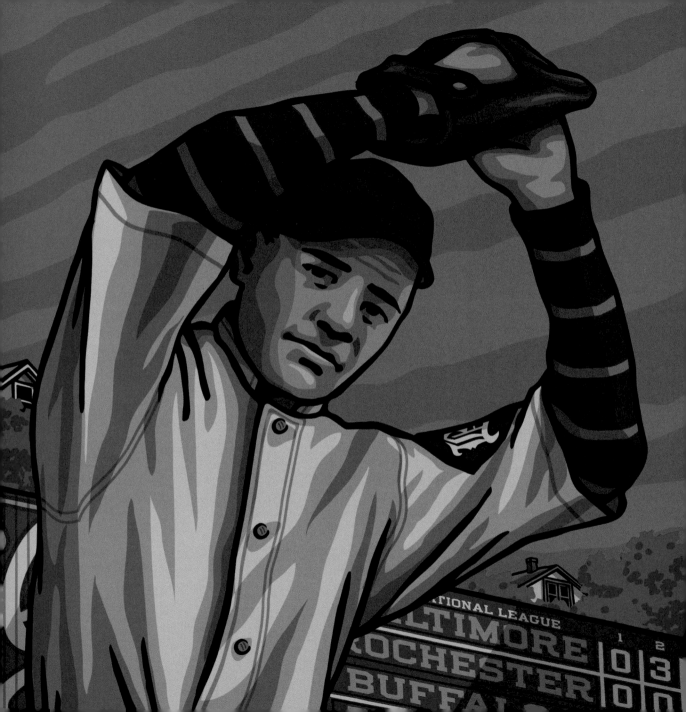

BABE RUTH

Becoming the Babe

Growing up neglected and wild on the rough Baltimore waterfront, George Herman Ruth's parents packed him off to the Catholic-run orphanage called St. Mary's Industrial School for Boys. Ruth bounced back and forth between home and this school until his mother passed away and his father sent him there for good. Although often referred to simply as a "reform school," St. Mary's was also a vocational school that taught its young wards various industrial trades such as cobbling, carpentry, and printing so they could have productive lives when released. Ruth worked in the school's shirt factory and in fact was so proud of the skills he learned at St. Mary's that until his death the nattily dressed slugger took pride in sewing and mending his own garments.

Finally surrounded by caring adults, Ruth thrived at the school. One of the Xaverians in particular, Brother Matthias, was able to harness the wild boy, and through the combination of a stiff hand and kindness George blossomed. It was under the tutelage of Brother Matthias that the boy learned the game of baseball.

It wasn't long before Jack Dunn, owner of the local minor league Baltimore Orioles, got wind of the locked-up young star. Dunn heard about Ruth from the director of Mount St. Joseph's College, who offered up the tip on Ruth to deflect attention away from his own pitching ace. Dunn took the bait and sat down with the Xaverian Brothers at St. Mary's and signed the 19-year-old to a minor league contract. There was one catch—in order to release George from St. Mary's, Jack Dunn had to accept legal guardianship of Ruth. This legal transaction formed one part of the famous nickname.

Traveling south to Fayetteville, North Carolina, for Baltimore's spring training, Ruth left the city of his birth for the first time. His new teammates were at the same time amused and amazed at the naive gentle giant trying to make their team. He believed anything the older players told him and was

> *Under the tutelage of Brother Matthias the boy learned to play baseball*

ripe pickings for pranks. Used to years of regimentation, Ruth couldn't believe that he could eat as much as he wanted and gorge himself on anything the waiter would bring. He used his pocket money to bribe the hotel elevator operator to let him run the contraption, once coming close to losing his head when he neglected to close the safety cage.

Jack Dunn had entrusted his veteran catcher Ben Egan to look after his prized find. Egan joined the rest of the veterans in playing jokes on the big rube, but shut them down when he felt it was going too far. Because of all the care lavished on the big kid, the other players took to calling him "Dunnie's Baby" or "Dunn's Babe." This was a fairly common and slightly derogatory way to describe a wet-behind-the-ears rookie at that time, and if the player was any good, he soon lost the nickname.

George made friends with the local children and from one received the use of a bicycle. When he'd finally mastered (or thought he had) the contraption, he decided to impress the other players relaxing on the porch of their hotel. Ruth raced by the hotel and after just barely avoiding an oncoming truck, crashed to the ground in a heap after hitting the curb. As the players rushed over coach Scout Steinman spoke for the whole team when he said, "If manager Dunn does not shackle that new babe of his, he'll not be a Rube Waddell in the rough, he'll be a Babe Ruth in the cemetery." Sportswriter Rodger Pippen of the *Baltimore News-Post* happened to be a witness to the crash and wrote the story up in the next day's dispatches. Just like that, the once derogatory moniker became the colorful nickname tacked onto the Orioles' most promising rookie. By the time the team started intrasquad games, George Herman Ruth was known as BABE RUTH.

Right from the start it was evident that "Dunnie's Babe" was the real thing. On the mound he dominated. Ruth had a nice curve and a fastball that swung to the left of the plate, confounding right-handed batters. He had a smooth, easy motion and didn't get rattled when there were runners on base. But it was his skill with a bat that attracted the most attention. In his first intrasquad game, Ruth smashed a ball to right field that traveled so far it made the newspapers both locally and back in Baltimore. Jim Thorpe once hit a

> *Just like that the once derogatory moniker became a colorful nickname*

legendary home run in Fayetteville, but this homer by Ruth topped even that. In batting practice the other players began complaining that they couldn't keep up with chasing all the baseballs Ruth hit over their heads and one even inquired whether the Orioles were going to provide cab fare for outfielders retrieving balls belted by the new kid.

The real test came when it was time to face major league teams. The Philadelphia Phillies came to town first. Philadelphia had finished second in the National League the year before and after a few innings had scored six runs off starter Smoke Klinglehoffer. With one out and a man on first in the sixth inning, Babe Ruth took the mound. He balked on his first pitch, advancing the runner to second. Ruth embarrassingly told catcher Ben Egan that he had forgotten there was a man on base. Ruth bore down and struck out the next two batters to end the inning and held the Phillies to two hits and no runs as the Orioles won 7–6. A few days later he went the distance against the best team in baseball, Connie Mack's Philadelphia Athletics. Giving up 13 well-spaced hits, the rookie struck out three A's and only slugger Home Run Baker was able to say he hit the kid well, going four for five off the lefty.

The Orioles played their way north and after arriving in Charm City played a game against the Brooklyn Dodgers. The newly christened "Babe Ruth" held the Dodgers hitless for a few innings and beat Brooklyn 10–6. If an unknown rookie pitching a game like that against a major league team wasn't enough, the Babe simply astonished everyone with his hitting. His first time up he smashed a ball to right fielder Casey Stengel, who had to hustle to make the catch for an out. To be fooled by an unknown rookie like that was simply embarrassing. In the dugout Brooklyn manager Wilbert Robinson chewed Stengel out for almost missing the ball and not playing the kid deeper. The next time up Ruth crushed another ball, sending Stengel, who had made an adjustment and played the rookie farther back, running in vain as the ball dropped out of reach for a triple.

In the words of Casey Stengel: "We lost the game. The kid beats us pitching and he beats us batting. That's when I first saw Ruth. I would say I was impressed."

Just when things were looking great for

> *"That's when I first saw Babe Ruth. I would say I was impressed."*

Jack Dunn and his Orioles, financial trag-
edy struck. The Federal League, billed as a
third major league, opened up a franchise
right across the street from the Orioles ball-
park. While Baltimore loved their Orioles,
they were minor league
ball. These new Federals,
called the Terrapins, were
supposed to be big league
baseball.

The new southpaw
debuted in the second
game of the season and
despite great weather
and the media buzz sur-
rounding the hometown
boy, fewer than 200 fans
watched Ruth pitch a six-
hit shutout against Buffalo.

Ruth continued to win
and Dunn, never known
for being stingy and
aware of the threat the
Federals posed, doubled
Ruth's salary to $200 a
month. Ruth later claimed that he turned
down a $30,000 offer from the Federals,
but even had the offer been valid, Dunn
was still legally responsible for the big
left-hander. Nonetheless he again gave the

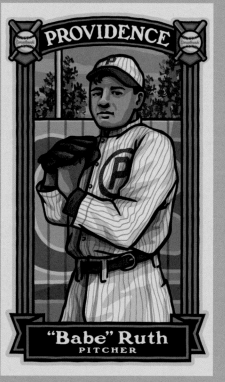

PROVIDENCE

"Babe" Ruth
PITCHER

Babe a raise, this time to $300 a month.
For a kid who grew up behind the walls
of an orphanage and never had money of
his own, this must have been staggering.
As he would throughout his life, the Babe
never forgot to be kind to
children, and biographer
Robert Creamer recounts
a great story in which
Ruth asked Jack Dunn to
set aside six tickets one
afternoon. When Ruth
said they were for some
friends of his, Dunn kept
an eye out, thinking they
were for gamblers or the
usual hangers-on that
latched on to young stars.
A bemused Dunn watched
as Ruth showed up for
the game surrounded by
six boys from St. Mary's.

Going into July Dun-
nie's Babe had won 14
games and lost six and
the team looked pennant-bound. However,
no matter how many games Dunn's boys
won, he couldn't compete with the Ter-
rapins. By July his only solution was to
break up the team. In big batches he auc-

tioned off his players, one to the Yankees, a handful to the Reds, and on July 9, catcher Ben Egan, pitcher Ernie Shore, and Babe Ruth were sold to the Boston Red Sox for $25,000. As the three men headed to Boston, Dunn's gutted team took a nosedive in the standings. He'd have to wait five more years until finally building his Orioles dynasty.

On July 11 the Red Sox tested their new acquisition against Cleveland. Ruth pitched seven innings and got the win. A few days later he faced the Detroit Tigers and took a loss. With a pitching staff that included Smoky Joe Wood and Dutch Leonard, Ruth sat on the bench for a few weeks before being farmed out to the Providence Grays of the International League. With Baltimore out of the running, the Grays were making a pennant drive and the Babe teamed up with Carl Mays to give Providence a major league–quality pitching staff.

As he had in Baltimore, the Babe attracted children like a pied piper, and stories are still told in Providence about the dozens of young fans he'd treat to ice cream and candy after Grays games.

Besides his pitching, Ruth turned heads when he unleashed his raw power at the plate. Though his average was a mediocre .231, 10 of his hits were triples, and on September 5 he was in Toronto pitching a one-hitter against the Maple Leafs when he hit a three-run blast that cleared the right-field wall, the first of 715 he'd hit in professional baseball.

On the mound Ruth continued to dominate, winning eight games as the Grays took the International League championship. With a few more weeks left in the major league schedule, Boston recalled the big lefty. He started a game against the Yankees and won, then pitched three innings of the last game of the season against Washington.

The three-run blast was the first of 715 he'd hit in professional baseball

Less than six months after passing through the gates of St. Mary's, George Herman Ruth had received the best nickname in baseball history and won a combined 24 professional baseball games. He watched his salary climb from $600 a year when he signed with the Orioles all the way to $2,500 when he became a major leaguer. During his first stint in Boston he'd met the woman he'd make his wife before the year was out.

Babe Ruth had arrived.

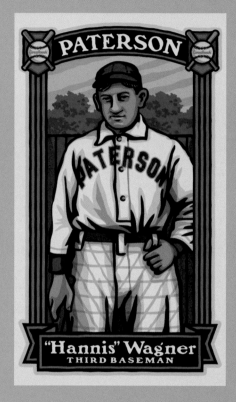

PATERSON

"Hannis" Wagner
THIRD BASEMAN

Back in the early 1980s baseball card collecting virtually exploded for kids and adults alike. It seemed everywhere you looked there was the famous T-206 Honus Wagner card, his mug gazing back across three-quarters of a century from his tobacco card. Every boy dreamed of finding that shoebox in the attic that contained a T-206 Wagner, a '52 Mickey Mantle, and a '33 Nap Lajoie. My brother Jason and I were no exception, spending hours in my grandparents' attic on Liberty Street in Passaic, New Jersey, looking behind boxes and in dark corners. The only thing we ever came across was a beat-up late-fifties football card of some goon that played for the Bears. Little did we know that not more than a mile or so away was a forgotten field in Paterson that the great Honus Wagner once played on.

When Ed Barrow, owner and manager of the Paterson Silk Weavers, heard of a great big ballplayer tearing up the Pennsylvania Iron and Oil League, he went out there to see for himself. Impressed, he signed the big kid on the spot. Dubbed "Hannis" by New Jersey newspapers because of his German heritage, he started off at first base and then moved to third. The future Hall Of Famer was not a very good defensive player. Although he drove in many runs for the Silk Weavers, his costly fielding errors lessened their impact. Wagner committed 41 errors during the 1897 season, the worst of his long career. In mid-July of that year Barrow sold him to the Louisville Colonels of the National League. Wagner was soon switched to shortstop, the local sportswriters changed his name from "Hannis" to "Honus," and a legend was born.

CHRISTY MATHEWSON *Not Fadeaway*

In the summer of 1900 the New York Giants were stuck in last place and desperate for pitching. When word reached New York of a college kid named Mathewson mowing down batters in the Virginia League, the Giants bought the 19-year-old from the Norfolk Mary Janes and brought him north.

After losing three games he was relegated to tossing batting practice. With his career looking like it was about to fade away before it began, Mathewson grew frustrated and had thoughts of giving up on pro ball. One afternoon manager George Davis was watching Mathewson warm up when he unleashed a pitch he'd never seen before. Suddenly, this college boy got a little more interesting.

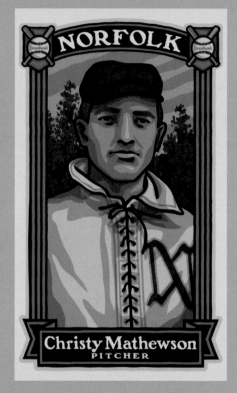

Two years before, during his summer break from Bucknell, Mathewson played semipro ball in Honesdale, Pennsylvania. One of their pitchers was an old lefty named Williams (first name lost to time) who was playing around with a strange new pitch he had no control over. Williams threw the ball like a curveball, except that the arm twisted counterclockwise before it was released. When thrown by a right-hander such as Mathewson, the ball broke in toward a right-handed batter. The pitch was painful to throw, but the effect on batters made it worthwhile to throw in a pinch and Mathewson practiced it in his spare time until he'd mastered its peculiar delivery.

Seeing the unusual break on the ball, Davis declared it a "fallaway" or "fadeaway." The later name stuck and Mathewson had the signature pitch that would win him 373 games and take him to the Hall of Fame.

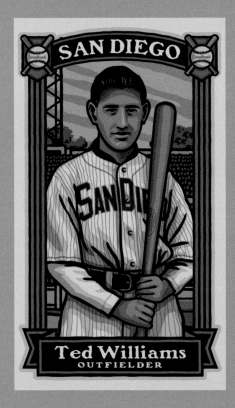

SAN DIEGO

Ted Williams
OUTFIELDER

In the spring of 1936 Ted Williams was just about to step onto the first rung of his lifelong dream. His father was a professional photographer and part-time rummy while his mother was with the Salvation Army, tirelessly ministering to San Diego's boozers, hookers, and single mothers. By the time Ted was a teen his dad had left, unable to put up with his wife's charity work and becoming more and more preoccupied with his drinking. His mom would disappear for long stretches being the Salvation Army's "Angel of Tijuana," and while Ted's older brother, Danny, used this time to hone his skills as a juvenile delinquent, the younger Williams concentrated on baseball, hitting in particular. Since his father's last name was Williams, no one knew that the youngster was actually half Hispanic (his mother's family was from Mexico), sparing him any distracting racism early on in his career.

While Williams was still a junior at Hoover High, scouts from the Yankees and Cardinals came knocking, but there was one problem: Ted's overprotective mother thought he was too young to leave home. Ted and his mom came to a compromise and they agreed to a tryout with the hometown San Diego Padres.

The Padres team Williams was trying to join for the 1936 season was led by former White Sox spitballer Frank Shellenback. Frank was in his second year as a manager and his team was a nice blend of mature, seasoned ballplayers like Herm "Old Folks" Pillette and Archie "Iron Man" Campbell and up-and-coming youngsters Bobbie Doerr and Vince DiMaggio. The

Padres played in the Pacific Coast League, a AA league, the equivalent of today's AAA, the highest level of the minor leagues.

The day of Williams's tryout, Shellenback was pitching batting practice and had the skinny kid step into the cage. According to Bobby Doerr, future teammate of Williams with Boston, then in his second year with the Padres, the older players were miffed by this reed-thin kid taking up precious time in the cage. After Williams hit two or three out of the ballpark, the veterans' grumbling turned to wonder as they asked each other, "Who is this kid?"

Shellenback knew talent when he saw it and for $150 a month Ted Williams became a professional ballplayer.

Williams was used sparingly by Shellenback but the manager kept the kid close on the bench, making sure he paid close attention to all aspects of the game. The Padres outfielders "Chick" Shiver, Vince DiMaggio, and Syd Durst were backed up by Vance Wirthman, but over the long season injuries enabled Williams to get some game experience. Still, when each man returned the Kid went back to the bench. Shellenback had no qualms about Williams's talent—he just wanted to bring him along slowly. Don't forget, the Pacific Coast League was essentially AAA level and Ted Williams was still in high school.

In the beginning of September left fielder "Chick" Shiver abruptly left the Padres. Shellenback had no choice but to insert Williams into the regular lineup. In his first game as a regular Williams slugged a triple and double in three tries, fielded every ball that came his way, and was written up in the paper for making two catches "hard enough to satisfy the most exacting test."

> *The veterans turned to each other and asked, "Who is this kid?"*

While many picked the Padres to quickly bow out of the pennant race, Williams's bat and glove work helped carry the team to the playoffs. In the two weeks he was with the Padres, starting left fielder the Kid hit .305 with six doubles, two triples, and seven RBIs. By the time San Diego faced Oakland in the first round of the playoffs, Williams had moved up in the batting order from the eighth spot to third. In the first game Williams hit his first home run as a professional, but the Padres eventually lost the playoffs in five games.

Didn't matter anyway; it was time for Ted to return to Hoover High for his senior year.

LOU GEHRIG

Uncovering the Mysterious "Lou Long"

In the spring of 1922 a strapping young man stepped off the Manhattan train and into the streets of Morristown, New Jersey. The city slicker shouldered his bag of baseball equipment and headed to Collinsville Oval where he was hired to play for the local ball club.

Semipro town baseball was big-time entertainment all across the country in the days before radio and television brought big league baseball into every home. While many towns fielded teams for the sheer enjoyment of the game, many hired ringers to give their teams the extra edge in order to win bragging rights among other local towns.

> *In the spring of 1922 a mysterious slugger named "Long" suited up for Morristown*

Morristown, located about 30 miles east of New York City, was no different. Besides a few token locals, the majority of the Morristown Athletic Club team was manned by baseball mercenaries, most of whom had spent time in the minor leagues and were veterans in the highly competitive New York–New Jersey semipro circuit. Second baseman John Kull had a cup of coffee with the World Champion 1910 Philadelphia A's and spent half a dozen years in the minors. Pitcher "Rags" Faircloth made it to the majors with the 1919 Phillies and spent almost two decades in the minors. Left fielder Walt Walsh went directly from the semipros to the Phillies in 1920 and pitcher Bill Mortimer spent time in the Blue Ridge League. Morristown's manager was Joe Sachs, a semipro lifer and former member of the vaunted Paterson Silk Sox, a factory team from North Jersey that before World War I played ball on a big league level.

Taking his place at first base for this team was the 19-year-old introduced as Lou Long. Whether anyone knew his real name is not known, but it seems that the press played along, saying only that he came to town with the reputation of being "the Babe Ruth of the semipros."

It was the kid's second season under an alias—the summer before he'd played for the Hartford Senators in the Eastern League

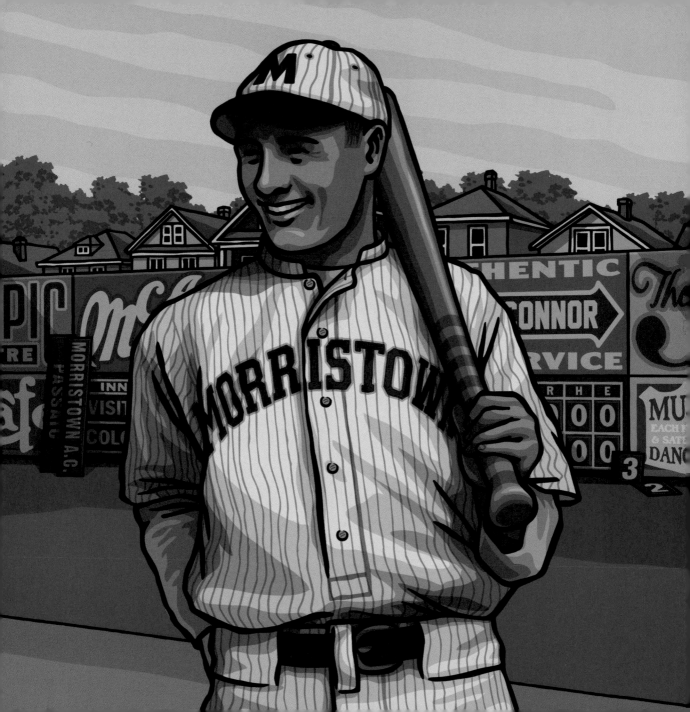

as "Lou Lewis." The first baseman needed the false name because he had an athletic scholarship to Columbia University and if it was revealed he was playing professional baseball it would render him ineligible for collegiate sports.

And that's exactly what happened in Hartford. After his first couple of games the local papers made the mistake of printing the kid's real name, and although subsequent box scores and stories carried the name "Lou Lewis" the cat was out of the bag. After he had played in 12 games for the Senators (and hit a lackluster .261) word reached Columbia's baseball coach Andy Coakley that "Lou Lewis" was really freshman Lou Gehrig. Coakley convinced the kid to leave the team and Gehrig reluctantly gave up a steady paycheck he sorely needed. Coakley then got in contact with the coaches for Cornell, Dartmouth, Middlebury, and Amherst and convinced them that the kid had made an innocent mistake. The admission successfully limited Gehrig's suspension to just one year.

Most Lou Gehrig biographies make it appear that the teenager was really not cognizant that his college eligibility would be forfeited if he played pro ball for money. Some even chalk it up to his being duped by New York Giants manager John McGraw, all part of an evil plan to get the kid kicked out of college and onto the Giants roster. However, since he played under a false name it can be argued that Gehrig knew exactly what he was doing all along. It was no secret that Gehrig came from a poor immigrant family and played ball against his parents' wishes. To earn a paycheck would not only fill his wallet for his upcoming Ivy League freshman year but convince his parents that there was a future in baseball.

That he played the following summer after his suspension was lifted makes it even more apparent that he was willing to risk his Columbia scholarship and education for the fast paycheck of a baseball mercenary. Just a few years earlier Jim Thorpe, the superhero of the 1912 Olympics, pioneering pro football player, and New York Giants outfielder had his medals taken away for appearing in pro baseball games while in college. While previously some colleges might have turned a blind eye to a player making a few bucks on the side, by the early 1920s rules governing collegiate athletics

Word reached Columbia's coach that "Lou Lewis" was really Lou Gehrig

were not only much stricter but were avidly enforced.

How Morristown secured the services of Gehrig is not known. One clue may be that Morristown's center fielder Arthur Carroll was a semipro player from Brooklyn and had been scouted by the Yankees two seasons earlier. The scout who found Carroll? Andy Coakley. That's right, the same Andy Coakley and Columbia baseball coach who feigned shock that Gehrig was playing for Hartford the summer before. Maybe the coach agreed to get Gehrig the Morristown gig in order to help the cash-strapped kid out. Morristown was a little more out of the way than Hartford was and not part of professional baseball.

Playing against teams from industrial cities like Bayonne, Hoboken, and Boonton, "Lou Long" made quite an impression. In his third game with Morristown he hit back-to-back home runs, reportedly the first time anyone had done that for the local nine. Unlike the papers in Hartford, the New Jersey papers did not reveal the first baseman's real name and he completed the 18-game season with 27 hits for a .450 average. He hit seven doubles, four triples, and four homers to round out his one and only season in the semipro trenches.

In the fall Gehrig returned to Columbia, where he played football and baseball. Gehrig tore up the 19-game Ivy League circuit, batting a school record .444 with a .937 slugging percentage and seven home runs, earning him the title of the "Babe Ruth of the Ivy Leagues." He was Columbia's most effective pitcher as well, with a 6-4 record including a 17-strikeout game, a record that still stands at the university.

After the college season ended Yankees superscout Paul Kritchell signed the young phenom and he was farmed out to the Hartford Senators—this time under his own name—and made his debut as a Yankee before the summer had ended. Today the only reminders that Lou Long ever existed are a few yellowed newspaper clippings and a faded team picture of a New Jersey town baseball team from 1922 that once hung in a long-gone Morristown tavern.

> *In his third game with Morristown "Lou Long" hit back-to-back home runs*

LEFTY GROVE

The Best Pitcher a Fence Can Buy

After a few weeks of working in a bituminous coal mine, Bob Groves quit. He told his dad, "I didn't put that coal in here, and I hope I don't have to take no more of her out."

After bouncing from job to job, Bob Groves found his new profession in 1919 when he began pitching for the Lonaconing, Maryland, ball club. A natural left-hander, the 19-year-old struck out 15 batters in his seven-inning, rain-shortened debut. Soon the Martinsburg Mountaineers of the Class D Blue Ridge League offered the youngster $125 a month to play ball, almost $50 more than his father made digging coal out of the ground. The Martinsburg management were happy with their new lefty, but the team was in the red due to a new outfield fence they constructed and had yet to pay off.

After Groves pitched six games for the Mountaineers, Jack Dunn Jr., son of the owner/manager of the Baltimore Orioles, arrived in town. The Orioles had won the International League pennant the year before, and Jack Dunn Sr. was assembling one of the greatest minor league teams of all time. Thirty-five hundred dollars later, Martinsburg had their new fence paid off and the 20-year-old fireballer was a Baltimore Oriole.

As was the norm, when Groves showed up in the Orioles clubhouse none of the other players acknowledged the rookie's existence.

> *Martinsburg offered him $125 a month, $50 more than his father made*

Groves's arrival meant someone lost their job, and it was only after he'd won a handful of games that his teammates warmed up to him. Not that he cared much—the rookie was a loner with a surly disposition. He showed up to win and that was all.

And win the Orioles did. The new lefty went 12-2 in 19 games as Baltimore stormed to another pennant. That fall the Orioles met the Louisville Colonels in the Junior World Series. Dunn sent his rookie to the mound twice, both resulting in losses, as Baltimore went down five games to three.

Groves's second year proved his rookie season was no fluke: 25 wins and an ERA of 2.54. He led all International League hurlers

in strikeouts, but he also led the league in walks, a problem that would dog him as he struggled to harness his fastball. His wildness proved costly the following year when the Orioles faced the St. Paul Saints in the Junior World Series and Groves lost the second game by walking in the winning run.

In 1923 he decided to work on his repertoire of pitches and developed a curveball. Since it crossed the plate so quickly, it didn't have much movement on it, but it did give the batter something different to think about. Around this time local Baltimore sportswriters began leaving off the *s* at the end of his last name and simply referring to him as "Lefty Grove."

Grove won 27 games in 1923 and again led the league in strikeouts and walks. Facing the Kansas City Blues in the Junior World Series, Grove won Game 2 with a four-hitter and was pitching another gem in Game 4 when he split a finger and left the game. After he was clobbered in Games 6 and 9, it was beginning to look like he was ineffective in big games.

Grove's lack of success in the Junior World Series failed to deter major league interest. Since the Orioles were an independent club Dunn did not have to sell any of his ballplayers unless he chose to do so. With the forced sale of Babe Ruth still fresh in his mind, Dunn aimed to make the major league owners pay through the nose if they wanted any of his boys.

After Grove went 26-6 and led the league in winning percentage and strikeouts, Dunn finally sold Grove to Connie Mack's Philadelphia Athletics. Mack knew a fireballer like Grove came along but once in a lifetime and agreed to Dunn's price of $100,600—$100 more than the figure the Yankees paid Boston for Babe Ruth in 1919. It was quite a return on Dunn's original investment of the cost of a fence!

It was quite a return on Dunn's original investment of the cost of a fence!

Grove, along with former Orioles teammates George Earnshaw, Joe Boley, and Max Bishop, formed the core of Mack's 1929–31 A's, considered to be the greatest teams in major league history. In the majors, Grove's .680 winning percentage is the highest of all pitchers with 300 wins or more, and he's considered one of the greatest left-handers to ever play the game. It's simply staggering to think of what the record books would look like had he made the majors four or five years earlier than he did.

CHAPTER 2
THE COULD-HAVE-BEENS

It all started with a guy named Pete Reiser. My grandfather would mention his name whenever a young player got hurt and never regained his former level of play. He would look off into the distance and recount this Reiser stealing home and making outfield catches that defied gravity. To my grandfather, nothing in this world was as unfair as the fate that had befallen Pete Reiser. According to him, Reiser could have been the greatest ballplayer of all time.

As a kid I wondered if this Reiser guy was so great, why wasn't he in Cooperstown, or even in any baseball history books I had? That sent me on a never-ending quest to uncover more of the guys who "could have been."

Some of the players you'll find in this chapter brought about the end of their careers by their own vices. Not everyone was born with the stamina of a Babe Ruth, and booze and too many late nights kept many players from realizing their potential.

Other budding stars found their careers derailed by physical injuries, especially pitchers. Up until the 1950s the Dodgers thought the way to treat sore arms was by repeatedly throwing baseballs at the flagpole in center field until whatever was wrong with the arm was worked out!

According to wartime baseball historian Gary Bedingfield more than 130 minor leaguers lost their lives in World War II, but no one knows how many survived the battles but never regained their baseball skills whether due to injury or age.

The best thing about the could-have-beens is that we are free to wonder what might have been had someone like Pete Reiser stayed injury-free. We can only imagine how fast Steve Dalkowski could throw a baseball. How about Monty Stratton, whose life story was retold on the silver screen by no less than Jimmy Stewart? Who knows how many records he would have broken had he preferred bowling or billiards to hunting rabbits?

All we're left with is speculation, and that's what makes their stories so interesting.

STEVE DALKOWSKI

Going Nowhere Fast

He came out of the housing projects of New Britain, Connecticut, average height with below average eyesight and a left arm that threw comets. The Orioles heard about his 18-strikeout high school no-hitter and signed him, the $4,000 bonus going toward a brand-new Pontiac ragtop.

No one knows how fast Dalkowski could throw, but veterans who saw him pitch say he was the fastest of all time. Some put the needle at 110 mph but we'll never know. He threw so hard that the ball had a unique bend all its own due to the speed at which it traveled. Physics made the thing dip halfway to the plate, then accelerate and rise one to two feet as it blazed across it. Someone likened it to a fighter jet taking off. The only problem was Dalkowski had no idea where the ball was going to go once it left his hand—to the left or to the right—and when it did go over the plate, more often than not it was three feet over the terrified catcher's head.

First stop was Kingsport, Tennessee,

> *How fast could he throw? Some put the needle at 110 mph but we'll never know*

where Dalko (as lazy sportswriters dubbed him) pitched 62 innings and averaged 18 strikeouts per game. Yet he only posted one win—turns out he walked even more batters than he fanned. His heater was so fast and uncontrollable that in one game the 18-year-old tore part of a batter's ear off.

He moved up to the Wilson Tubs, where one of his pitches eluded his catcher, sailed past the ump, and tore through the wooden backstop. Cal Ripken Sr. was there; he saw it happen.

Later in '58 he was sent to Knoxville in the Sally League, where one terrified batter had to leave the game to change his underpants after a Dalko fastball barely missed taking off his head. The Orioles sent him to South Dakota, where he pitched a one-hitter for the Aberdeen Pheasants—but lost 9–8 because of the walks he issued.

In 1959 he went to spring training with the Orioles, where a whole team of experts tried to harness Dalkowski's left arm. The Orioles had the phenom pitch the last inning of a preseason exhibition game against the

Reds. Dalko struck out the side with nine pitches. The O's sent him back to Aberdeen where he recorded 21 strikeouts in a game, a Northern League record.

Down in Pensacola in 1960 Dalkowski drilled a guy in the back with his fastball—not anything out of the ordinary except the dude he hit was inside the stadium standing in line for a hot dog. The guy lived to have Dalko sign the ball for him.

In 1960 spring training came and went with absolutely no progress in Dalko's aim. The more the coaches tried to give him advice the farther outside the strike zone he threw. He was still just 21. There was plenty of time.

The O's sent him to Stockton in the California League. He held the Reno Aces to four hits, struck out 19, but lost 8–3 due to nine walks. In one game a pitched ball sailed over the head of the catcher and busted the ump in the face, breaking his mask in three places, knocking him back 18 feet, and landing him in the hospital for three days. A radio announcer broadcasting one of Stockton's games was hit with a Dalkowski fastball—up in the radio booth.

Spring came and more pitching geniuses

He held the Reno Aces to four hits, struck out 19, but lost 8–3 due to nine walks

failed to tame Dalko's wildness. His life began to spiral out of control with as much velocity as his fastball. Scotch and soda became his hobby and he racked up drunk and disorderly arrests like strikeouts. Still, Dalko was a friendly guy, and his teammates loved him and tried to look after him as best they could. One even confiscated his paychecks and doled out an allowance to the pitcher so he'd have something left after the season ended.

In 1962 the Orioles sent him to Elmira. In between drunk driving Cadillacs into cop cars, Dalkowski set all the wrong kinds of records: 120 pitches without getting out of the second inning and a 27-strikeout game in which he walked 16. At least he won that one. But Elmira had something no other Orioles farm team had: a young manager named Earl Weaver.

At one point in the season Weaver gave all his players IQ tests—Dalkowski bottomed out at 60: "mild mental disability." In those two digits Weaver saw the answer to Dalko's wildness—he simply could not comprehend too many ideas at once. Here the Orioles pitching gurus had been trying to teach him curves, changeups, sliders,

and Dalko had no idea what to make of any of that.

Weaver worked with the flamethrower constantly, just having him throw fastballs, nothing else. Don't worry about runners on base, don't think about the count, just throw the ball as hard as you can. It worked.

In over 50 innings Dalko fanned 104 batters and walked only 11. The opposition scored exactly one earned run off him. He was ready for the big show.

This time spring training with the Orioles was something else. Reporters couldn't find anyone else worth writing about and the future seemed bright for Steve Dalkowski. The photographer from Topps baseball cards showed up at the training camp in Miami and snapped a head shot of Dalko. When kids opened up fresh wax packs of ball cards that summer there was Steve Dalkowski, one of the four "1963 Rookie Stars" on card 496. But he never appeared in a major league game in 1963 or any other year.

At the end of spring training Dalko was informed he'd made the cut, was measured for a set of Orioles uniforms, and took the field for the last exhibition game. Called on to pitch the ninth inning, Dalkowski fielded a bunt, threw the ball to first, and heard a pop. His shoulder was done and so was his career.

He was informed he'd made the cut and was measured for a set of uniforms

He spent three years tumbling down the rungs of the minor leagues, a blur of sub–90 mph fastballs and scotch. At 26 he was out of baseball and couldn't bring himself to return home. He dropped off the grid and picked fruit in California, dividing his time between itinerant work camps and the drunk tank. Somehow Frank Zupo, his old catcher from Stockton, tracked him down and brought him home to New Britain. He dried out and even got to throw out the first pitch at a local minor league game (it bounced 20 feet in front of the plate). Then he disappeared again.

His sister brought him home for good and checked him into an assisted living home where he's been since 1993. If any of Dalkowski's pitching misadventures sound familiar, it may be because the guy who wrote the movie *Bull Durham* once played minor league ball for a manager who once played with—you guessed it—Steve Dalkowski.

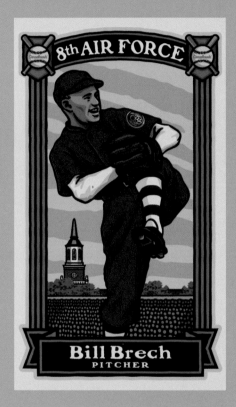

8th AIR FORCE

Bill Brech
PITCHER

The last thing Bill Brech thought he would get out of his war service was the title of the best pitcher in the Army Air Forces.

Before World War II engulfed the globe, Brech was a talented semipro hurler back in Secaucus, New Jersey. In 1943 he was a sergeant in the Eighth Air Force, the unit charged with the daylight bombing of the Third Reich. In order to help maintain the morale of the bomber crews who faced only a one in five chance of finishing their tour of duty, the Eighth Air Force fielded a ball club made up of talented former pro ballplayers.

Brech quickly emerged as the ace of the Eighth Air Force M.P. Fliers, playing all over England against other American and Canadian army teams that boasted former professional ballplayers. His greatest game was a 1943 no-hitter against the Ground Forces All-Stars in front of 12,500 fans at Empire Stadium in Wembley. Brech dominated the military league that year, winning more than 20 games and at one point racking up 61 strikeouts in four games. In 1944 he threw another no-hitter to beat the First BADA Bearcats and win the Air Service Command Championships.

From 1943 to 1945 Brech appears to have averaged 15 strikeouts a game, and his performance against major league talent led to many professional offers when he was discharged. He signed with the Harrisburg Senators but at age 24 he felt he was too old to start a career in baseball and called it quits. He got himself a good job with a steel container company in Secaucus and sated his thirst for baseball by pitching semipro ball into the 1950s. The ace of the Mighty Eighth passed away at age 56 in 1978.

During the late 1930s it seemed that the only hope the White Sox had of dragging the team out of the American League cellar rested on the shoulders of a thin six-foot-six-inch Texan named Monty Stratton. In three seasons Stratton managed to rack up a winning 35-21 record with a 3.67 ERA for a truly miserable White Sox team.

Stratton never had a desire to play pro ball. He was too busy running his family farm to support his widowed mother. One day the local town team tapped him to pitch, the idea being that even if he couldn't pitch well, he would at least scare the opposing team with his size.

But pitch well he did. Stratton was soon signed to a White Sox contract and after a couple of years burning up the minor leagues with his fastball, he made it to Chicago. Then, after three brilliant summers, it all ended.

Hunting rabbits on his family farm after the 1938 season, Stratton tripped and his pistol went off, blowing a hole in his right leg, severing an artery. Doctors amputated and Stratton was left trying to adjust to a wooden leg and a life without baseball.

In what has to be one of the most remarkable comebacks of all time, Stratton, with his wife Ethel acting as his catcher, taught himself to pitch again. He made it back into pro ball in 1946 when he pitched for the Sherman Twins of the Class C East Texas League. Despite batters' relentlessly bunting against him, Stratton won 18 games, inspiring Hollywood and Jimmy Stewart to immortalize him in the 1949 movie *The Stratton Story*.

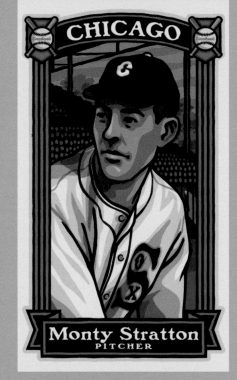

CHICAGO

Monty Stratton
PITCHER

WILLARD HERSHBERGER

The Man Who Destroyed Himself

The Sunday-morning traffic that moved through the lobby of the Copley Plaza Hotel surged and flowed around the group of ballplayers who sat in the plush armchairs. Some fiddled with cigarette lighters and watches but most pretended to study the newspapers they hid behind. None were open to the Sunday sports section. A handful of newspapermen went from man to man only to be quietly shooed away after scribbling a few lines in their notepads. After a while, most simply took seats next to the men they were trying to talk to and sat silently as well. Though everyone wanted to be alone, no one took the elevator to their rooms, for upstairs was where Willard Hershberger, catcher for the Cincinnati Reds, had killed himself the day before.

Willard Hershberger's early life was like something from a mediocre Hollywood movie: a loving family in the picturesque setting of Lemon Cove, California. The boy grew big and strong, riding horses and hunting along with playing baseball and football. By the time he was a senior in high school, it was obvious Willard was bound for a career in professional baseball. A young man couldn't have asked for a better childhood.

Then in November of his senior year his father took his own life. The devastating loss forever cast a pall over the once friendly and fun-loving Californian.

Willard was signed by the New York Yankees and gradually made his way up their chain of farm teams. By 1937 Hershie, as he was inevitably nicknamed, was the starting catcher for the Newark Bears, a team regarded as the greatest minor league team of all time. Though he was considered the best backstop in the minor leagues, he remained quiet and troubled, always worried.

When the Cincinnati Reds needed a hard-hitting backup for Ernie Lombardi they traded for Hershberger.

The Reds were in the midst of building a club that would win the National League pennant in 1939 and the World Series in 1940.

His early life was like something from a mediocre Hollywood movie

Hershberger became valued for his knack for getting a key hit when needed, and his skill behind the plate made him the National League's best backup catcher. In the heat of the 1939 pennant stretch those two attributes made Hershberger indispensable.

After being swept by the Yankees in the 1939 World Series, Cincinnati retooled and fielded an even stronger squad in 1940. Nonetheless, it was a tough pennant race as Brooklyn and Cincinnati traded first place no less than seven times. With the country still suffering from the Great Depression, the players' share of the World Series money was a huge incentive to win the pennant again. As spring turned to summer, Hershberger began acting even more oddly than his teammates were accustomed to. Though he was consistently hitting over .350, each time he failed to deliver at the plate he sulked inconsolably, and he constantly badgered the team doctor with imaginary illnesses. The other Reds kidded him about it. It was a way to blow off the pressure of a tight pennant race. Stuffing pill bottles in his locker or telling the hypochondriac he didn't look well was all good-natured fun—to everyone but Hershberger.

As August loomed, a record heat wave enveloped the eastern half of the country, and Cincinnati began to falter. Ernie Lombardi went down with a severely sprained ankle, making Hershberger the starting catcher. When the Reds lost a few close road games, Hershberger began to crack, imagining his teammates placed the blame solely on him. The pressure proved to be too much for the sensitive, quiet catcher.

July 31, 1940, was his breaking point.

Playing the Giants at the Polo Grounds, the Reds were winning in the bottom of the ninth when two home runs gave New York a dramatic come-from-behind win. Hershberger blamed his judgment in calling the pitches for the tough loss.

As the Reds took the train north to Boston, the catcher grew more despondent. The Reds dropped the first game of the August 2 doubleheader and the second was scoreless through 12 innings. Hershie came to the plate five times with men on base—his old specialty—and all five times came up empty. That the rest of the Reds bats were silent didn't register in his mind; Hershie carried the weight of the entire team on his back and it began to show. When Boston won on a home run, the catcher was inconsolable.

Reds manager Bill McKechnie was a kind and understanding man, so much so

that he was called "The Deacon." Knowing that something was terribly wrong, he and coach Hank Gowdy talked with the catcher after the game. Throughout the evening Hershberger poured his heart out about his insecurities, sobbing uncontrollably. Late that night when he and McKechnie parted, the manager felt his catcher had pulled himself together. He was wrong.

The next afternoon was another double-header. When Hershberger failed to show at the ballpark, McKechnie had the team's traveling secretary call his hotel room, where the irritated catcher said he was sick. He did promise to show up for the second game and sit in the stands.

When the second game started and no Hershberger, McKechnie knew something bad had happened. He asked Dan Cohen, a Reds fan who occasionally traveled with the team, to return to the hotel and see what was wrong.

Earlier, while the first game was entering the sixth inning, Hershberger went into his bathroom. As his portable radio broadcast the ballgame in the other room, the catcher opened a vein in his neck with a razor. By the time the Reds finished the game with a win, Willard McKee Hershberger was dead.

The memory of Willard Hershberger hung over the Reds for the rest of the summer. McKechnie told the team that they owed it to Hershie to win the pennant, and each man wore a black armband in memory of the catcher. In a novel tribute for the time, the Reds retired Hershie's number 5 for the rest of the season. While the retirement of Hershberger's number 5 wasn't permanent, in 1984 it was finally hung up for good—after Johnny Bench, who wore it on his own back for 17 seasons, retired from the game.

Cincinnati took the pennant by 12 games, but going into the World Series against Detroit they faced a serious deficit behind the plate. In desperation they activated coach Jimmy Wilson. Though he hadn't caught a game in years, he became the hero of the 1940 World Series, batting .353 as Cincinnati won in seven games.

That November the Reds sent Willard's mother a check for $5,803.62, a full share of the World Series winner's money. Having carried the weight of the whole ball club on his shoulders, the boys felt Hershie earned it.

> *The Reds retired Hershie's number 5 for the rest of the season*

RUSS VAN ATTA

The Babe, a Dog, and One Dead Finger

Back when I was growing up in New Jersey, my grandparents would take my brother and me into the northwest part of the state to pick apples. Sussex County was far away from the belching smokestacks, endless overpasses, and teeming city streets you think of when "New Jersey" comes to mind. Sussex County was and still is a dazzling wilderness of rolling green foothills, black-and-white milk cows, racehorses, and tidy red barns, the reason New Jersey's called "The Garden State."

Now, back then, in the late 1970s, chances were if you stopped in any diner or tavern in the county there would be one thing that they all had in common besides Taylor ham sandwiches and cold Ballantine beer in bottles—an autographed picture of Babe Ruth. Every single establishment seemed to have one; they were as common as a calendar. Who was behind this countywide plethora of Bambino ephemera? The Sheriff, that's who.

Long before he was known as "The Sher-

Van Atta's debut was one of the most memorable in the history of the game

iff," Russ Van Atta was just another poor kid trying to escape the northwestern New Jersey zinc mines. Working underground for 53 cents an hour wasn't how he wanted to spend the rest of his life, and Russ figured baseball was his way out. A southpaw pitcher, Van Atta received a partial scholarship to Penn State in 1924. By the time he graduated Van Atta was the Nittany Lions' ace, losing only a single game in four seasons.

The New York Yankees signed him, and five years later he was wearing his own set of pinstripes with the number 14 on the back.

On April 25, 1933, the Yankees were in Griffith Stadium to play the pennant-bound Washington Senators. Russ Van Atta took the ball and began one of the most memorable and infamous debuts in baseball history.

For the first three innings the rookie kept the Senators scoreless. In the top half of the fourth, Yankees outfielder Ben Chapman came to bat. Chapman had a mean streak a mile wide and was a rabid anti-Semite. Slid-

ing into second with a double, Chapman needlessly spiked Washington's star second baseman, Buddy Myer. Myer jumped to his feet and kicked Chapman in the head. Being half Jewish he undoubtedly figured Chapman's bigotry had something to do with his spiking. The two went at it and both benches emptied as the players ran onto the field.

Van Atta was among them but was quickly grabbed by his manager Joe McCarthy and pushed back toward the bench—the Yanks couldn't afford to have him thrown out of the game or injured. Returning to the dugout he found only two Yankees still there, Babe Ruth and Lou Gehrig.

The umpires returned calm and ejected Chapman and Myer. As Chapman walked past the Senators bench, Washington pitcher Earl Whitehill shouted something and Chapman belted him in the mouth.

Now all hell broke loose.

Three hundred fans rushed onto the field to attack Chapman. Yankee Dixie Walker did his best to defend his teammate but was soon overwhelmed. The rest of the Yankees charged in and it took police twenty minutes to beat back the crowd. Dixie Walker was ejected and a handful of fans were taken away in handcuffs. It was probably one of the worst riots in major league history, but the day wasn't over yet.

Much to Van Atta's credit he refused to become rattled by the battle. At bat he went four for four, knocking in a run and scoring three. He kept the Senators to five hits and shut them out 16–0, one of the best debut performances for a pitcher in history.

Everything Van Atta did that 1933 season went his way. The rookie developed a nasty little curve, the key being the pressure he put on the ball with his middle finger. He closed out the season 12-4, his .750 win-loss percentage leading the Yankees starters. Van Atta went home to the Jersey foothills a conquering hero. The *Sporting News* picked him, along with future Hall of Famers Hank Greenberg and Joe Medwick, for their 1933 freshman all-star team. Besides the accolades in the sporting press, Van Atta had also made an influential friend: Babe Ruth.

Both ballplayers had a passion for the outdoors—hunting, fishing, and golf—and Van Atta proudly took the big slugger home with him on off days to sample what the Garden State had to offer. The Babe fell in love with Sussex County and continued to visit well into the 1940s.

Anyone in the know predicted great things for Van Atta, but a week before Christmas, this tiny article appeared:

HOUSE BURNS.

Russell Van Atta, New York Yankee pitcher, his mother, wife, and child were left homeless when fire destroyed the family residence at Lake Mohawk, near Sparta, N.J., on December 13. Firemen from Sparta tried to save the house but the flames had gained such head-way that their efforts were unavailing.

Losing his house was a lousy way to cap off a great year, but baseball season, and what was supposed to be another great year, was just around the corner.

Right from the start something was wrong. His fastball lost its sting and the newfound curve lost its bend. By May Van Atta had slipped from starter to the bullpen. Newspapers speculated on causes: the dreaded sophomore jinx, strained arm, maybe the batters simply "figured" the

southpaw out. No one knew for sure until the real reason finally leaked out.

Remember that December fire? Well, there *was* an injury that fateful night. As the flames engulfed the home, Van Atta took stock of his family members—mother, wife, child, dog . . . wait, where was the dog? Realizing his cocker spaniel was missing, he dashed back into the burning house. Somehow he sustained a terrible cut on the index finger of his left hand, severing the nerves. Van Atta staggered back outside clutching his pitching hand only to discover his dog faithfully waiting for him.

As the winter turned to spring, Van Atta's finger healed in appearance but the nerves had been destroyed. He could no longer get a good grip on the ball, which pretty much threw his newly found curveball out the window and robbed his fastball of its velocity. The finger was so badly damaged he could run a lighted match along it without feeling a thing—not a bad trick at cocktail parties but meaningless for a pitcher trying to stay in the game. He told no one about the injury, not even his wife.

The Babe's pitch was simple: If you don't elect Russ I'm not coming back

After a horrible 1935 spring training, the Yankees dumped him on the St. Louis Browns. During the next five summers Van Atta went 18-32 for the miserable Brownies. By 1940 he returned to the foothills of New Jersey.

Still popular at home, Van Atta ran for sheriff of Sussex County, and with the help of his old pal Babe Ruth, easily won. The Babe's campaign pitch was simple: With a wink of the eye he told the locals if you don't elect Russ, I'm not coming back anymore. That's how Russ Van Atta became Sheriff Van Atta and the reason behind all the signed pictures of the Babe once found throughout Sussex County.

After a term as sheriff Van Atta moved on to a highly successful career with the Gulf Oil Company. Shrewd land deals made the former Yankee a wealthy man, and Sheriff Van Atta spent his retirement traveling around the country visiting his old teammates, reliving his once promising career. Alzheimer's finally claimed the old southpaw. He died at the age of 80 on October 10, 1986.

RYAN FREEL *Run, Farney, Run!*

CINCINNATI

Ryan Freel
UTILITY

Baseball was everything to Ryan Freel. He poured his whole body and soul into the game and unfortunately that's what led to his suicide at the age of 36.

He came up with the Blue Jays in 2001 but didn't stick. Cincinnati gave him a shot at the age of 27 and he didn't disappoint. Freel's unbridled play brought excitement to an otherwise lackluster Reds team. He charged balls, played any position, swiped bases, and hit well in the clutch, reminding Reds fans of the great Pete Rose. Seasons of .285, .277, .271, and .271 followed, making him indispensable.

Being a big league ballplayer was his life's ambition, and he relished every minute of it. Freel respected his fans, going out of his way to sign autographs and make public appearances. He had a quirky side as well, talking to a voice in his head teammates dubbed "Farney."

Freel's career began a quick decline after he was seriously injured in a 2007 outfield collision. He suffered severe headaches afterward, and a knee injury further hampered his performance. He was traded to Baltimore in 2009 and shortly afterward was beaned during a pickoff play. He was out of the game a year later.

Freel wrestled with demons his whole life—bipolar disorder, alcohol issues, anger problems—which playing baseball helped him control. Once out of the game and suffering from CTE, a degenerative neurological condition brought on by numerous concussions, Freel became despondent as his life spiraled out of control. Unable to face life out of baseball, Ryan Freel tragically ended his life in 2012.

When 10-year-old Karl Spooner severely injured his teacher with a snowball to the face in the winter of 1941, he and everyone else in Oriskany Falls, New York, knew he had something special. By the time he graduated high school in 1950 the National League champion Phillies put together a lucrative offer, but they needn't have bothered—Spooner was a Dodgers fan and when the Brooklyn scout came around, Karl signed on the dotted line.

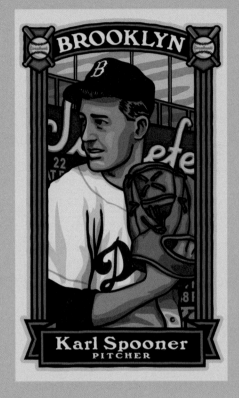

By the time the Dodgers called him up at the end of the 1954 season the sportswriters were calling him "King Karl." That summer his blazing fastball won him 21 games for the Fort Worth Cats, leading his team to the Texas League playoffs.

With a week left in the 1954 season Spooner took the mound to face the New York Giants, who would go on to win the World Series that year. The kid lived up to his nickname by tossing an effortless complete-game shutout and striking out 15 Giants. The next week he struck out 12 Pirates on his way to another complete-game shutout. It was the last game of the 1954 season and all winter long, Brooklyn fans couldn't wait to see what the future held for King Karl.

They didn't have to wait long. Spring training brought an abrupt end to everyone's hopes when he was rushed into a meaningless exhibition game before properly warming up and tore his shoulder. In 1955, Spooner went 8-6, then was sent to the minors in '56 and, two years later, had washed out of baseball entirely. It was the end of one of the most promising pitchers in baseball history.

MOONLIGHT GRAHAM

Going Nowhere Fast

On June 29, 1905, the New York Giants were murdering the Brooklyn Superbas 10–0. With the game all but won, John McGraw pulled his regulars and began sending his new guys and second-stringers in to play. In the bottom of the eighth, McGraw sent 25-year-old rookie Archie Graham in to replace outfielder George Browne. Graham, called "Moonlight" because of his speed, raced out to his position in Washington Park's right field.

After an unremarkable inning in the outfield the eager rookie was waiting to bat in the top of the ninth when Claude Elliott popped up for the Giants' third out. Graham went back to right field and finished the game without getting a chance to bat. A few days later he was sent to the minors, McGraw promising to call him back later in the year. He never did, making Moonlight Graham one of almost 1,000 other forgotten ballplayers who had a single taste of the big leagues.

Unlike most ballplayers, Graham was college educated, and he had just gradu-

> **McGraw promised to call him back later in the year. He never did.**

ated from Baltimore Medical College when he was signed by the New York Giants. He played a few more seasons of minor league ball before he hung up his spikes for good and started his medical practice.

After stops in Scranton and Chicago, ill health caused Graham to seek the clear air of Chisholm, Minnesota. He married a local girl, Alecia Flowers, and became the doctor for Chisholm's public school system. Doc Graham lived out the rest of his 82 years in Chisholm, passing away in 1965, a much-beloved member of the modest Minnesota community.

Chances are no one would have remembered Archie Graham and his one-line entry in the *Baseball Encyclopedia* had it not been for W. P. Kinsella's 1982 novel *Shoeless Joe*. The book was later made into the hit movie *Field of Dreams*, in which Graham was portrayed by Burt Lancaster, propelling Moonlight Graham from forgotten major leaguer into the most famous short-timer in baseball history.

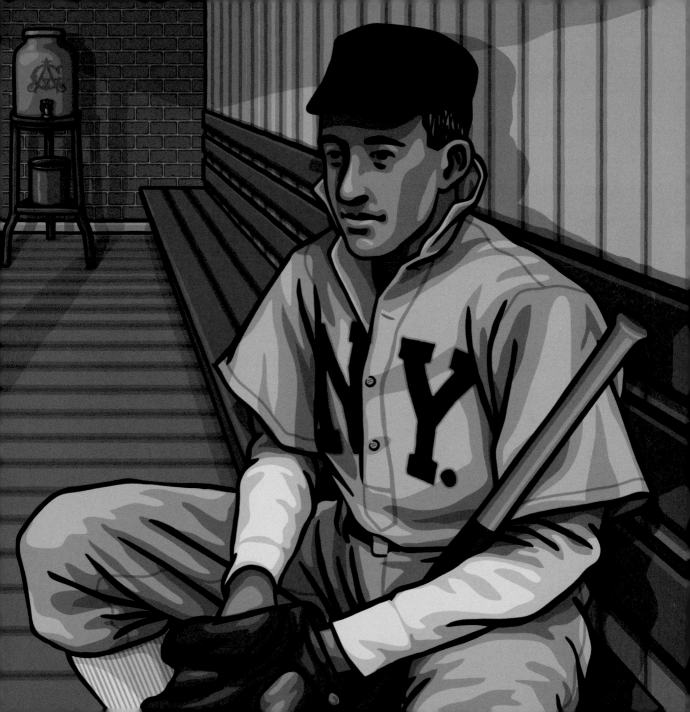

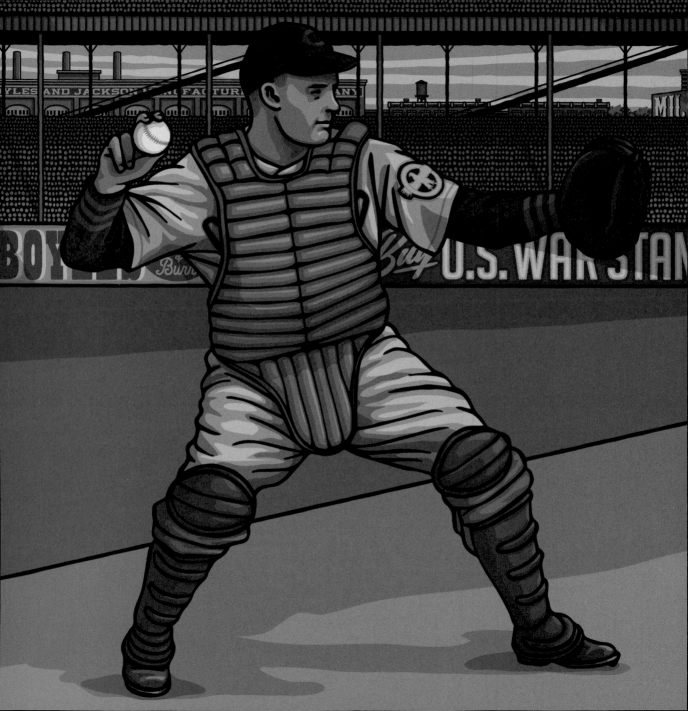

PAUL GILLESPIE

A Short, Distinctive Career

The PA announcer's voice was still reverberating around the Polo Grounds as Cubs rookie Paul Gillespie dug his spikes into the dirt and waited for his first pitch in the major leagues. An exciting and memorable moment for any big leaguer, but when Gillespie knocked a Harry Feldman fastball into the bleachers for a home run that September 11, 1942, afternoon, he joined an elite group of players who hit a homer in their first major league at-bat. It was one of several noteworthy moments in Gillespie's short, distinctive career.

Paul Gillespie received his break in professional ball through his friendship with Rudy York of the Detroit Tigers. The two both called Cartersville, Georgia, home, and York convinced Detroit's manager Mickey Cochrane to give the 18-year-old the once-over when they passed through Atlanta in the spring of 1938. Cochrane must have liked what he saw in the burly catcher, because before the Tigers left town they'd signed Gillespie to a minor league contract.

Before the Tigers left town they'd signed Gillespie to a minor league contract

His first assignment was with the Lake Charles Skippers of the Evangeline League, the bottom rung of the minor leagues. Gillespie hit a credible .312 in 129 games, but due to some contract shenanigans he was released from the Tigers organization by Baseball Commissioner Kenesaw Mountain Landis and declared a free agent. The Brooklyn Dodgers quickly snatched up the catcher and he began a three-year stretch that saw him play for no fewer than eight different teams. By the summer of 1942 he was with the Tulsa Oilers, a Chicago Cubs affiliate. When Gillespie was acknowledged as the best catcher in the Texas League the Cubs called him up for a closer look. On September 11 the team was in New York playing the Giants when Gillespie hit that home run off Feldman. He got into five games, hitting another round tripper and finishing with a .250 average.

By now World War II was in full swing, and by the time the 1943 season started he was in a Coast Guard uniform. Gillespie's wartime service revolved around playing

baseball, and he kept in big league condition by being teamed with former Cardinals pitcher Al Jurisich. The two led their Louisiana-based Coast Guard team to the USO championship. In the late summer of 1944 Gillespie was given an honorable discharge from the Coast Guard. That the war was still in full swing suggests that he was let go for medical reasons, not uncommon with professional athletes, most of whom had at one time or another suffered injuries that made them poor recruits for active service.

On September 21, Gillespie's first game back with the Cubs, he again found himself facing the Giants at the Polo Grounds. With one on in the first, the big catcher hit a two-run homer, again making a great first impression at the Giants' expense. He got into five games before the season ended and was deemed a sure-bet regular for the '45 season.

When the 1945 season began, Paul Gillespie and three of his Cubs teammates were at the front and center of a minor baseball controversy. Gillespie was one of four Cubs who wore a gold and blue eagle (military uniform buffs call it the "ruptured duck" patch) on their left sleeve signifying an honorable discharge from the armed forces. Men discharged from the military wore this eagle patch on their uniforms or as a lapel pin to distinguish themselves from men who for whatever reason did not serve in the military. In the civilian world this was no cause for concern, but when it came to baseball, league officials balked. Since the beginning of the war, many fans had cried foul when big, healthy ballplayers continued to appear in the big leagues while every other able-bodied male in the country was drafted. Major League Baseball had been very self-conscious about its players' appearing to get special draft exemptions, and now here was a patch that would make it easy to distinguish at a glance which players served and which ones did not. An early form of political correctness prevailed and the patch was retired sometime during the summer.

An early form of political correctness prevailed and the patch was retired

By that last year of the war, organized baseball had been thoroughly drained of its best talent. The Cubs emerged as the front runners of a dramatically weakened National League but still had to contend with the defending World Champion St. Louis Cardinals. It was during the late-

summer pennant stretch that the big Georgian emerged as the team's best-fielding catcher and clutch hitter. Though not a power hitter, Gillespie put on a show for the ages on August 15, 1945, when he hit two home runs at Brooklyn's Ebbets Field, one of which was a grand slam. The two blasts counted for six of the Cubs' 20 runs that afternoon.

The Cubs had already clinched the pennant when they faced the Pirates at Forbes Field on September 29. In the fourth inning Gillespie stepped to the plate to face Rip Sewell. With one on, the catcher knocked one into the stands for a home run. The homer brought his batting average to .288 and the season ended the following afternoon. As he jogged around the bases, Paul Gillespie had no way to know that it was the last hit of his major league career.

The Cubs faced the Tigers in the World Series and Gillespie was the team's first-line backstop. As every Cubs fan knows, the '45 series ended in a Cubs defeat, and the same can be said for Gillespie's major league career.

Only two men have hit homers in their first and last major league at-bats

In the ninth inning of Game 2, Gillespie was running out a single when he tripped, aggravating an old knee injury. Gillespie was a gamer, however, and he was back behind the plate in Game 5. This proved to be his last appearance, though, as he further damaged the knee swinging at a Virgil Trucks curveball.

During the winter the Cubs sent him a new contract with a raise in salary, and in January 1946 he married Louisiana native Pat Ozment. He underwent surgery to fix his knee injury and looked forward to being the Cubs' starting catcher in 1946. But it was not destined to be. The operation was unsuccessful, and after a disappointing spring training the Cubs released him to the minor leagues.

Though Paul Gillespie's major league career lasted less than three summers it was nonetheless one of some distinction. To this day only one other man in the entire history of Major League Baseball has hit a home run in his first and last big league at-bat. Gillespie was the first and John Miller did it in 1965 and 1969.

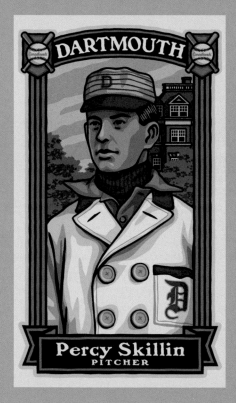

DARTMOUTH

Percy Skillin
PITCHER

Back in 1906, Percy Skillin had it all. The 19-year-old southpaw was in his sophomore year at one of the nation's elite colleges and possessed an arm that had major league teams throwing money at him.

He came to Dartmouth in 1905 from Oak Park, Illinois, and made an immediate impact, winning his varsity D in his very first game. By the end of the season he was considered the best collegiate pitcher in the East. During the summer he played semipro ball in the much-vaunted Chicago City League. Skillin matched arms with the major league mercenaries of Nixey Callahan's Logan Squares and the best blackball team in the country, the Leland Giants. Tall and lean, Skillin possessed great speed with pinpoint control that when combined with a coolness under fire made him unbeatable.

Returning to Dartmouth in 1906 he was made the team's captain, a rare honor for a mere sophomore and a true measure of his maturity on the ball field. He dominated the Ivy League circuit with two shutouts and a no-hitter against Brown. He won seven of his 10 decisions and the three losses were through fielding errors by his teammates—two were three-hitters and the other was a two-hit masterpiece. Skillin struck out 124 and was charged with a single earned run the entire season.

The Red Sox put an unbelievable $4,000 on the table to entice the teen to drop out of Dartmouth, while Cleveland was reported to have presented Skillin with a comparable offer. He turned down both offers and returned to Oak Park a local hero. As the most popular ama-

teur ballplayer in the city, he hired out his left arm to various teams throughout the summer. Again the youngster faced off with the best in outsider baseball. Rube Foster, thought by many to be the best pitcher in blackball history, had joined the Lelands and Skillin battled the future Hall of Famer on numerous occasions.

The name Percy Skillin now was so well known in baseball circles that it caused a problem when he returned to Dartmouth in the fall of 1907. As is the case today, athletes could lose their collegiate eligibility by playing professional ball. At the turn of the century these rules were usually winked at if the player employed an alias, which Skillin did not do. At first he was declared ineligible but somehow it was settled and he returned to captain the team again.

The 19-year-old Ivy Leaguer had major league teams throwing money at him

Following another fine season at Dartmouth, Skillin was approached by the Chicago Cubs. The Northsiders were the best team in the National League and would win back-to-back World Series in 1907 and 1908. That they gave the Ivy Leaguer the full-court press to get his signature on a contract speaks to how good a prospect this kid must have been. At this point it looked as if Skillin was close to putting Dartmouth on hold and making the jump to the big leagues, but not for the Cubs: Skillin was a White Sox fan. He held out for an offer from the Southsiders and was rewarded with an invitation to try out when he returned home to Oak Park that summer.

However, Skillin never appeared with the White Sox or with any other major league team. All the innings pitched during the previous three years had taken their toll on his magic left arm. He graduated from Dartmouth, class of '08, and took a job as a representative of the Spalding Sporting Goods Company. He pitched semipro ball around Chicago until he married in 1913, then went overseas during World War I, teaching baseball in France. Skillin put his Dartmouth education to good use and became a wildly successful investment broker and a very rich man. The home he commissioned on Chicago's North Shore is still considered an architectural landmark of the Prairie Style. The ace of the Ivy League passed away at the young age of 39, and today the name Percy Skillin still appears in the top 10 of many pitching records at Dartmouth.

SILK SOX

Otto Rettig
PITCHER

During the teens and twenties the Doherty Silk Company of Clifton, New Jersey, fielded one of the finest semipro teams in the nation. Stocked with generously paid professionals, the Silk Sox played and won against all levels of competition. The Silks' greatest triumph came on September 26, 1916, when 10,000 fans came to Clifton's Doherty Oval to see them take on the mighty New York Giants.

The pitcher that day was 22-year-old Otto Rettig, a native New Yorker with a nasty curve. The unknown totally dominated the big leaguers and at one point Giants third baseman Heinie Zimmerman threatened to throw his bat at Rettig after striking out. Old Heinie shouldn't have taken it personally for Rettig fanned 12 other Giants on his way to a three-hit shutout. Once manager John McGraw got over the humiliation of being blanked by a semipro factory squad he told Rettig to report to the Polo Grounds for a tryout.

Though making the big leagues would have been the dream of most men in the country, Rettig turned down McGraw's contract because he made more money playing for the Silk Sox. Shortly afterward Rettig burned his arm out, but through a long rehab he reinvented himself as a junk-ball pitcher. In the summer of 1922 Rettig presented himself to the Philadelphia A's. Connie Mack threw Rettig into a game against the Browns, which he promptly won, 6–3. However, a few days later he faced Ty Cobb's Tigers, who swatted his junk balls all over the park. Still, Rettig showed he did indeed have the stuff to make it all the way to the majors, leaving us to wonder what he could have done when he was in his prime.

While some ballplayers complain they never catch a break, Jimmy Lyston had one break too many.

The 18-year-old Lyston was signed by his hometown Baltimore Orioles in 1921 and was farmed out for seasoning. Almost immediately he suffered a broken finger and returned home to Baltimore to recuperate.

This was a good break. The Orioles had suffered a series of injuries and manager Jack Dunn tapped the now-healed Lyston to be their utility man. Virtually every starter on the early-1920s Orioles made the majors and the way Lyston made headlines, it looked as if he would share the same destiny. A songwriter even penned a song about Lyston, which included the verse, "Dunnie made a star out of the Babe and he'll make a star out of you."

The bad break came in early August when Lyston was hit by a mudball thrown by Newark pitcher "Happy" Finneran. The youngster was unaware he had broken his arm and kept playing for three more weeks until Dunn noticed he was unable to throw. The team doctor discovered that the arm had been broken just below the elbow, and the nerve damage was so severe that he'd never be able to throw a baseball again.

Lyston proved the doctor wrong, but the injury kept him from advancing to the majors. After seven seasons of pro ball, he became a Baltimore police captain, had two daughters, six grandchildren, and ten great-grandchildren. He'd probably tell you that that was the best break of all.

BALTIMORE

Jimmy Lyston
SECOND BASEMAN

PETE REISER

The Heartbreaking Ballad of Pistol Pete

As a kid in the late 1970s, I was a New York Mets fan and there really wasn't much too cheery to talk about my favorite team. So when I sat down and talked baseball with my grandfather, a die-hard Brooklyn Dodgers man, the conversation would often turn to the past and the players he watched from the bleachers at that mythical place called Ebbets Field. Van Mungo, Babe Herman, Dizzy Dean, Mel Ott, Gil Hodges, Joe Medwick, Hack Wilson, Jackie Robinson—he'd seen them all. I'd heard all their names before,

> *The things that made him the greatest were the same things that destroyed him*

all except the one my grandfather said was the best of 'em all, the best there ever was, the best there ever would be. If I close my eyes, I can see my grandpa as he put his hands together, tightly gripping an imaginary bat, and recounted this ballplayer's savage hitting, his reckless fielding and blazing speed that made him the fastest in both leagues, and how he was blessed with an all-out, unrivaled love of the game. Then his eyes would glaze over, remembering that the things that made this ballplayer the greatest

he had ever seen were the same things that destroyed him. . . .

His name was "Pistol Pete" Reiser. Even as a boy on the sandlots of St. Louis he was fast and daring; he hit from both sides of the plate and played the game with a smile that revealed his joy. He was a natural. That was the way Pistol Pete would always play the game.

Cardinals scout Charley Barrett picked him out of 800 prospects who showed up at a tryout camp in 1936. At 15 years old the kid was too young to sign, so Barrett took him on as a chauffeur, touring the lower rungs of the Cardinals' farm system. When he turned 17 he finished up his first pro season by batting .283.

Cardinals owner Branch Rickey salivated over the reviews of the boy and personally micromanaged his advancement. The Cardinals' boss saw a dynasty of pennant-winning clubs built around this boy. It wasn't to be.

When Branch Rickey acquired another

club in the same league as his Newport one, he violated an MLB rule barring a team from owning more than one club in the same league. Commissioner Kenesaw Mountain Landis proclaimed Reiser and more than 70 other Cardinals prospects free agents and forbid St. Louis from reacquiring them for a period of five years.

Today, Branch Rickey is known as that great pious gentleman who integrated baseball, which of course is true. But he was also a ruthless, cutthroat businessman. Rickey had his old pal and general manager of the Dodgers, Larry MacPhail, acquire Reiser and hide him in the low minors until it was safe to trade him back to St. Louis. On the surface it was a solid plan, except for one thing: Pete Reiser was too darn good.

One day during spring training in 1939, Brooklyn's manager, Leo Durocher, penciled Reiser into the lineup. In his first at-bat he hit a homer, and after three games he'd reached base 11 consecutive times. Durocher couldn't control his enthusiasm and held out his new discovery to anyone who would listen. Back in St. Louis, Branch Rickey was shocked to see his great secret splashed all over his morning sports page. He called MacPhail, who fired off a telegram to his manager telling him to send Reiser back down to the low minors. Durocher, whose drive to win trumped anything else in life, only relented after MacPhail threatened to fire him.

Back in the obscurity of Class A ball, Reiser suffered his first major injury. Throwing a ball from the outfield to make a play he injured his arm. Somehow he managed to play for weeks before X-rays showed he'd fractured the arm. Not content to sit around recuperating when there was ball to be played, Reiser taught himself to throw with his other arm, borrowed a glove, and took the field. That's the way Pistol Pete played the game.

When Reiser's .370 average in the minors began making headlines, MacPhail couldn't keep the kid in the minors any longer without Commissioner Landis growing suspicious. Rickey reluctantly gave up on his greatest discovery and by July Pistol Pete was a Brooklyn Dodger. In 58 games he hit .293, and when spring 1941 came, the only problem facing the Dodgers was to decide what position to start him at.

Weighing all the options, Durocher put Pete in the outfield. It made sense—his arm was so strong and his speed so blinding that it was the natural place for him, and for 1941 at least, it all worked perfectly.

The Dodgers stormed their way to the pennant, beating back Rickey's own Cardinals the last week of the season. Reiser thrilled the Brooklyn fans with his wild and reckless play. He slid hard, dived for balls, and played each game like it was the World Series. He ended the year leading the National League in doubles, triples, slugging, and runs scored. His .343 average made him the youngest player ever to win the batting crown.

Reiser's great numbers had come at a price: early in the season, reliever Ike Pearson of the Phillies drilled Reiser in the head with a fastball and he didn't regain consciousness until 11:30 that night. Though ordered to spend a week in the hospital, the next afternoon he was in uniform and sitting in the Dodgers dugout. With the game on the line and the bases loaded, Durocher asked Pistol Pete if he could pinch hit. Facing Pearson again, Reiser hit a grand slam to win the game. He could hardly focus his eyes enough to circle the bases, but somehow he did it. That was the way Pistol Pete played the game.

The next July Reiser was batting .356, riding an 11-game hitting streak, and leading the league in stolen bases. No one came close to Pistol Pete's raw talent and he was indisputably the best player in the National League.

Brooklyn held an eight-game lead over St. Louis when they swung into Sportsman's Park. In the eleventh inning of a 6–6 tie game, Enos Slaughter hit a deep fly to Reiser in center field. At the crack of the bat Pistol Pete put his head down and charged. Reiser swerved at the last minute to avoid a flag pole that stood in the field of play, reached out, and made a tremendous one-handed catch—then slammed headfirst into the concrete wall, the ball rolling free. Reiser recovered and threw it toward the infield. Everyone in the stadium watched Slaughter race around the bases. It was close but Slaughter scored to win the game.

No one realized that Pistol Pete lay in a crumpled heap at the base of the wall

In the excitement no one realized that Pistol Pete lay in a crumpled heap at the base of the outfield wall. His skull was fractured. Blood flowed from his ears and there was brain damage. His shoulder was dislocated. Leo Durocher openly wept as he was carried away on a stretcher. It was July 19, 1942, and Pistol Pete Reiser was never the same again.

From that point on, Reiser's career became the stuff of tragic legend. While in the army he crashed through an outfield wall in an exhibition game, dislocating his shoulder. When he was discharged he rejoined the Dodgers and crashed into the outfield wall in St. Louis again. He was carried from the field unconscious and ordered to stay home. Laid up in his apartment he burned his hands lighting a stove. He was back in uniform four days later. With the Dodgers and Cards racing for the '46 pennant, Reiser bore down even harder and broke his calf bone trying to steal second. As he lay in the dirt, manager Durocher stood over him screaming, "Get up! You're all right!" Reiser looked at his ruined leg and said, "Not this time, skip." The bone was sticking out of the skin.

Despite the injuries Pistol Pete did the impossible that year: 34 stolen bases and an unbelievable record-setting seven steals of home! One wonders what might have been had he simply dialed back his drive and enthusiasm, taking the proper time to recover and save himself. But that wasn't the way Pistol Pete played the game.

By the time he retired in 1952 his speed and drive had led him to sustain injuries that would have killed a lesser man: five serious head-on collisions with outfield walls—11 times he was carted off the field on a stretcher; 9 of those times unconscious. Once, he was given his last rites by a Catholic priest when he failed to regain consciousness after four days. He'd sustained five skull fractures and two broken ankles. His shoulder was dislocated too many times to count, and his head bore the scars of horrific beanballs. It is because of Reiser that players now wear batting helmets and outfields have padded walls and warning tracks. But it was all too late for Pistol Pete.

Years later, when some sportswriter was banging out one of those wistful "what could have been" pieces, Pistol Pete summed up his fractured career as this:

"It was my way of playing," he said. "If I hadn't played that way, I wouldn't even have been whatever I was. God gave me those legs and that speed and when they took me into the walls, that's the way it had to be. I couldn't play any other way."

THE INTERNATIONAL GAME

Within a few years of the New York Knicker-bockers playing the first "modern" game of baseball in 1839, the sport quickly spread wherever an American stepped foot. Christian missionaries brought the game to Japan and clipper ship sailors played it in Shanghai. Puerto Rican students taught their friends when they returned home from American schools, and U.S. Marines brought baseball with them as they fought countless small wars throughout the Caribbean at the turn of the century.

Baseball became the recreational counterpart to American industry and might. The game echoed both the good and bad aspects of life—there always has to be a winner and a loser, and a game cannot end in a tie. It was a modern game that utilized basic and traditional skills, had complicated rules, yet was beautiful in its simplicity. It was the only game that offered an individual the opportunity to shine but at the same time he could not do so without the combined help of his teammates. There was something about the game that appealed to the immigrants who streamed to America's shores at the turn of the century and to learn it was often the first step one took toward becoming "American." Different cultures found some aspect of the game they could relate to. Japan, for instance, embraced the game for its similarity to the spirit of judo and other martial sports. The Japanese passion to play baseball ran so deep it even trumped the draconian nationalism that swept over the island during the war years. And after 1945 it helped rebuild the spirit of a defeated people.

In some places the game also took on a meaning much deeper than simple recreation. Baseball became a symbol of freedom in Spanish-ruled Cuba after the game was outlawed by the colonial government.

American baseball fans may go their whole lives without ever hearing any of those stories, and sometimes it's hard to remember that the game has never been limited to the cities where major league teams are located. Baseball has as firm a foundation around the globe as it does in Texas, New York, and Chicago.

ALEXANDER CARTWRIGHT

Spreading the Joy of Base Ball

No chapter about the spread of baseball would be complete without Alexander Joy Cartwright.

"Alick," as he was called by his friends, published the first accepted rules of the game in 1845. The following year his team, the New York Knickerbockers, played the first game using those rules on Hoboken, New Jersey's Elysian Fields. His rule book made the game easier to learn and "base-ball" teams sprung up throughout the Metropolitan area. When the Mexican-American War broke out in 1846, soldiers from New York brought the game with them as they marched west.

Cartwright left New York City in 1849 to prospect for gold in California. Traveling by wagon train, Alick and the other New Yorkers in the group taught bemused settlers, Indians, soldiers, and miners the game during the five-month journey.

By the time he reached California the gold fields had been worked over, so the wandering ballplayer boarded a ship for China.

> *He taught settlers, Indians, soldiers, and miners as the wagon train moved west*

When he reached the Sandwich Islands—now called Hawaii—Alick was so overcome with seasickness he decided to stay. In the island paradise Cartwright thrived in the export business and in banking. He sent for his family and the Cartwrights became well-respected members of the Anglo-American community. Alick's reputation was so exemplary that he was asked to handle all of King Kamehameha's financial matters and later was appointed a diplomat. Honolulu's library, Rapid Transit bus company, and fire department were founded through Cartwright's boundless energy, and through it all he still had time for the old game he loved.

In 1852 he laid out the island's first baseball diamond and taught countless settlers and natives the game. By the time Cartwright passed away in 1892, the game he helped pioneer was being played by paid professionals in the newly founded National League and in countless countries around the globe.

HABANA

Nemesio Guilló
BASE BALLIST

In 1864 Nemesio Guilló returned home to Havana after studying at Alabama's Springhill College. Like every student who studies abroad, Guilló brought back souvenirs. It just so happened Nemesio brought back Cuba's first baseball bat and ball. Nemesio and his brother Ernesto began teaching their friends the game, beginning a Cuban love of baseball that would endure through years of revolution and remain strong to this very day.

The Guillós founded the Habana Base Ball Club in 1868 and the sport had just begun to spread when the first Cuban War of Independence began. The Spanish colonial government quickly outlawed the foreign game and instructed the island's sportsmen to take up Spain's national pastime: bullfighting. Inadvertently, baseball became a symbol of freedom to Cubans, a peaceful mode of resistance against the hated Spanish colonial power. Cubans of all backgrounds learned the game secretly and played with a passion equal to that of their American neighbors. The war ended in a rebel defeat in 1878, but as a nod to allowing Cubans a certain amount of autonomy, the colonial government repealed the ban on baseball.

Guilló's Habana Club became a charter member of the Cuban League. Nemesio played the first few seasons, hitting in the neighborhood of .250, before retiring to a successful import business. His team, later known as the Habana Reds, became the Yankees of Cuba, lasting until Castro outlawed professional sports in 1961. Though far from the best ballplayer Cuba would produce, Guilló was by far the island's most influential.

LUCAS JUÁREZ *Mexico's El Indio*

U.S. Navy sailors introduced baseball to the port city of Vera Cruz in 1846, and when American engineers began building Mexico's railroad system in the 1870s they spread the game throughout the interior. But it's a short tour by the World Champion Chicago White Sox in the spring of 1907 that is credited with cementing the game's popularity and establishing the reputation of Mexico's first great ballplayer.

Known by his nickname "El Indio," Lucas Juárez was a rare combination pitcher/catcher. The righty with the luxurious handlebar mustache was from Paso del Norte, now called Ciudad Juárez, and began playing ball professionally around 1900. When the White Sox ventured south he was playing for the country's best team, Club Mexico, and an exhibition game was scheduled between the two teams. For the first half El Indio dominated, his sharp breaking curve and fastball striking out six of the World Champions before he ran out of gas. The final score was 14–4 White Sox, but Charles Comiskey was so impressed with the native pitcher that he tried to entice him north. Juárez, who was illiterate and most likely didn't speak English, refused to go to the States, the first of several offers he turned down.

Besides being Mexico's first pitching star, with a bat in his hands El Indio was a power hitter who possessed good speed on the bases. He spent the later part of his career in Vera Cruz, playing until 1917. When the Mexican Baseball Hall of Fame was founded in 1939, El Indio was among the first nine selected and garnered the most votes out of all the candidates.

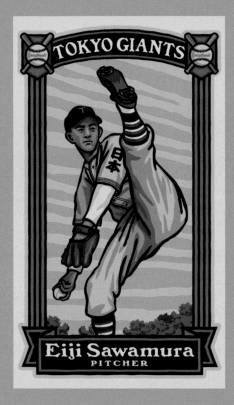

TOKYO GIANTS

Eiji Sawamura
PITCHER

Before dawn on December 2, 1944, the USS *Sea Devil*, a U.S. Navy submarine, quietly stalked a Japanese convoy near Kyushu, the southernmost of the main Japanese islands. The *Sea Devil* surfaced in the pre-dawn darkness to track the convoy by sight. A sudden wave nearly swamped the sub—a sailor was washed off the bridge and water poured into the open hatch, flooding the crew's mess, radio room, and both of its dual engine rooms. Fortunately, the damage was repairable and in one of the engine rooms Motor Machinist Mate Third Class Ray Ebbets worked with the rest of the black gang to get their station back on line. To those of the crew who were baseball fans, the motor machinist mate's last name must have rung a bell: Ray Ebbets's grandfather was Charlie Ebbets, owner of the Brooklyn Dodgers and the man whom Ebbets Field was named for.

But all that didn't matter at that moment. The *Sea Devil* was on a trajectory to intercept a Japanese convoy and the men in the extreme fore and aft of the sub armed and loaded their torpedo tubes. The captain of the *Sea Devil*, Commander Ralph Styles, ordered his ship to submerge and prepare for attack.

Commander Styles launched four torpedoes at one freighter and after missing, quickly ordered two more fired at another one. This time the torpedoes hit, and within minutes the freighter began slipping beneath the sea. Commander Styles swung his sub out of the path of a destroyer and fired four more torpedoes at a troopship. The *Sea Devil* was now almost directly in the path of the convoy. The skipper sounded the dive alarm and headed for the

safety of the deep sea. On the way down everyone on board from Commander Styles to Motor Machinist Mate Ebbets could hear the huge explosion as the *Sea Devil*'s torpedoes ripped into the hull of the troopship and ignited the stores of ammunition carried in her hold. Although they couldn't see it, the *Hawaii Maru* disintegrated in a massive explosion, killing every last man aboard her.

Among the 1,843 soldiers of the Twentythird Division who perished that morning on the *Hawaii Maru* was Lieutenant Eiji Sawamura, Japan's greatest baseball player.

To Ray Ebbets and even to most baseball fans among the crew of the *Sea Devil*, the name Sawamura probably wouldn't have rung a bell, but if you added that he was the Japanese schoolboy who struck out Babe Ruth, Jimmie Foxx, Lou Gehrig, and Charlie Gehringer, you then might have gotten more than a few to exclaim, "Oh yeah!"

Just over 10 years earlier, in what must have seemed like another world, Eiji Sawamura was a 17-year-old high school student with a blazing fastball and tantalizing curve who was hand-picked to represent his country against an American All-Star

> *Among those who perished that morning was Japan's greatest ballplayer*

team led by Babe Ruth. He'd been raised to be a ballplayer—his father had played years earlier, and he passed his love of the game down to his firstborn son. After years of practice with his father and pitching in national high school baseball tournaments, he found the country's best colleges vying to recruit him. At the time there wasn't a professional baseball league in Japan, and college competition was the highest level a ballplayer could aspire to. When it was confirmed that Connie Mack was bringing an American All-Star team to Japan in the winter of 1934, Sawamura was one of the first players asked to join the Japanese team. There was also talk of a professional Japanese baseball league for 1935.

There was a hitch, however. If Sawamura played on a professional team he would not be eligible to go to college. Sawamura decided it was a gamble he was willing to take, reasoning that he could potentially make a good enough living at pro ball to enable him to send his younger siblings to college. Of course there was also the honor of representing his country against the best ballplayers in the world and seeing how he would personally do when pitted against them.

In his first two appearances against the Americans, Sawamura was hit hard. It wasn't something to be ashamed of; the Americans won every game by a large margin and no Japanese pitcher had been able to handle the seasoned professionals. It was in his third try that he became an instant legend.

With the midday sun at his back, the 17-year-old took the mound in the bottom of the first inning at Kusanagi Stadium in Shizuoka, a city about 80 miles south of Yokohama. Before more than 30,000 fans Sawamura faced leadoff batter Eric McNair, shortstop of the A's, who hit a harmless pop fly for the first out. Future Hall of Famer Charlie Gehringer was up next. He was one of the toughest men in the majors to strike out, but Sawamura did just that, with a little help from the glaring sun behind him. Next, the great Babe Ruth took his place at the plate. Although the big man was at the end of his career, he could still pound the ball. The locals he faced on the tour presented no obstacle to him, and he hit one home run after another, captivating the appreciative Japanese fans. Although he hadn't performed all that well against the Americans, Sawamura had fanned the Bambino 10 days earlier and went into his windup knowing that the Babe was indeed fallible. Two fastballs and one curve later, he did it again to end the first inning.

In the bottom of the second Sawamura took the mound to face Lou Gehrig. Against Sawamura's big leg kick, blazing fastball, and that midday sun, Gehrig went down swinging. The Japanese crowd, who had routinely rooted for the American stars thus far, now began to sense that something magical was happening. Ever since the turn of the century American teams had come to Japan and thoroughly defeated the locals. In most games it wasn't even a close contest, but here and now, a homegrown ballplayer was striking out the greatest baseball players in the world.

The giant Philadelphia A's first baseman Jimmie Foxx was up next. His muscular physique had intimidated the best pitchers in the American League, but here in far-off Japan an unknown 17-year-old high school kid struck out the nine-time All-Star. That Earl Averill broke the strikeout streak by getting thrown out on a grounder didn't matter; Eiji Sawamura was an instant national hero.

He went into his windup knowing that the Babe was indeed fallible

After the game Connie Mack reportedly attempted to sign him to an A's contract but Sawamura declined. He didn't know English and didn't want to leave Japan. American newspapers picked up the story, and while many baseball fans might not have known the kid's name, they sure knew the story of the Japanese schoolboy who struck out Ruth, Gehrig, Gehringer, and Foxx. The American All-Stars spoke highly of the young pitcher. By the time they left, Sawamura had struck out every big leaguer on the team except Bing Miller at least once. The American ballplayers told reporters that the kid's fastball floated upward, and with more seasoning he could make the major leagues.

By the end of the tour, Sawamura had struck out everyone except Bing Miller

Back in Japan, Sawamura and most of the team formed the nucleus of the Dai Nippon Tokyo Yakyu Club that was sent to tour North America in the spring. Quickly renamed the Tokyo Giants, the team played from Canada to Mexico and as far east as Cincinnati. Sawamura did fairly well when pitted against minor league Pacific Coast League teams but extremely well against midlevel semipro competition. His fastball was estimated as being in the low 90s and his curve was judged to be of major league quality. While he was in Milwaukee a man approached Sawamura before a game, thrusting a piece of paper at him. The young pitcher, who didn't speak English, thought he was signing another autograph for a fan. Only after that same man confronted the Tokyo Giants' manager after the game, inquiring when Sawamura would report to the Pittsburgh Pirates, did it finally come to light that the "fan" was actually a scout! According to the Giants' business manager, Sotaro Suzuki, it took a small payoff to make the scout tear up the contract.

Sawamura had come to hate America by the time the tour ended. He couldn't get used to the lack of rice at mealtime and blamed it for what he perceived to be his poor performance on the tour. He didn't like the arrogance of North American women and the Western culture differed too much from what he was used to back in Japan. Although it may have been tempting to join a professional American baseball team, Sawamura was destined to return to Japan and become a founding member of that country's first professional baseball league.

From the start of that league's first season in 1936, Eiji Sawamura was the undis-

puted star. He pitched Japan's first no-hitter, and the following year tossed another one, as well as winning a remarkable 33 games for the Tokyo Giants. Then, at the height of his fame, he was asked to once again serve his country, this time in the army.

At his induction physical he was singled out as the ultimate specimen of Japanese manhood. Sawamura trained as an infantryman, and in April 1938 was sent to war. As he battled across China with the 33rd Infantry Regiment, Japanese newspapers following the ballplayer wrote fanciful stories of how his great pitching arm was now put to use lobbing grenades so accurately that he saved his comrades time and again from certain death. He was shot in his left hand in the fall of 1938 but recovered quickly and rejoined his unit. He gave morale-boosting exhibitions, throwing the heavy hand grenades in distance competitions for the benefit of grateful troops. The press ate it up and baseball fans back home devoured news of their great hero.

After completing his military service in 1940 he rejoined the Giants. Now 24, Sawamura had contracted malaria in China and suffered from insomnia. The two years

He left the famed fastball back in China and had to rely on his brains

of war and hand grenade exhibitions had done serious damage to his arm, and he was forced to alter his delivery from an overhand to a sidearm motion. His control was still as good as it ever was, but he left the famed fastball back in China and had to rely on his brains instead of speed. Though he tossed his third no-hitter, Sawamura wasn't the pitcher he had once been. His record of seven wins and one loss looked good on the surface, but with all the star players in the military, the Japanese Professional Baseball League was a shell of its former self. Even facing lesser-quality opposition he slipped to a 9-5 record in 1941. Nonetheless he was still a star, and his mere presence pulled in the crowds. He married his longtime sweetheart Sakai Yuko in the fall of 1941 and just days later was recalled to active duty.

When the Japanese army invaded the Philippines in December 1941, Eiji Sawamura was with them. Where he once challenged the Americans on the baseball field, he now fought them on the field of battle. Again his legendary accuracy in throwing hand grenades was put to use, saving him and his comrades from certain death at the hands

of the Americans. Brought up in the way of the modern Japanese warrior, in which surrender is not an option, Sawamura could not hide his disdain when American troops put down their rifles and surrendered. When interviewed by newspaper correspondents, Sawamura repeated false rumors of atrocities against Japanese civilians by U.S. troops that enraged readers back home. Because of his great fame, Eiji Sawamura became a valuable propaganda tool, as his story of sacrifice and duty was used to inspire the home front.

Sawamura was discharged in the spring of 1943 and again rejoined the Tokyo Giants. Whereas in 1940 he relied on his famed control when his speed left him, a year in the jungle had robbed him of that last remaining talent. When the Giants declined to sign him for 1945, the pitcher thought about shopping his services around to other teams. The owner of the Giants, Sotaro Suzuki, convinced him to retire, arguing that it would be useless trying to hang on to past glory and would do nothing except cheapen his memory. He was a hero to millions of his countrymen and should go out with grace and honor. Sawamura agreed, but in the end it didn't matter. With the Japanese Imperial Army being systematically wiped out island by island, Sawamura found himself again recalled into the service. He was on the way to the Philippines when the convoy his ship was traveling with crossed paths with the USS *Sea Devil*.

Each season the Sawamura Award is given to the best pitcher in Japan

After the war baseball played a large part in restoring normalcy and pride to a devastated Japan. Eiji Sawamura, in part due to his timely retirement, which preserved his legend, was held up as Japan's greatest ballplayer. His death in the war also helped promote an antimilitaristic feeling among the Japanese people. In 1947 the reconstituted Nippon Professional Baseball League introduced the Sawamura Award, given at the conclusion of each season in recognition of the best pitcher in the game. When the Japanese Baseball Hall of Fame was founded in 1959, he was among the first nine inductees. To this day he is still a legend, often referred to simply as "Japan's Number One."

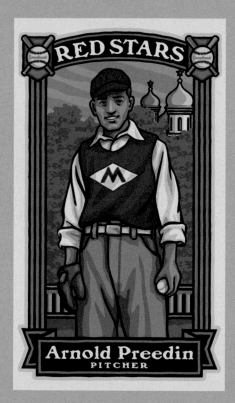

RED STARS

Arnold Preedin
PITCHER

During the Great Depression, many Americans looked to socialism and communism as the cure to the unemployment and poverty they found themselves in. Propaganda from the Soviet Union trumpeted a land of equality where unemployment simply did not exist. In what turned into a little-known exodus, thousands of Americans packed up and moved to the Soviet Union during the early 1930s.

Though they did their best to shed their American ideals and fit in as good Soviet citizens, there was one passion from their former lives they refused to relinquish: baseball. Wherever Americans settled in Russia, ball clubs popped up. When they wore out the precious bats, gloves, and balls brought from home, they handcrafted new equipment. In Moscow, where the largest group of American expats settled, games were played in the city's famous Gorky Park.

By far the best team of Americans was the Moscow Foreign Workers' Club. The team was nicknamed the Red Stars and wore red-colored tank tops with an M within a diamond on the chest. On their heads the players wore cherished baseball caps carried with them when they left America. The captain of the Red Stars was a pitcher from Boston named Arnold Preedin. He and his brother Walter arrived in Russia with their parents, American radicals chasing their dream in the "Worker's Paradise."

The Moscow Foreign Workers' Club played mostly in the city it called home, but as more Americans arrived in Russia, Preedin organized road trips to Leningrad and Karelia. A 1934 Red Stars game in Petrozavodsk, near the Finnish border, was broadcast live over Soviet

radio and the *Moscow Daily News* regularly published game recaps and box scores.

At first the Russians reacted like most Europeans when introduced to baseball—it was too complicated. Yet, as more ball teams were formed by American workers, their curious Soviet comrades began to catch on. When a championship game between the Moscow Foreign Workers' Club and a team of Finnish-American lumberjacks from Karelia attracted more than 2,000 fans the Soviet government took note. To test interest in the game, the Soviets had Arnold Preedin and his Red Stars play exhibition games before a variety of different crowds, from Red Army soldiers to prison camp inmates.

During a halftime exhibition at a soccer game, 25,000 screaming fans convinced the Soviets that baseball just might be the national sport of their new world order. Plans for a Soviet League were begun and even Dynamo, the official sports club of the Soviet secret police, announced it was forming not one, but two baseball teams.

That winter American singer and actor Paul Robeson visited Moscow. Back before he discovered acting and radical politics, Robeson was Rutgers University's star catcher and All-American end. To give the Red Stars bona fide celebrity credentials, Preedin and the team named Robeson their "honorary captain."

Just as baseball seemed on the verge of conquering another country, Soviet ruler Joseph Stalin initiated the great purges that would take the lives of millions, including almost every member of the large American expatriate population. Simply holding on to American magazines or visiting the U.S. embassy brought swift arrest by the secret police and a trip to the Gulag—or worse.

Arnold Preedin was no exception. Just a few short years after the Moscow Foreign Workers' Club Red Stars were featured in sports pages across the Soviet Union, he and his brother Walter were arrested and shot in an apple orchard outside Moscow.

Baseball never became the Soviet Union's national pastime.

Dynamo, the KGB's official sports club, decided to form its own baseball team

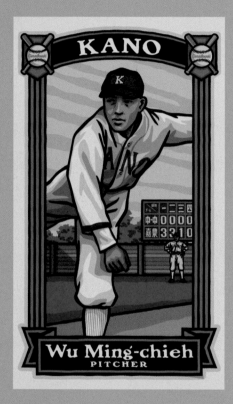

KANO

Wu Ming-chieh
PITCHER

When the Japanese occupied the island of Taiwan in 1895, they brought the game of baseball with them. Just like the United States, Japan believed baseball could unite different ethnic groups. Three distinct ethnic groups called the island home: Han, who were descendants of Chinese settlers; native Taiwanese aborigines; and the recent Japanese colonists. Each group had its own distinct culture, and the groups did not regularly mix. Originally baseball was played only by the Japanese, but in the 1910s the colonial government mandated that the game be taught in schools as a way to assimilate all groups into the Japanese culture.

Since 1915 Japan has held a National High School Baseball Championship—called "Koshien" after the city that hosted it. As a colony, Taiwan was entitled to send a team to Koshien each summer, though none had met with much success. From the start, every team representing Taiwan was composed mainly of Japanese students from the northern part of the country where the large cities and schools were located. In 1931 all that changed when a school from the southern town of Chiayi won the right to represent the island at Koshien.

In 1928 the Kagi Norin School of Agriculture and Forestry (called "Kano" for short) hired a Japanese accountant and former ballplayer named Hyotaro Kondo to coach the team. Kano's baseball program had been a miserable failure due to lack of discipline and unity on a team made up of Han, natives, and Japanese. Kondo instituted a rigid training program that made the boys work together, and they began to win. It is the 1931 team's story

that solidified baseball as Taiwan's national game and is one that is still a source of Taiwanese national pride.

The star of the team was their pitcher and cleanup hitter, Wu Ming-chieh, an ethnic Han. Wu led the team, considered an underdog, to the Taiwan Koshien qualification tournament, where one of his wins was the first perfect game in Taiwanese history. By the time Kano emerged the tournament's winner, Taiwanese of every ethnicity had fallen in love with the scrappy team. When the team arrived in Koshien it found that fans there had adopted Kano as their favorite. That a team from one of the colonies composed of different ethnicities could work as one was an inspiration to Japanese fans. But as heartwarming a story as it was, no one expected Kano to advance very far. But it did—all the way to the finals.

In front of 55,000 fans, Wu took the mound in the championship game. It was the fourth time in seven days he had pitched and his fingers began to blister. Though in terrible pain and experiencing control problems, he convinced Kondo not to take him out.

Wu rubbed dirt from the mound into his bleeding fingers and continued the game

Wu rubbed dirt from the pitcher's mound into his bleeding fingers and continued the game. Over the radio millions listened as Kano refused to give up. Though Kano lost the championship, its second-place finish was celebrated throughout the Japanese empire and the team returned to Taiwan as national heroes.

Wu graduated in 1932 and entered Tokyo's Waseda University. Since Japan had yet to form a professional league, Waseda was one of six universities that participated in an annual tournament that was the highlight of Japanese baseball. In the 1936 series Wu was 12 for 36 with seven home runs, winning the tournament's batting and home run crowns.

Wu lived most of his later life in Japan, and although pressured to accept Japanese citizenship, he proudly remained a Taiwanese national. To this day the 1931 Kano team are celebrated as national heroes and were the subjects of a recent big-budget movie. A life-sized statue of Wu Ming-chieh stands in his hometown of Chiayi, a memorial to the schoolboy and the game that inspired two nations.

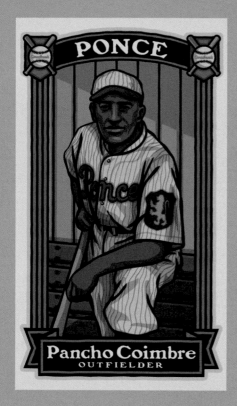

PONCE

Pancho Coimbre
OUTFIELDER

Just like their Cuban counterparts, Puerto Rican college students brought baseball back to their island after studying in the United States. When American troops occupied the island after the Spanish-American War the game took off in popularity. One of the island's early stars was Ponce native Francisco "Pancho" Coimbre.

Though he was a stocky five-foot-eight and 170 pounds, Pancho Coimbre was a fleet-footed high school track star as well as baseball phenom. His bat and rifle arm made him a sought-after sandlot ballplayer, which inadvertently led to legal problems. Believing he had accepted money to play ball, the governing board of student athletics attempted to rule Coimbre ineligible for school competition, but a court decided in Coimbre's favor and he was allowed to continue playing high school sports.

By now a well-known young talent, the 17-year-old Coimbre turned pro in 1926. At first his strong arm was put to use on the mound, but he quickly evolved into a speedy outfielder. Coimbre was a solid contact hitter whose almost supernatural eyesight made him virtually impossible to strike out, enabling him to always put the ball in play.

Only skin color kept him out of the major leagues, forcing Coimbre to spend his entire career on the fringes of "organized" baseball. Besides playing in his native Puerto Rico, which at the time had an amateur league, Coimbre was invited to the Dominican Republic and Venezuela, both of which had professional leagues that attracted the best outsider ballplayers in the Western Hemisphere.

The level of Coimbre's talent was acknowledged when he was chosen to play for the famed Los Dragones de Ciudad Trujillo club in 1937. With Satchel Paige, Josh Gibson, Sam Bankhead, and Pedro Cepeda, Los Dragones boasted the best talent outside Major League Baseball.

However respected Coimbre was at this time, it was when the Puerto Rican Professional Baseball League was founded in 1938 that he truly became a superstar. The new league attracted the best Latino and black American ballplayers. As a native son, Coimbre became the fans' favorite, playing for his hometown team of Ponce.

Though he played summers in Mexico and in the Negro Leagues in the United States, Coimbre played 13 consecutive winter seasons with the Ponce Kofresi (Pirates) and helped lead them to five Championships. Though now in his thirties, he only got better with age. In the highly competitive winter league, Coimbre hit over .400 twice and won two batting titles, and at age 34 he was the league MVP. With his paranormal eyesight and bat discipline he recorded only 20 strikeouts in 13 years, including three consecutive seasons

His supernatural eyesight made him virtually impossible to strike out

without a single whiff! His career average of .337 puts him at number two on the all-time Puerto Rican Winter League leaders list, ahead of Hall of Famers Roberto Clemente and Orlando Cepeda.

Though Puerto Rico attracted a never-ending flow of great foreign talent each winter, it was Pancho Coimbre who was the island's most popular ballplayer. Residing only a block away from the stadium, Coimbre could be found after each home game leading a trail of young boys as if he were the pied piper of Ponce.

To this day he stands right beside Roberto Clemente as the greatest baseball player Puerto Rico has produced. In fact it was Coimbre, a Pittsburgh Pirates scout after his playing days ended, who convinced the club to draft the 19-year-old Clemente when the Brooklyn Dodgers left him unprotected.

Tragically, Puerto Rico's first great ballplayer died at the age of 80 when a fire engulfed his home. In 1991 the Puerto Rican Baseball Hall of Fame was founded, and Pancho Coimbre was among the first group elected.

MONTERREY

Héctor Espino
FIRST BASEMAN

While you'd think that it would be every ballplayer's dream to play in the major leagues, some, like Héctor Espino, are perfectly happy to spend their entire career in the lower levels of the game. During his prime, half the teams in the major leagues were begging the Mexican national to sign with them. But the man called "Mexico's Babe Ruth" turned them all away.

From his teens, Héctor Espino seemed destined for baseball greatness. He made the Mexican big leagues in 1962 when he signed with the Monterrey Sultans. His .358 average and 23 homers led the Sultans to the championship and won him the Rookie of the Year Award. Seasons of .346 and then .371 solidified his stature as Mexico's greatest ballplayer. The only place left to go was north.

The St. Louis Cardinals bought Espino's contract in the waning months of the 1964 season and assigned him to their top farm team in Jacksonville. In an act that was unheard of at the time, Espino refused to report unless he received a cut of his sale price, which he did. That show of *cojones*, combined with his reputation south of the border, made his minor league debut the most anticipated in recent memory. In 32 games with the Jacksonville Suns, Espino batted an even .300 with three home runs, earning him an invite to the Cardinals' spring training in 1965. Espino got as far as the Dallas airport before he turned back. He never appeared in the U.S. leagues again.

Espino went back home to Mexico and continued to pound the ball out of ballparks. Playing in both the summer and winter leagues, the sturdy first baseman began racking

up home run totals that made major league scouts drool.

One hundred, 200 . . . as reports of "Mexico's Babe Ruth" filtered across the border, the Angels appeared to have succeeded in coaxing Espino north, but a racial comment by their manager, Bill Rigney, and the team's assistant GM calling him a coward made the proud slugger stay home.

Four hundred, 500 home runs . . . the Mets and Padres sent their men south. They promptly returned empty-handed. Even Ruth's Yankees failed to induce the great Espino to leave Mexico.

Six hundred, 700 home runs . . . by the time he retired in 1984, it's estimated he hit between 755 and 790 home runs. 484 of them were hit playing for teams considered part of organized baseball's minor league system, putting "Mexico's Babe Ruth" 52 homers in front of "The West Coast Babe Ruth," Buzz Arlett.

Espino's unique combination of raw talent, kindness to fans, and unabashed faith in his own ability makes his comparison to the real Ruth all the more relevant. A typical "Ruthian" story often told revolves around a road trip to a stadium where a local store offered a new suit to any player who could hit a home run. As he was getting off the team bus, the poorly paid but loyal bus driver asked the slugger if he could hit a homer and win him a suit. Espino said he would, then held up two fingers and whispered, "Two suits." In true Ruthian fashion, Espino did just that.

So why didn't "Mexico's Babe Ruth" give the major leagues a try? There are a few different explanations. The often repeated and easy go-to story is that he met with good old American racism during his short stint with Jacksonville back in 1964. Makes a great story, but Espino's own wife, who accompanied the slugger to the States, staunchly denied they were treated badly—in fact she said that the people of Jacksonville were very good to the two of them.

The most likely reason for Espino's playing his whole career in Mexico is simply that he liked it there. In Mexico he was undeniably the best. Everywhere he went he was HÉCTOR ESPINO, the greatest ballplayer in Mexico. While in the United States it is the ultimate compliment to have "The Babe Ruth of" precede your name, in Mexico Héctor Espino needed no prefix to demonstrate how great he was.

The Angels, Padres, Cardinals, and Mets all tried in vain to sign Héctor Espino

NAGOYA

Harris McGalliard
CATCHER

After giving minor league baseball a shot in the late 1920s, Harris McGalliard came to the conclusion he'd never make the majors. He was wrong—he'd make the majors, just not in the United States.

McGalliard played semipro ball around Los Angeles and eventually was invited to join the L.A. Nippons, a crack squad made up of Japanese-American ballplayers. As the team's lone Caucasian, McGalliard was the team's catcher and leading slugger throughout the early 1930s as the Nippons ruled the SoCal semipro scene.

The team made several trips to Japan, where they easily beat all competition. Though baseball crazy, the island nation did not yet have a professional baseball league, but the 1934 Babe Ruth–led tour of Japan changed that. When the Tokyo Giants toured the United States in 1935, they played against the Nippons and were particularly impressed by McGalliard. His powerful bat and ease among the Japanese earned him an invitation the following year to play pro ball.

Nineteen thirty-six marked the first season of the Japan Professional Baseball League. McGalliard and three other teammates from the L.A. Nippons joined the Nagoya Golden Dolphins. The American players shared their years of experience with the Japanese and in turn McGalliard embraced the culture of Japan insofar as learning the difficult language. Japanese fans loved the catcher's spirit for the game, but his name proved too difficult to say in their language, so he became known as "Bucky Harris," after the Washington Senators' current manager.

The newly christened Bucky Harris became known for distracting opposing batters by singing songs in broken Japanese as he crouched behind the plate. The inaugural Japan League season was a split season, and in 39 games the American import hit .327. The next season was an expanded split season in which McGalliard, now with the Tokyo Eagles, won the batting crown with a .310 average.

The American had his finest year in 1938, when he led the league in home runs and hit .324 in the spring and .320 in the fall. It would also prove to be his last, as McGalliard left Japan for good in November 1938. He and his wife were expecting a baby and antiforeign feelings were beginning to become evident throughout Japan. When the war began the former catcher joined army intelligence as a Japanese language expert.

After the Battle of Leyte Gulf in 1944, war correspondent Russ Brines followed Lieutenant McGalliard around as he talked to the captured Japanese soldiers. When he came across one whom he overheard discussing baseball, McGalliard slyly asked the man, "Do you remember Bucky Harris, an American who coached baseball in Tokyo in 1936?" When the prisoner said he did, his interrogator asked, "What became of him?" The soldier said, "He is still in Japan. I know him well. He has taken out Japanese citizenship and is still playing ball."

McGalliard walked away chuckling, explaining to the war correspondent that he was in fact Bucky Harris.

In another camp McGalliard was in the process of interrogating a soldier when the man suddenly recognized the officer before him. "You're Bucky Harris, aren't you?" Turns out the prisoner was Tamotsu Uchibori, catcher for the Tokyo Giants, and the two had played against each other many times.

After the war McGalliard ran a masonry contracting business in Southern California. His three-year stretch as a baseball star in prewar Japan never failed to amuse him, and he was fond of telling interested admirers, "Over there I was a big shot. Over here I was nothing."

Indeed he was. In 1976 Bucky Harris was invited back to Japan as a special guest during the Nippon World Series between the Yomiuri Giants and the Hankyu Braves.

"Over there I was a big shot. Over here I was nothing."

SATCHEL PAIGE

Baseball as a Campaign Tool

Hall of Famer and blackball legend Satchel Paige was almost as good a storyteller as he was a pitcher. In a career spanning five decades and a dozen countries, Satchel accumulated countless great tales of his exploits, and this is one of his most famous.

In 1937 the Dominican Republic was under the thumb of a dictator named Rafael Trujillo, who found his control over the island nation beginning to slip. One rival in particular began gaining in popularity, partly through his alliance to a powerful baseball team in the Dominican Baseball League. An election loomed in 1938, and what better way to regain the hearts and minds of a baseball-mad country than to field an even greater team to represent the capital city, Ciudad Trujillo?

So in the spring of 1937, Dominican agents were dispatched to America to bring back a team of hired guns to win the pennant for Trujillo. According to Paige, a carful of Trujillo's torpedoes abducted him off a New Orleans street at gunpoint and took him to a hotel room. Confronted with an offer he couldn't refuse, along with a suitcase filled with money, Paige agreed to assemble a dream team of outsider ballplayers.

Okay, let's pause there and hose down Paige's tale and see what it looks like underneath.

> *Trujillo knew only one thing could keep him in power besides guns: baseball*

Rafael Trujillo was indeed the dictator of the Dominican Republic from 1930 up until 1961, when he was assassinated. Trujillo's regime was, in fact, a bit wobbly in the spring of '37. Opposition groups were gaining strength in the countryside and El Presidente's secret police roamed the streets in red Packards—dubbed *carros de la muerte* ("cars of death")—picking up dissidents.

The Dominican Baseball League attracted many Caribbean ballplayers during the mid-1930s. For 1937, Liga Dominicana was streamlined to three teams representing the country's biggest cities: Águilas Cibaeñas (Santiago), Estrellas Orientales (San Pedro de Macorís), and Los Dragones de Ciudad

Trujillo. The Santiago team was supported by Trujillo's opposition and were the odds-on favorite to win the '37 pennant.

Dr. José Enrique Aybar, Trujillo's pal and head of the National Congress, took the reins of Ciudad Trujillo and figured if he made it a winner it would bolster El Presidente's popularity. Los Dragones already had a few key Latino stars, including pitcher Rudy Fernandez and Puerto Rican slugger Perucho Cepeda, but to guarantee a championship, Dr. Aybar sought out the best money could buy, and that meant Satchel Paige.

As far as the abduction at gunpoint story goes, it most likely never happened. The pitcher was offered $30,000 to recruit and fund a team of Negro League stars. At the time, Paige was training with Gus Greenlee's Pittsburgh Crawfords, considered by most historians to be the greatest assemblage of blackball talent before integration. Since they had the best roster in blackball at the time, he knew the right men for the job. First was his personal catcher, Cy Perkins. Then came Cool Papa Bell, the team's speed-demon hit machine. The addition of Sam Bankhead, Leroy Matlock, Schoolboy Griffith, and Harry Williams

As far as Paige being abducted at gunpoint, it most likely never happened

effectively gutted the Pittsburgh Crawfords. When Josh Gibson, blackball's greatest slugger and almost Paige's equal in popularity, was recruited, Crawfords owner Gus Greenlee contacted his congressman about a foreign power stealing his players. While a minor international incident heated up, Paige and his mercenaries ducked out of the country.

The eight-week, 32-game season had already begun when Paige and his men arrived. They were feted like the stars they were and almost immediately the nightlife took its toll. Paige, hungover in his first start, performed poorly. Gibson couldn't hit, and quickly Santiago was atop the Liga Dominicana standings. Dr. Aybar's plan to boost Presidente Trujillo's image now began to make him look like a fool. That, in a dictatorship with secret police roving the streets in "cars of death," was not a good thing.

According to Paige, the team was shadowed by armed escorts and locked up at night. The truth, as Los Dragones pitcher Rudy Fernandez told it, was a little less extreme. Since the DR was not exactly a crime-free paradise, with revolutionaries and unsavory characters roaming around,

an armed escort was detailed to make sure no harm came to the pricey imports. When the Americans' nightclubbing and womanizing began to affect their game, Dr. Aybar secluded a few of the key members, including Paige, on the nights before a game. The result was that Ciudad Trujillo began climbing up the standings.

With a dozen games left to play, Ciudad Trujillo was neck and neck with Santiago. Though they didn't have the star power of Paige, Bell, and Gibson, Santiago had as strong a team as Los Dragones. Cuban superstar Martin Dihigo is widely regarded as the greatest ballplayer of all time. Chet Brewer was one of the best pitchers outside the majors during the 1920s and 1930s and is often considered as good as or better than Satchel Paige. Luis Tiant, father of the future Red Sox pitcher, rounded out a solid rotation. Clyde Spearman was one of Paige's Crawfords teammates and was runner-up for the Liga Dominicana batting crown that year.

Since Estrellas Orientales was out of the running, the league was narrowed down to just the two top teams with eight games left to play. Ciudad Trujillo took the first four, and Paige, who seemed to benefit from his enforced sobriety, won two of them. Still, Santiago remained ahead by less than a percentage point, and if they won three of the remaining four games they would be champs. Although a few of the team's Cubans, including Luis Tiant, deserted, Águilas Cibaeñas took the next two games. One more and the championship was theirs.

Now, this is a pretty dramatic setup, right? Two games left, winner take all? Two teams of baseball mercenaries, one representing a banana republic dictator and the other the voice of opposition—you couldn't dream something like that up. But Paige could turn any good story into a made-for-TV movie.

In his memoirs and quite a few newspaper and magazine stories, Paige recalled how the gun-toting crowd was primed for revolution—a clear warning to win or else. Pitching the game of his life, Paige still found himself down 5–4 going into the seventh. According to Satch, Trujillo had his soldiers line up on the sidelines—a very clear message of what the consequences would be if Los Dragones lost. Fortunately, Ciudad Trujillo staged a two-run rally and took a one-run lead. Paige, throwing to save the lives of himself and his teammates, shut down Santiago for the last two innings and won the game.

In actuality, Paige's victory was not a do-or-die scenario in the slightest. If Santiago managed a win, an eighth game would have followed to decide the championship. In fact, Paige didn't even start the game, only entering in the ninth when Ciudad Trujillo was up 8–3. Granted, there was a bit of drama by the time Paige came in: Santiago had two men on base with one out. Paige gave up three hits and the score tightened to 8–6. A sure Dragones victory was now in jeopardy. Though the reality was not as dramatic as he probably would have liked, Paige bore down and, aided by a game-saving throw from the outfield by Sam Bankhead, finally got out of the inning and won.

With the season finished, the Americans did quickly return to the United States, but found heavy fines levied against them by their former teams. The renegades hooked up with a midwestern promoter and formed the "Trujillo All-Stars." Playing throughout the country, Paige told the press an ever-growing tale of the team's experiences in the Dominican Republic.

Realizing that regaining their stars was more important than taking a stand against contract-jumping, the Negro League owners allowed the mercenaries to return, all except Satchel Paige. His reputation as the best pitcher in the game allowed him to still earn outsider baseball's biggest salary by hiring himself out to the highest bidder.

Baseball in the Dominican Republic was effectively ruined for a generation—the high cost of foreign talent bankrupted all three teams. That summer Trujillo stepped up his reign of terror, culminating in the "Parsley Massacre." Trying to rid his country of dark-skinned Haitians and Dominican dissidents, the dictator unleashed his army. Knowing the French Creole–speaking Haitians couldn't pronounce the trill of a Spanish *r*, Trujillo's men would hold up a sprig of parsley, asking suspects, "*¿Qué es esto?*" or "What is this?" More than 20,000 people couldn't pronounce "*perejil*" the correct way and were shot. The international outcry forced the dictator to take himself off the ballot in the 1938 "election," and he instead ran a puppet until he returned to power a few years later.

Baseball remains the national pastime of the Dominican Republic, and native sons Juan Marichal, Pedro Martinez, Albert Pujols, and Manny Ramirez are among the best ballplayers to ever play in the majors.

Baseball, just like any other sport, has had its share of bad guys.

My father and I were always fascinated by the game's disreputable and disgraced characters because, well, honestly, they're more fun to talk about than choirboys like Lou Gehrig or Roberto Clemente.

For me the 1919 World Series scandal was always a great topic for debate not only because of the repercussions that helped shape the modern game but because I enjoyed trying to find out what happened to the eight banned players after they were exiled from the game. What did they do? Where did they go?

I needed to know, and over the years I discovered that all eight continued to play the game they both loved and that had betrayed them long after the major leagues turned its back on them. To me it's unbelievably fascinating to think of six of the eight "Black Sox" taking the field in a small town wearing uniforms with the name "Ex-Major Stars" across the front as the crowds ceaselessly heckled the disgraced men. Or Shoeless Joe Jackson, once the game's purest hitter, reduced to hiring himself out to small towns every weekend to make a buck. Seeking the fate of ring-leader Chick Gandil, I found a whole "outlaw" league based in the copper-mining towns of Arizona that offered a temporary haven for exiled ballplayers.

The game has also offered redemption to a few ballplayers who began their life on the wrong path. Take Alabama Pitts: The small-time stick-up man was sent to New York's notorious Sing Sing prison, where he could have spent his sentence learning to become a more hardened criminal, but instead found reform through his athletic abilities. His story and the public reaction to it reflect the American spirit of offering a man a second chance.

These are the guys who make the game interesting, more human. It proves that baseball attracts people from all walks of life, both good and bad, and that while sometimes the game brings out the worst in people, it can also offer a lifeline to a better way of living.

EDDIE CICOTTE

Throwing It All Away

After being banned from organized baseball, the eight Chicago players implicated in fixing the 1919 World Series spent 1921 waiting in vain for an appeal of Commissioner Landis's decision. The eight men underestimated the absolute power the new commissioner of baseball now wielded.

By the spring of 1922 the players understood they were not likely to be let back into the major leagues. Faced with the need to make a living, the players decided to capitalize on their notoriety. Former White Sox star pitcher Eddie Cicotte joined Lefty Williams, Swede Risberg, Joe Jackson, Hap Felsch, and Buck Weaver to form a barnstorming team called the "Ex–Major League Stars." Lord knows how this name must have angered the new commissioner of baseball, but the team played a few games around the Midwest. To the players' surprise, fans turned out in droves to ridicule the outcasts, and most teams refused to play them due to warnings from the commissioner's office. Young players were told that associating with the banned players could render them ineligible to participate in organized ball. Older players understood what a terrible mark the whole affair of 1919 cast over their beloved game, and local newspapers, which were usually more than enthusiastic about a barnstorming team of major leaguers, railed against the shunned players.

Risberg got the best of the match and knocked out two of Eddie's teeth

All was not well in the Ex–Major League Stars' clubhouse, and the team broke up when Cicotte fought with Swede Risberg over money. The rough-and-tumble Swede got the best of the former ace and reportedly knocked out two of Eddie's teeth. This was the last time this many Black Sox were together on one team, and most now became baseball mercenaries on the fringes of outsider baseball.

Cicotte drifted back to his family in Michigan, anonymously working on an assembly line for the Ford Motor Company, trying to make sense of his once great career.

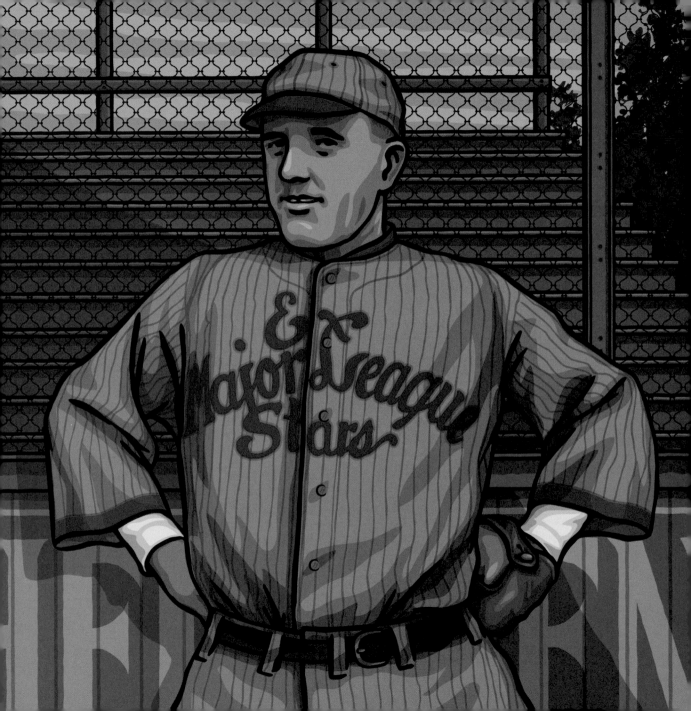

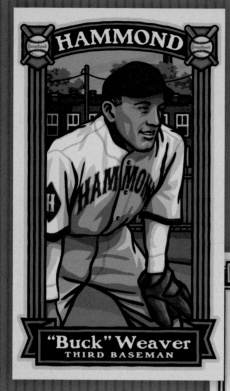

HAMMOND

"Buck" Weaver
THIRD BASEMAN

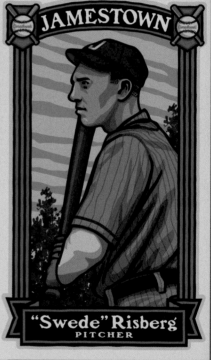

JAMESTOWN

"Swede" Risberg
PITCHER

HAMMOND HAMMONDS

"Buck" Weaver was an outstanding fielder and the only third baseman Ty Cobb would not steal against. Weaver apparently knew of, but refused to participate in, the fixing of the 1919 Series. This knowledge was used against him, and his stellar batting and errorless play in the Series wasn't enough to save him. Weaver and seven of his teammates were banished from the game after the 1920 season. He spent the mid-1920s playing in the outlaw Copper League in Arizona, but fellow Black Sox Gandil and Risberg kicked him out of the circuit. Weaver returned to Chicago, where he was still a popular figure, and played on various semipro teams, notably the Hammond, Indiana, ball club. Buck spent the rest of his life trying to clear his name of the Black Sox stain. "The Ginger Kid" died in Chicago in 1956.

Buck spent the rest of his life trying to clear his name of the Black Sox stain

BLACK SOX

Shoeless Joe wasn't lying when he said, "Swede is a hard guy." Risberg once fought Ty Cobb to a tie and was known as one of the toughest men in baseball. In the 1919 Series he made a record eight errors and went 2 for 25 at the plate. After acting as the muscle behind the fix, Swede was thrown out of organized baseball and knocked around the western half of the United States and Canada playing in mining towns with and against other banished players. As he got older Risberg began pitching, and in 1930, while playing for Jamestown, North Dakota, tossed a no-hitter against the LaMoure ball club. Swede struck out seven, walked five, and went two for four at the plate. An old spike wound courtesy of Ty Cobb never healed properly, and Risberg had his leg amputated later in life. He died in California in 1975.

SCOBEY MONTANA GIANTS

His good nature and smile earned him the nickname "Happy," and his natural ability made him a star in the American League. He still holds the record for most double plays (15) by an outfielder in a season. Hap Felsch was paid $5,000 to throw the Series, and his almost comically inept fielding gave the first clues that the games were not on the level. After being thrown out of organized baseball he spent 15 years knocking around with various town teams around the country, including 1925, when he and Swede Risberg starred for the Scobey, Montana, Giants, getting $600 a month plus expenses. This was apparently a low period in Felsch's life, and he and Risberg gained onerous reputations as drunks who should not be crossed. Felsch retired from baseball in the early 1930s and operated a bar in Milwaukee until his death in 1964.

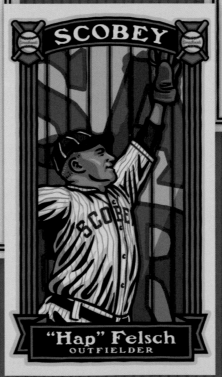

SCOBEY

"Hap" Felsch
OUTFIELDER

Felsch and Risberg gained reputations as drunks who should not be crossed

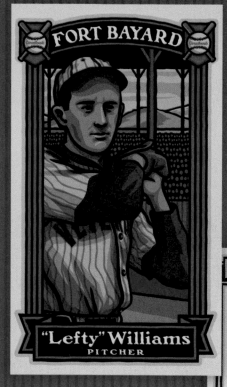

FORT BAYARD

"Lefty" Williams
PITCHER

He quit baseball when other players refused to appear with him

UNIVERSAL

Fred McMull
THIRD BASEMAN

FORT BAYARD VETERANS

Uninterested when approached to throw the Series, Lefty Williams relented after being informed the fix was in anyway. Lefty received only half of the promised $10,000, but that was still almost double his regular salary. He and the other players may have tried to call off the fix halfway through, but when Lefty's wife was threatened he went ahead with it. Williams lost three games and it was due in part to his suspect play that the Series came under close scrutiny. After his banishment he drifted west to the outlaw Copper League where Weaver and Gandil were playing. He took to drinking whiskey between innings and as the game wore on he became meaner and more intimidating on the mound. Lefty's swan song was his 1926 no-hitter against the Douglas Blues. Dogged by alcohol abuse, Lefty died in Southern California in 1959.

BLACK SOX

Chick Gandil was the mastermind behind the fixing of the 1919 World Series. Described by his contemporaries as a "professional malcontent," Chick was a thug, suspended during the 1919 season for punching an umpire. He made the most from the fix, pocketing some $35,000, nine times his regular salary. After being turned down for a raise in 1920, he left the game and squandered most of his earnings. Later he and the other Black Sox formed a touring team and then played on various semipro copper-mining teams in New Mexico. From 1925 to 1927 he played for the Douglas Blues, Fort Bayard Veterans, and Chino Twins, managing the last team to the 1927 championship series. Abruptly leaving before the series started, Gandil became a plumber and died in 1970, always denying the White Sox threw the 1919 World Series.

UNIVERSAL FILM STUDIOS

Though Fred McMullin is thought to have been part of the fix because he overheard the plan, this is not true. McMullin's sound baseball knowledge made him the White Sox's advance scout, and he may have given his teammates a flawed report on the Reds pitchers they were to face in the World Series. McMullin received $5,000 for his part in the fix, which was only two at-bats and no time in the field. After being banned he played semipro ball in Los Angeles for Universal Film Studios but had to quit when other players refused to appear with him because it would hurt their chances to enter organized baseball—playing on the same field as a banned player was grounds for being blacklisted. Ostracized by his former ballplayer friends, he later became, of all things, a deputy U.S. marshal. McMullin died in Southern California in 1952.

CHINO

"Chick" Gandil
FIRST BASE & MANAGER

Gandil died in 1970, always denying the White Sox threw the 1919 World Series

S OELESS JOE J CKSON

Another Day in Baseball Purgatory

Joe Jackson spent many years of forced exile from the big leagues traveling around the country as a ringer for small-town baseball teams. He died in 1951 having accepted that he would never be forgiven. This is an imagining based on a June 28, 1922, New York American *newspaper article describing one day in Jackson's baseball purgatory.*

The man standing in the shade of the building was deeply suntanned and wrinkles ran round his face, making him seem older than his 32 years. He wore a black suit, finely tailored, though of an older-style cut and starting to show its age around the edges. In his rough, callused hand he gripped a leather travel bag, which, upon closer examination, showed that the ornate brass plaque between the handles had been crudely altered: Someone had scratched away all traces of the original engraved initials.

The man stood outside the box office entrance to the town ballpark. It was a small, well-built ball yard, but in actuality he hardly took notice. After all, he'd played

in a different one almost every weekend that summer and now they were all starting to blend together. If he hadn't stopped at the coffee shop back in the train station he'd probably have had no idea he was in Hackensack, New Jersey.

After he had stood around in the late-morning sun for a few minutes, a caravan of dirty open cars turned into the dirt lot beside the ballpark. They stopped in a cloud of dust, and a dozen men poured out. These were to be his teammates for today's ballgame. He watched as the men unloaded canvas bags of equipment. The oldest-looking one of the group saw him standing near the box office door and walked quickly over to him, extending his hand. He introduced himself as the manager. In his other hand he offered up a manila envelope. The suntanned man opened it, pretended to count the money inside, and quickly shoved it in his coat pocket. It was time to get ready.

The locker room was a locker room in name only. The small room was damp and had two long wooden benches that ran the length of the room. The walls had a shelf about neck high opposite each bench and a row of hooks beneath that. Each of the ballplayers staked out a space on one of the benches and unpacked his small traveling bag. Most of the players talked loudly with one another, laughing and throwing around swear words. Their accents were harsh to his ears and sometimes not too easy to follow. A few of the players stared unabashedly at the suntanned man, and he began to grow more uncomfortable than he usually felt. As the suntanned man undressed, he hung his jacket from a hook and folded his black pants and silk pink shirt. Running his hand over the folded silk garment to smooth it out before placing it on the shelf, he quietly touched the gold embroidered "J" monogram over the pocket.

The man's name was "Josephs"—at least that's what the scorecard said

The suntanned man removed a worn baseball uniform from his leather satchel. It was of a rougher quality wool than he was used to but it was a baseball uniform just the same. There was no name on the front, just black pinstripes. The cap he retrieved from the satchel was black as well, with a white button and white "P" on the front—a souvenir of an afternoon up in Poughkeepsie the week before. His name was "Joe Nutter" that day.

The manager appeared with another ball-

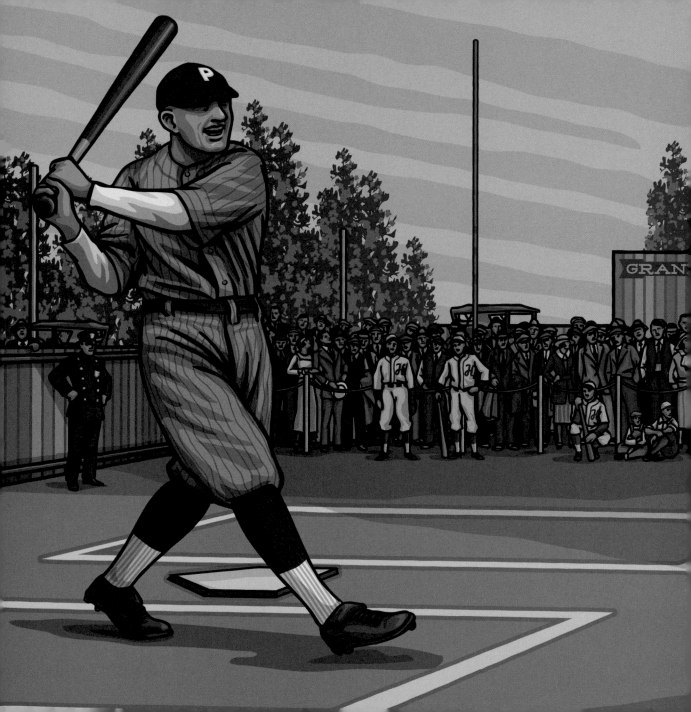

player in tow. He introduced him as "Smith," but the suntanned man recognized him as a young pitcher with Toronto. He couldn't recall his name, but it sure as hell wasn't Smith. The manager repeated the story he'd already heard—that his Westwood town team, traditionally a local powerhouse, had been unexpectedly clobbered by Hackensack a month before. There was always a heated rivalry between the two towns and the games always attracted spirited betting, the action being covered by heavies from nearby New York City and Newark. Westwood swore Hackensack had a few ringers on their team that day and, needless to say, much money was lost by Westwood's fans. Plenty of people were pissed off and thirsty for revenge. Taking up a collection, Westwood decided to purchase some insurance for today's game, hence the manila envelope of cash. Today, the suntanned man's name was "Josephs," at least that's what it said on the lineup card.

By this time he could hear the roar of the crowd. Through the row of filthy windows that lined one wall above the shelves he could make out much movement as hundreds of people jostled for seats. He could hear men shouting and children squealing. Someone threw something through one of the open windows and every few minutes some wise guy would bang on the glass and shout something nasty. One of the suntanned man's temporary teammates sidled up and said: "They know you're here."

Emerging from the darkness of the locker room, he pulled his cap down as low as he could over his eyes to protect them from the sun. The crowd went wild when they recognized him.

"My God, it's Shoeless Joe Jackson!"

Spectators were spilling out onto the field and bits of paper littered it. Glancing out to center field he could see it was cleared of fans, which made him feel a little better. The roar was deafening. There must have been more than 1,000 here today, probably more. Ugly, twisted faces shouted unintelligible words at him. Small children stared and women craned their necks and stood on tiptoe to catch a glimpse of him. He'd seen it all before. He did this every weekend.

The game wasn't much to remember as far as he was concerned. It was a standard affair—the Hackensack manager came over

One of his teammates sidled up and said: "They know you're here"

to the Westwood bench and in between swear words made it clear his team would be playing the game under protest. Westwood held back the Toronto pitcher until he was unleashed in the third inning after Hackensack scored a few runs. It was smart managing, as it gave the gamblers time to settle the odds before the Toronto kid shut the opposition down for the rest of the game.

In between "Josephs's" hitting a home run, a double, and two singles, there were a few notable incidents. A news photographer ran onto the field while Westwood was batting and attempted to take a photo of him as he sat on the bench. Two of his teammates started shoving the newsman and threatened to beat the hell out of him if he didn't get back to the stands. When Westwood's catcher reared back, ready to throw a punch, the fella ran off so fast he left his hat behind. The catcher stomped on it with his spikes and the rest of the ballplayers laughed. A few times the game was stopped, not by the umpire but because everyone paused to watch a fistfight in the bleachers. He noticed that the couple of policemen stood by and did nothing—

They threw more crap on the field; this sure wasn't Comiskey Park

wading into a crowd like this was pointless, and after a few minutes the fighting stopped on its own anyway. At a few points in the afternoon the play was stopped while the players collected some of the larger items that had been thrown onto the grass. Bottles of beer, scorecards, newspapers, and even a few straw hats were picked up and thrown in a pile behind home plate. One call by the amateur umpire caused a heck of a row. When he called Westwood's left fielder out for supposedly not touching first base on his way to an easy double, the bench cleared, and for a time it looked as if the poor umpire was going to catch a beating. Josephs sat on the bench and watched. The guy missed touching first by a mile anyway. A few innings later a Westwood fan charged out of the stands and accused a Hackensack outfielder of putting a concealed second baseball in play when he couldn't get to a deeply hit fly ball. Josephs just pulled his cap lower over his eyes and thought about his wife.

He was proud of one play he made that day, not at bat but in the outfield. On a long ball hit out to him in center, he made the catch and threw a straight liner back to

the surprised catcher, who tagged out the equally surprised runner to end the inning. The bases had been loaded and it squelched a rally, and when all was wrapped up it probably made the difference in Westwood's 9–7 defeat of Hackensack. Most of the crowd cheered, but some threw even more crap on the field; this sure wasn't Comiskey Park.

After the game he tried to dress as quickly as possible. Half the team was drunk and in various stages of undress. One of the guys threw his spikes through one of the glass windows. He was too busy packing his leather satchel to find out why. Someone was pounding on the locker room door but no one answered. After a while he slipped his black suit coat over his pink silk shirt, once again obscuring the embroidered "J" above the pocket. He opened the locker room door and, ignoring the lingering spectators in the parking lot, headed off toward the train station, trying to remember where he was going to be next weekend and what his name would be when he got there.

SING SING

"Alabama" Pitts
OUTFIELDER

Edwin Pitts's mama nicknamed him "Alabama" to distinguish him from his pop, also named Edwin, who was born in Georgia. At age 15 Alabama left home, joined the navy, and served a three-year hitch. Landing in New York City with no prospects, Pitts fell in with a former shipmate and decided that robbing liquor and grocery stores was a good idea.

Years later it was claimed Pitts resorted to robbery just to feed himself, but in reality the two men pulled a few successful heists before they were caught robbing the Reeves Grocery Store on Amsterdam Avenue. Leaving his buddy outside as lookout, Pitts entered and pulled a revolver on manager John Costello. Snatching $80, he ran outside, where his partner waited with a taxi. With Costello running after the getaway cab screaming, the taxi was quickly stopped a couple of blocks away. Pitts and his inept partner were arrested for armed robbery and sentenced to 8 to 16 years in Sing Sing Prison.

If Alabama had committed his crime a decade earlier his time spent confined within the stone walls of Sing Sing would have been much different. Fortunately for him the new warden, Lewis Edward Lawes, believed in rehabilitation through sports and other activities instead of dank confinement. Lawes formed competitive baseball, football, and basketball leagues made up of not only the inmates, but their guards as well. The plan soon began to bear fruit as the prison's disciplinary problems reduced dramatically.

In this environment, 19-year-old Alabama Pitts flourished. The New York Yankees visited

Sing Sing in September 1933 and newspapers reported that Pitts made quite a stir with his superior fielding skills. He was batting .500 when Hall of Famer Johnny Evers brought his Albany Senators team to Sing Sing.

Due to Pitts's exemplary behavior and leadership as team captain, Warden Lawes obtained permission to chop off three years from his sentence. Johnny Evers, who remembered Pitts from the game he played against Sing Sing, offered him an Albany contract, and that's when trouble started.

The International League officials refused to validate Pitts's contract for moral reasons. Surprisingly, public opinion swung in the opposite direction: It was 1935 and the country was mired in the Great Depression. Americans could sympathize with a guy stealing money so he could eat. The case was brought before Commissioner Landis, who gave Pitts the okay, stipulating that he not be used for exhibition games as a novelty attraction.

Pitts was described by his Albany teammates as a tough character who took no notice of pain. He kept to himself but was not unfriendly and never spoke of his time behind bars. One disconcerting trait the new player possessed was the way his eyes quickly and comprehensively surveyed a room upon entering it.

Wearing his lucky number 7 on his back, Pitts went two for five in his first game, with a couple of nice plays in the outfield, but it went downhill from there. Alabama had the serious problem of not being able to hit the curveball and was further hampered when an untreated spike wound culminated in blood poisoning. He drifted down the levels of organized baseball and into the semipro ranks.

By 1939 he was playing for a mill team in Valdese, North Carolina. Pitts was in a seedy roadhouse with some teammates when he drunkenly tried to dance with the girlfriend of a local tough named Newland LaFevers. LaFevers pulled a blade (if you were ever to get knifed in a roadhouse, you just know it would be by a guy named "Newland LaFevers") and fatally severed an artery under Pitts's right armpit. Some 5,000 people showed up to see Alabama Pitts returned to the earth. He was just 31 but left behind one heck of great nickname and a truly tragic story.

The Yankees visited Sing Sing in 1933 and Alabama Pitts made quite a stir

The STRANGE *and* TRAGIC TALE

It all started with a dice game. Frank "The Weasel" Warfield and Oliver "The Ghost" Marcelle were blackball superstars, teammates on the champion Baltimore Black Sox. Warfield managed and played second. He was intimidating and abrasive and enjoyed berating his players while everyone watched. He was quiet and brooding, quick with a knife, unpopular and sarcastic. Behind his back teammates dubbed him "The Weasel."

Oliver Marcelle was the best third baseman of the 1920s. His ability to appear at the right spot out of nowhere earned him the nickname "The Ghost." He was a good-looking Creole and the vainest man in the league. He also had one of the nastiest dispositions in the Negro Leagues, a stone-cold street fighter who would use anything to gain the upper hand: bottles, chairs, knives. Already nasty, he was only worse when under the influence of alcohol. He fought umpires, opposing players, and even his own teammates.

Perhaps it was inevitable that these two high-strung characters would eventually go at each other. They'd just finished up the 1929–30 winter season in Cuba and were shooting craps at their hotel in Santa Clara.

> **He was unpopular and sarcastic; his teammates dubbed him "THE WEASEL"**

Warfield was riding a winning streak and for every winning throw of the dice The Weasel threw, The Ghost crapped out, finally coming up broke. Marcelle asked Warfield for five bucks to continue, said it was owed to him by the Black Sox. The Weasel refused and things got nasty.

Marcelle slugged Warfield in the mouth and so began a brawl so brutal that it only ended when The Weasel did something unimaginable—Warfield bit off the side of Marcelle's nose. The Ghost was rushed to a hospital, where he pressed charges against his former manager. Warfield cooled his heels in a Cuban jail for a few days while a minor international incident swirled. Since officials just wanted to rid themselves of two violent foreigners, the charges were dismissed and The Weasel was quietly released.

Obviously the two men could never play on the same team again, so Marcelle joined the Brooklyn Royal Giants for the 1930 season. Besides being one of the most violent players in the Negro Leagues, Marcelle was also one the vainest. Being so visibly disfigured in the days before plastic surgery was a crushing blow, and he took to wearing a black eye patch over the hole in his nose. The once sarcastic and cruel player was now on the receiving end of an endless cycle of jokes from both players and fans. He left organized ball and drifted out West where he was not known, anonymously playing semipro ball in dusty frontier towns before disappearing altogether. Warfield died under shady circumstances two years after the fight. Always the ladies' man, he was with a woman that July night when he was rushed to the hospital bleeding. Internal hemorrhaging led to a heart attack and death. He was 37.

"THE GHOST" *fought umpires, opposing players, and even his own teammates*

NEW YORK

Ben Chapman
OUTFIELDER

Even a team as conservative as the New York Yankees needed a guy like Ben Chapman. The tough-as-nails outfielder came out of Nashville, Tennessee, and literally fought his way to the major leagues, where he took his place in the outfield beside Babe Ruth. He hit over .300 his rookie year in 1930 and quickly became a minor star of the early 1930s.

Chapman added the speed element to a lineup heavy with sluggers. When Ruth or Gehrig hit a home run, they often knocked in Chapman as well. He swiped 61 bases in 1931, a record that stood for more than 30 years, and led the American League in steals for three consecutive years.

He was brash and mouthy, with enough balls to tell the aging Babe Ruth, "If you were paid as much as you're worth you'd be making less than I am." Chapman played every game as if his life depended on the outcome and broke up close plays with his brute strength and determination. In one 1933 game against the Senators, Chapman intentionally spiked second baseman Buddy Myer. The incident was often held up as proof of his anti-Semitism, and it's been reported by many authors that he would give the stiff-armed Nazi salute to Jewish fans in Yankee Stadium, though there aren't contemporary newspaper articles confirming this. Manager Joe McCarthy encouraged his filthy brand of verbal debasement because it unnerved the other teams, giving the Yankees an edge. Chapman churned out a nonstop flow of bigoted abuse directed toward players of every nationality and religion. It's disheartening to think of this guy calling Hank Greenberg a "kike" while sitting on the same bench as

Lou Gehrig and Joe DiMaggio, but guys like Chapman were a necessary evil that clever managers like McCarthy exploited to their team's advantage.

By 1936 Chapman was slowing down, and he was traded to the Senators when Joe DiMaggio proved he was star material. Chapman bumped around from Washington to Boston to Cleveland before being released to the minors. He'd carved out a very good 15-year major league career and could boast of a lifetime .302 average, a World Championship, and three trips to the All-Star Game.

He managed in the minor leagues and counteracted the wartime manpower shortage by reinventing himself as a pitcher. The 35-year-old made it back to the major leagues, where he posted an 8-6 record for the cellar-dwelling Brooklyn Dodgers. After the war he was hired to manage the Philadelphia Phillies, and that's where Ben Chapman became a part of one of the game's darkest moments.

Chapman was vehemently opposed to the integration of baseball and ordered his pitchers to bean Jackie Robinson rather than walk him if he ran up a three-ball count. The ceaseless vile abuse he spewed from the third-base coach's box was considered so disgusting that it made headlines across the country. Instead of turning other whites against integration and making Robinson quit, Chapman's attacks instead shone a bright light on accepted racial attitudes of the time and swung public opinion firmly behind Robinson. At one point Chapman was made to meet Robinson on the field before a game and pose for pictures in an awkward attempt to smooth over the previous incidents. He was let go as Phillies manager the following season.

Even a team as conservative as the Yankees needed a guy like Chapman

In his retirement Chapman showed no animosity toward blacks or anyone else with an ethnic makeup that differed from his. For his part, he claimed that he'd learned a lot over the years and steadfastly insisted that the abuse he heaped on Robinson was no different from what he slung at Italians, Poles, Jews, or northerners throughout his long career. It was just part of the game as he knew it, he claimed, and indeed it was; it was just that its time and usefulness had passed him by.

NEW YORK

NY

WGN

Jake Powell
OUTFIELDER

When the Yankees sent Ben Chapman to the Senators they got Jake Powell in return. A fiery competitor, Powell aimed to win at all costs.

In April of 1936 Powell beat out a single by deliberately crashing into first baseman Hank Greenberg, breaking Greenberg's wrist so severely he missed the entire season. Powell refused to apologize, innocently stating he had simply beat out a base hit.

Powell will forever be remembered for a 1938 pregame interview he gave on WGN radio. When asked what he did to keep in shape during the winter, Powell responded with, "Oh, that's easy. I'm a policeman in Dayton, Ohio. I spend the off-season clubbing niggers over the head." WGN immediately cut off the transmission but the damage was done. The Yankees made Powell tour bars and taverns in Harlem buying drinks and apologizing, but no amount of free beer could make up for his comments. The odd thing was, Powell wasn't a cop. He'd made the whole thing up.

The black press demanded he be banned for life, but Commissioner Landis only suspended him for 10 games, while Yankee manager Joe McCarthy issued a moratorium on his players' giving unscripted interviews.

As hostile fans heckled and threw bottles at Powell, his effectiveness quickly waned, and he was out of the majors by 1940. After drifting around the low minors he turned up in Washington, D.C., where he and a girlfriend got pinched passing bad checks. When police brought the pair in for questioning the outfielder somehow got hold of a pistol and shot himself in the chest and temple. He died before an ambulance arrived.

The only explanation for what Jimmy O'Connell did in September of 1924 was that he was incredibly stupid. Just a few years earlier the Black Sox scandal almost destroyed the game, resulting in eight players' being banished from baseball for life. O'Connell, then an up-and-coming outfielder on the New York Giants, approached his old pal from the minors, Heinie Sand, now the Phillies' shortstop. The outfielder offered Sand $500 to throw a few games so the Giants could gain some ground in the tight pennant race. Sand, smarter than his old friend, reported the incident to his manager, and within days the hapless Giants outfielder was in front of Commissioner Landis.

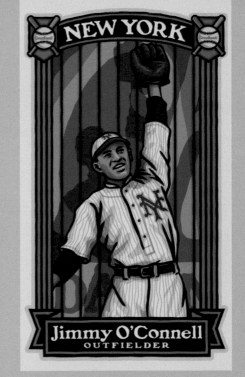

O'Connell innocently told Landis that he did indeed offer $500 to Sand. He stated that Giants players Frankie Frisch, Ross Youngs, and Highpockets Kelly and coach Cozy Dolan instructed him to offer the money to Sand.

Frisch, Youngs, and Kelly, all future Hall of Famers, completely denied the accusation, but Coach Dolan stupidly told the commissioner he couldn't remember anything. Not that he didn't do it, but that he couldn't remember. Landis had no choice but to throw both men out of organized baseball. Many believe Giants manager John McGraw was behind the whole affair, and he did indeed set up Dolan with some valuable Florida real estate after he was exiled.

Jimmy O'Connell had no such compensation. The once promising ballplayer was reduced to playing outlaw baseball in western mining towns alongside fellow exiles Chick Gandil, Buck Weaver, and Lefty Williams.

"OLE BILL" RUMLER

Exile and Redemption in Hollywood

While the 1919 Black Sox scandal is well known by every baseball fan, the numerous other scandals that rocked professional baseball at the time are not. A scandal second only to that involving the Black Sox involved the 1919 Pacific Coast League pennant race.

In July of 1920 Vernon Tigers first baseman "Babe" Borton showed up at the Los Angeles hotel where the visiting Salt Lake City Bees were staying. Borton approached a number of Salt Lake players offering $300 cash to throw that afternoon's game. Borton wasn't very careful in his role as the world's most inept bagman, and his fat stack of cash quickly came to the attention of league officials.

Flashing wads of cash in a busy hotel lobby really wasn't a smart idea, since for years rumors had been circulating that gamblers enjoyed an uncomfortably close relationship with many Coast League players. Borton tried the usual denials, testifying that the money was just losses owed in craps games, but no one was buying it. Borton was banned from the game and a number of other players were suspended.

Second only to the scandal involving the Black Sox was the 1919 Pacific Coast League scandal

While league officials tried to end the scandal there, the investigation uncovered even more corruption. Turns out Borton had spent much of the previous season handing cash out to ensure that the Tigers won the pennant. Vernon, the town that the Tigers represented, is just south of Los Angeles, and at the time was pretty much a law-free zone. Gambling was overlooked and the town boasted all the seamy elements Southern California could offer. The cash Borton was spreading around came from what was called the "Fan's Fund"—supposedly donations from Vernon fans. That many of the "fans" were gamblers was a fact lost on no one. Amongst the "subscribers" to the fund were quite a few Hollywood luminaries, such as actor Fatty Arbuckle, movie studio mogul Samuel Goldwyn, and Sid Grauman, owner of the famed Chinese Theater. By the time

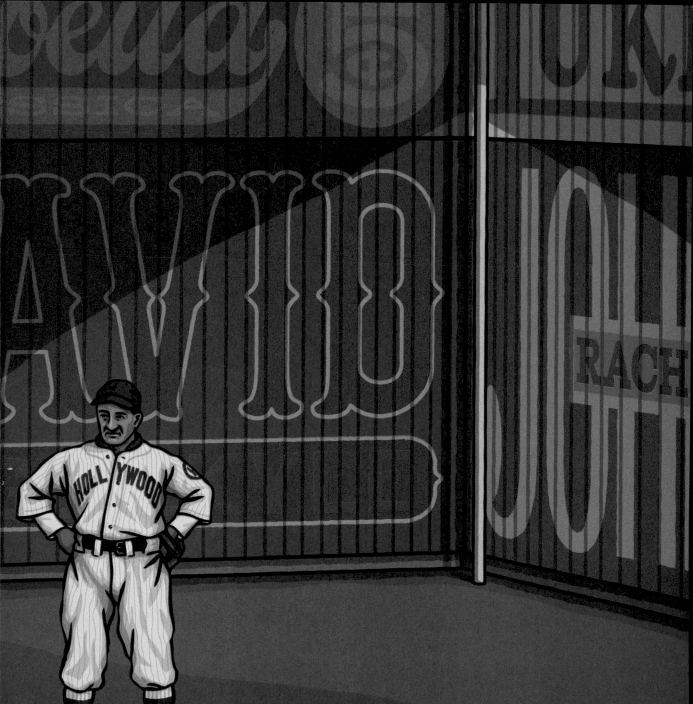

the investigation ended dozens of PCL players had testified to having been offered bribes to throw games during the 1919 and 1920 seasons.

Among the players implicated was Salt Lake's star outfielder, Bill Rumler. At the time 29 years old (hence his nickname "Ole Bill"), he was having the best season of his career, batting .350 and expected to rejoin the major leagues the following year.

Borton testified he gave Rumler $200 (some say $250) to lie down against Vernon when the two teams met at the end of the 1919 season. Investigators found a bank draft in the amount of $250, which Rumler insisted was from a friendly bet over the 1919 pennant. Since Borton and his Vernon team won the pennant, it was never clear why Rumler was the one paid off, and the outfielder was suspended indefinitely. Coast League president William McCarthy was so convinced Rumler was dirty that he emotionally vowed to resign if the other owners voted to reinstate him. They voted unanimously to a five-year ban, amounting to a lifetime, because Rumler was pushing 30. No one expected to hear from Ole Bill again.

No one, that is, except Ole Bill himself.

Among the players implicated was Salt Lake's outfielder Bill Rumler

Rumler never changed his story and always insisted on his innocence. He went underground, changed his name to Red Moore, and played on any team that would pay him. Roaming the outfield on rough-and-tumble teams representing mining towns in the Dakotas and smoke-belching industrial cities in the Midwest, Rumler bided his time until the five years had passed.

In the spring of 1929 Ole Bill resurfaced at the Hollywood Sheiks' training camp. Much had changed since Rumler's exile—for one thing, his old team, the Salt Lake City Bees, had relocated to Hollywood and were now the Sheiks, after the Rudolph Valentino movie. To everyone's surprise, the old man beat out all competition to become the Sheiks' starting center fielder.

Bill Rumler had a season that players half his age would die for. In 140 games the 38-year-old batted a career high .386 and smacked 26 home runs, leading the Sheiks to the PCL playoffs against the Mission Reds. After dropping the first two games, the Sheiks roared back and won the next three. In Game 4 Rumler was hit in the head by a pitch and knocked unconscious. He was rushed to the hospital, where it

was feared he would pass away during the night, but Rumler surprised the doctors by regaining consciousness. The physicians all insisted he not play anymore that year, but Ole Bill had come too damn far to end it like that.

Defying everyone, he checked himself out of the hospital and suited up for the sixth game against the Reds. Sitting on the bench, he watched as the Sheiks fought the Reds to a 3–3 tie. In the bottom of the eighth with two on and one away, Rumler was sent in to pinch-hit.

With the screams of the hometown crowd of 15,000 reverberating inside his battered skull, Ole Bill lined a single to left that scored the go-ahead run, winning the game and championship.

Now Ole Bill Rumler's season was over.

It has to be one of the best comeback stories of all time, so good in fact that whatever came after could only be underwhelming. Rumler's 1930 season started off just as well as the previous year's, but eventually bad luck and age caught up with him. On an overnight train Rumler had a nightmare and kicked his foot through his Pullman car's window. The deep cuts cost him a week on the pines but he roared back and was batting a killer .353 when he busted his ankle in August, putting him out for the remainder of the season.

Come spring, he tried regaining his old form, but after years of injuries, Ole Bill's body had finally caught up to his nickname. He signed on with the Denver Bears but only managed .236 with them before he switched to a barnstorming team called the Canadian-American Clowns for what was left of the season. The year 1932 found Ole Bill as player-manager of the Class D Lincoln Links. Come June he was hitting .350 and had managed the Links to a 12-26 record when he punched an umpire in the nose. Rumler was fined $25 for inciting a riot and the league suspended him indefinitely. Ole Bill Rumler's professional baseball career was over.

After years of injuries, Ole Bill's body finally caught up to his nickname

Rumler returned to where he started from, Milford, Nebraska. There he remained a popular town character and became Milford's police chief until retiring in 1964 at the age of 73. When he died two years later in 1966, Ole Bill had never wavered from his story about the $200, always insisting he never threw a baseball game for money.

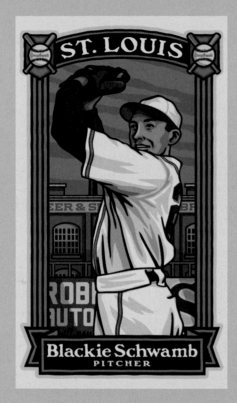

ST. LOUIS

Blackie Schwamb
PITCHER

Ralph Schwamb earned his nickname "Blackie" because he dressed in all black to emulate the bad guys he rooted for in western movies. Taller and stronger than kids his own age, Blackie divided his time between baseball, petty crime, and drinking. When World War II came Schwamb landed in the U.S. Navy, but the only action he saw was in various naval prisons because of his constant need to go AWOL. After the war Blackie drifted to Los Angeles and began a career as an enforcer for gangster Mickey Cohen.

In his spare time Blackie would drink and pitch sandlot baseball. A St. Louis Browns scout liked what he saw and his report read in part, "He's a screwball, but he can pitch."

Blackie's erratic behavior and alcohol problems followed him throughout his minor league career, but he was the bright spot in an otherwise dismal St. Louis Browns farm system. The parent club called him up, and Schwamb registered his first win on July 31, 1948. The postgame celebration never stopped. Beer before and during the game and an upgrade to whiskey afterward, followed by some brawling. He got clobbered in his next start and a few days later was handed his first loss. Schwamb was relegated to the bullpen.

Relief pitching in 1948 wasn't the specialist position it is today, and most relievers were has-beens or guys who couldn't go the distance. To Blackie Schwamb the assignment was an insult, and he spent his time in the bullpen polishing off a case of beer during the game. In the games he managed to get into he was drunk and got hit hard. When he pitched bat-

ting practice he beaned his teammates. The other players stayed away from him. He was different. Dangerous.

Though the Browns thought he had talent, he was sent back to the minors. He went back to L.A. and got nailed on a robbery charge. Blackie was out on bail the night of October 12, 1949, when he and a pal and his wife decided to rob a doctor from Long Beach named Donald Buge. In a booze-fueled rage, Blackie savagely beat the doctor to death with his bare hands. The once promising pitcher was sentenced to life in prison.

At San Quentin Blackie Schwamb became a sort of folk hero, playing major league–quality baseball behind the prison walls. When he was paroled in 1960 he'd won 131 games and lost 35. This tally includes no fewer than three no-hitters, and many of those wins were against top-shelf semipro teams stocked with major league players. Blackie's reputation was such that scouts would bring prospects to play San Quentin to see how their boy would do against Schwamb.

Upon his parole Schwamb received a few offers from major league teams to try out again. After much haggling, the powers that be that ran organized baseball decided Blackie could play ball, but only after one season of semipro ball to make sure his behavior on and off the field was acceptable. He reluctantly complied, and by the spring of 1961 Blackie Schwamb was a member of the Hawaiian Islanders, the Los Angeles Angels' top farm team. It was the comeback of the century, a story fit for the big screen. But it didn't last. The Islanders were a terrible team owned by another terrible team. Schwamb, despite his best efforts, could do no better than one win and two losses, and he was released after appearing in six games. Blackie drifted back to California, floating up and down the coast from job to job. He was even sent back to jail after being found with a handgun, although he only did one year—he could have been sent back for the remainder of his original life sentence.

Eventually Blackie found a certain peace in life, living with a woman he met while working a warehouse job and becoming a proud stepfather to her daughter. Racked with lung cancer, Blackie Schwamb, former St. Louis Brown and convicted murderer, died four days before Christmas 1989.

> *The other players stayed away. He was different. Dangerous.*

The Dangerously Talented
DAVE "LEFTY" BROWN

The sun was bright and warm as Jack Wells burst out of the run-down house in the colored section of Greensboro, North Carolina. A white man like Wells's just being in the segregated section of town raised eyebrows, but when he reached the end of the block, stumbled, and passed out, the locals knew well enough that in the Jim Crow South of 1938 this was a very bad thing.

When Wells woke up in the hospital, he told the police that an athletic-looking black man in a "glossy green shirt" had sandbagged him—that is, hit him in the back of the head with a weighted sandbag. Four dollars was missing. Finding a black guy in the colored section of Greensboro wearing a shiny green shirt wasn't that difficult, and soon a fellow matching the description, green shirt and all, was sitting in the police station.

Assault on a white man was rare in Greensboro, and the entire detective squad gathered around the assailant as he was questioned. His name was Dave Brown and

His name was Dave Brown and detectives learned that he had once played baseball

detectives learned that he had once played baseball. One of the detectives remembered a peculiar wanted poster he'd seen 13 years earlier. He never forgot it due to the unusual mug shot—the male Negro was wearing a baseball cap with the intertwined "NY" of the Yankees on its crown. The detective went through the piles of wanted circulars and eventually emerged with the yellowed sheet.

"WANTED FOR MURDER by the New York City Police Detective Division: Dave Brown (Negro)."

It was a long, bumpy road Dave Brown took from San Marcos, Texas, to Greensboro. He was the fourth of eight kids born into extreme poverty. Like many in similar circumstances, he grew up bending the law in order to get by, but unlike the rest of his peers, Dave Brown had a left arm that came along only once every couple of decades.

Being black, he had no other option than to play segregated baseball, and on the sandlots of Dallas he earned a reputation

DETECTIVE DIVISION
CIRCULAR No. 5
JULY 23, 1925

POLICE DEPARTMENT
CITY OF NEW YORK

PLEASE POST IN A
CONSPICUOUS PLACE

Police Authorities are Requested to Post this Circular for the Information of Police
Officers and File a Copy of it for Future Reference

WANTED FOR MURDER

DAVE BROWN (Negro)

DESCRIPTION—Age, 28 years ; height, 5 feet, 11 inches ; weight, 165 pounds ; seal-brown colored skin ;
kinky hair ; very erect. He is a professional ball player and pitched for the Lincoln Giants up to the time
of the crime. He may be found playing with some other colored baseball club.

Shot and Killed Benjamin Adair in front of 69 West 135th Street, this City, April 28, 1925. He has
been indicted for this crime and a bench warrant issued for his arrest.

If located, arrest and hold as a fugitive from justice and advise the Detective Division.
Kindly search your prison records as this man may be serving a sentence for some minor offence.

Telephone 3100 Spring

RICHARD E. ENRIGHT.
POLICE COMMISSIONER.

for speed and a good curve thrown with pinpoint control. However, the year 1919 found the ballplayer sentenced to a Texas chain gang for highway robbery. It looked as if Brown's prime ball-playing years would be spent in irons digging ditches when he was suddenly paroled. The man who wielded the key to his freedom was a fellow Texan named Rube Foster.

Foster had been a superstar pitcher at the turn of the century but by 1919 he was the owner/manager of the Chicago American Giants, the finest team in blackball. Whether Foster saw Brown pitch in Texas or just heard of the lefty from his Texas pals is not known, but Foster wanted the 24-year-old lefty badly enough to post a $20,000 bond for his release.

Brown's first year at the top level of black baseball has gone unrecorded. There was no organized Negro League in 1919, and the American Giants barnstormed throughout the Midwest playing small-town teams and other traveling ball clubs.

The following year Rube Foster founded the eight-team Negro National League, and Lefty Brown quickly emerged as the circuit's best southpaw. For the first three years of the league's existence Brown simply dominated the short season, posting league records of 13-3, 17-2, and 13-3 with an estimated ERA of around 2.50. Behind his left arm the American Giants won the pennant each of those seasons, and Lefty Brown became a superstar.

In 1921, probably Brown's finest season, 5 of his 17 wins that summer were shutouts. At the end of the season Rube Foster challenged the Atlantic City Bacharachs, champions of the East, to a playoff to determine the best team in blackball. Lefty won three of the hard-fought games to make the American Giants the undisputed champs of black baseball. After just

NEW YORK

Lincoln

Lefty Brown
PITCHER

a couple of seasons at the professional level Brown was regarded as the best lefty outside the white leagues. Many of the men who played with and against him considered him the finest left-hander the Negro Leagues produced. His contemporaries thought him mild-mannered and cheerful—far from the hardened veteran of a Texas chain gang you'd expect.

After his remarkable record in the Negro National League, Brown left for the more lucrative playing fields of the East. The New York City area boasted no fewer than three top-tier independent black teams: the aforementioned Bacharachs, Brooklyn Royal Giants, and Lincoln Giants. Besides a lively rivalry among those three clubs, the metropolitan area was a hotbed of semipro baseball, and there was no shortage of strong white ball clubs to play against. These matchups were as popular as Giants or Yankees games, and the good teams turned a nice profit, enabling them to lure the star players from Foster's league.

While he was in Chicago, Brown enjoyed success under the watchful eye of Rube Foster, a strict disciplinarian who did not stand for shenanigans on his team. The ballplayers on Foster's club kept their noses clean or they were quickly released. When Brown joined the Lincoln Giants in the spring of 1923 he did not have someone as strong-willed as Foster to answer to.

Prohibition and the Harlem Renaissance coincided with Lefty Brown's arrival in New York, making it one of the most exciting places on earth for a star ballplayer like himself. The Lincoln Giants were a veritable powerhouse, and he took his place in the rotation with Bill Holland, Smokey Joe Williams, and Sam Streeter, all blackball legends.

Prohibition and the Harlem Renaissance coincided with his arrival in New York

As could be expected in New York of the Roaring Twenties, Brown's game suffered: In 13 league games he went 5-6. He was still a star and as such was invited to play winter ball in Cuba. The 1923–24 Santa Clara Leopardos were said to be the greatest team in Cuban baseball history, and Brown won 18 games as they took the pennant.

Back home in 1924 Lefty Brown went 12-8 in 26 games for the Lincolns. While a far cry from his Chicago days, he was still thought to be the best lefty around, and as the 1925 season opened, many believed his best years were ahead of him.

On the afternoon of April 27, Brown

opened up his season by beating the Lincoln Giants' bitter rivals, the Bacharachs. Holding the Atlantic City bats to a single run on seven scattered hits, Brown and a good portion of his teammates hit Harlem's speakeasies to celebrate. By 3:00 a.m., Brown, Oliver Marcelle, and Frank Wickware were wandering around 135th Street. Whether they were simply stumbling home, or as was alleged, looking for cocaine, trouble caught up with Lefty Brown again.

According to a handful of witnesses, a man holding a revolver ran at the ballplayers hollering, "Now I've got you!" Brown pulled a .45 automatic and plugged the guy in the abdomen. The three Lincolns then jumped in a cab and tore off into the Harlem morning. By dawn their assailant, Benjamin Adair, was dead.

It didn't take the NYPD long to figure out who the gunman was. Lefty Brown, Oliver Marcelle, and Frank Wickware were superstars of the day. Everyone in Harlem knew their faces and in turn the cops knew exactly where to look for them. When detectives showed up at the Catholic Protectory Oval, the Lincolns' home grounds, Marcelle

For more than half a century no one was quite sure what became of Lefty Brown

and Wickware were taken in for questioning, but Lefty Brown was gone.

A bench warrant was issued for the pitcher's arrest, and on July 23, 1925, what was perhaps the oddest wanted poster in criminal history was sent out to cop shops all over the United States. There in black and white was Dave Brown wearing his cap bearing the Yankees-style "NY" along with the name "Lincolns" in script descending down the left front side of his flannel jersey. It wasn't something any police officer would forget after seeing it on the wall. The fledgling FBI was notified but had no luck locating the fugitive hurler. In fact, for more than half a century, no one was quite sure what became of Lefty Brown.

In 2005 Peter W. Gorton published a paper called "The Mystery of Lefty Wilson." Turns out Brown hadn't really fallen off the face of the earth but had changed his name to Wilson and hidden out on the fringes of outsider baseball. Shortly after fleeing New York City, Brown hooked up with Gilkerson's Union Giants, a mediocre barnstorming outfit from Chicago. The team played small towns throughout the upper Midwest and frequently came into contact with ball-

players who knew him from his former life. Surprisingly, no one ratted him out, and he left the Union Giants when they crossed the border into Mexico. "Wilson" made a nice little career as a pitcher for hire, especially in the Minnesota region, where small-town baseball was serious business. Bertha, Wanda, and Sioux City all had the mysterious lefty take the mound for them throughout the late 1920s. He met up with other baseball mercenaries, such as Negro League ace John Donaldson and Black Sox exiles Swede Risberg and Happy Felsch, who circulated in this mysterious world of outsider baseball.

Brown disappears again after 1930. Many writers repeated the rumors that he died under mysterious circumstances in Denver, date unknown. This rumor may have been spread by his old pal Oliver Marcelle, who himself was living in exile in that city after his nose had been bitten off in a fight.

And that's where the story ended until researcher Gary Ashwill found a series of newspaper articles reporting the sandbagging arrest of Dave Brown in 1938.

NYPD officials were contacted, and after denying he was *the* Dave Brown of Lincoln Giants fame, the suspect waived extradition to New York City. Then the New York cops decided against extraditing him because of a lack of evidence to prosecute. Greensboro also dropped the charges against Brown, as Jack Wells had checked out of the hospital and evaporated.

Dave Brown, shiny green shirt and all, walked out of the Greensboro police department and, as was his custom, once again disappeared off the face of the earth.

WANDA

Lefty Wilson
PITCHER

It was June 30, 1934, and as the midday steamy heat smothered the coastal town of Norfolk, Virginia, the large crowd of spectators milling around the outside of Bain Field were mad. They couldn't secure one of the 8,000 sold-out tickets to see the Yankees. The mighty New York Yankees, who were in town playing their Class B farm team, were equally mad that they had to spend a precious off-day playing a meaningless exhibition game in the sweltering humidity. On top of that, they were in the midst of a pennant race and first baseman Lou Gehrig, instead of going on the injured list because of a broken toe, stayed in the lineup. More than a few grumbled that this supposedly selfless act was, in fact, nothing more than Gehrig's selfish pursuit of playing in the most consecutive games. But the big right-hander on the mound for the hometown Norfolk Tars was really mad. This was his chance to shine against the parent club and he'd already given up three runs in two innings, including a home run by Lou Gehrig. He hated Lou Gehrig, and now as he came to bat a second time, pitcher Ray White was really, really mad.

Ray White had met Lou Gehrig before. While captain of the baseball team at Columbia University, Gehrig's alma mater, White had been thrilled to be introduced to the famous first baseman. But Gehrig acted uninterested and rude to the young pitcher. Was it done purposely? Was this a case of Gehrig's shyness or did Gehrig have something against Ray White? In the spring of 1934 the Yankees faced the Tars in a spring training game. Ray White, now a promising young Yankee farmhand, faced Gehrig for the first time. After Lou belted

two home runs off him, White fired a blazing fastball at him in his next at-bat. The ball grazed the side of his head, and when asked about the beanball later in the locker room, Gehrig uncharacteristically snarled, "That guy can go to hell!"

Now, a few months later, Gehrig again faced White after hitting a home run off him in the first inning. Although this was just an exhibition game and the batter was Lou Gehrig, to Ray White, this was payback time. He fired the ball right at Gehrig, slamming it into the center of his head. Gehrig collapsed like he had been shot. Yankee manager Joe McCarthy screeched, "My God, there goes the pennant," and raced out to his fallen star. After more than five scary minutes, teammates helped a shaken Gehrig to his feet and led him off the field. An ambulance raced him to a local hospital.

It is not recorded what Ray White did or said immediately after the beaning. Did he look on defiantly at the fallen star? Did he rush forward to try to help? It is not known, but it is part of the record that after Gehrig was carried away, the next batter, fiery Ben Chapman, screamed angrily at White and belted one of his pitches right back at him,

Lou Gehrig uncharacteristically snarled, "That guy can go to hell!"

almost knocking the Norfolk pitcher off the mound.

At the hospital X-rays showed that although Gehrig suffered a concussion, his skull was not fractured. Doctors recommended a few days off for much-needed rest, but Lou would have none of that. The next day, his head so grotesquely swollen that he had to use one of Babe Ruth's larger caps split open in the back to fit, he took the field against the Washington Senators. Although in pain, Gehrig banged out three triples before the game was called in the fifth inning because of a rainstorm. Gehrig went on to lead the American League in batting average (.363) and home runs (49) that year. His run-in with Ray White, as well as White himself, faded into obscurity as just another footnote in baseball history. Or did it?

Five years later Lou Gehrig finally failed to take the field for a game. He had been feeling fatigued and not hitting the way he used to. He left the team and went to a succession of specialists, who diagnosed him as suffering from amyotrophic lateral sclerosis, the fatal illness that would forever be known as "Lou Gehrig's disease." Within two years he was dead. But recently doc-

tors have suggested that Gehrig may not have died from the disease that bears his name but been the victim of gradual brain degeneration that occurs after numerous head injuries. Gehrig had suffered a few concussions during his career, White's beaning being the most significant of them. Patients suffering from a concussion are made to rest in order to let the brain heal, but Gehrig resumed his ball playing immediately after each injury. Symptoms of gradual brain degeneration are similar to and often confused with amyotrophic lateral sclerosis.

So did Ray White kill Lou Gehrig? No, of course not. At worst he was trying to send a message to someone who slighted him and showed him up by knocking three of his pitches into the bleachers. By the rules of baseball in 1934, Ray White was doing his job. So did Lou Gehrig kill Lou Gehrig? It's a real question. It's a fact that he refused to rest as he should have. Fellow players have said that his drive to play every single game might have actually hurt his team. Cal Ripken likewise faced similar criticism during the latter part of his career while chasing the same record. Ironically,

By the rules of baseball in 1934, Ray White was just doing his job

if Gehrig did indeed rest after each injury, his career and life may have lasted longer. Did the pursuit of a record that ultimately meant nothing to his team end in the death of one of baseball's most beloved players? It's not possible to say.

Ray White never made it to the Yankees. He made it as far as AAA before suffering an arm injury. In 1938 he was back in Norfolk as the Tars' manager, where he had the opportunity to do what he always said Lou Gehrig refused to do for him. The Yankees wanted White to play a shortstop named Claude Corbitt, but he had faith in another shortstop, Phil Rizzuto. White and the Scooter had attended the same high school and he believed in giving a fellow alumnus a chance. Rizzuto batted .336 for the pennant-winning Tars and went on to be one of the most beloved Yankee stars.

White left baseball and eventually became president of the Royal Crown Cola Company. While acknowledging his problems with Gehrig, he always denied that he deliberately meant to hurt the Iron Horse, just a pitcher's instinctive reaction to a player who took him deep in his last at-bat.

CHAPTER 5
THE PEOPLE'S GAME

The best thing about baseball is that anyone can play it, and over the course of its history, just about everyone from presidents to dictators have played it.

The People's Game illustrates a wide array of those who are well known for wildly different reasons, yet all share one thing: They played baseball.

Some are known for their prowess in other sports, like football's "Papa Bear" George Halas and Olympic hero Jim Thorpe. Others made their mark far away from the ball field, like writers Jack Kerouac and Stephen Crane. Though their books are read in every high school in America, the two literary giants considered themselves athletes before intellectuals.

Dwight Eisenhower and Fidel Castro are two men of completely different ideologies who faced off during the Cold War. Yet both are linked through baseball, one denying playing professionally to preserve his reputation, the other inventing a false career to embellish his.

Just like kids, grown men have used baseball as a way to pass the time. During the 1930s and '40s, traveling big bands formed their own ball teams and challenged the other bands they encountered during their travels. This tradition has continued since then, from bluegrass legend Bill Monroe's semipro All-Star ball club in the 1950s to Bruce Springsteen's pickup games while touring with the E Street Band.

I love highlighting these guys because it makes them more human. How many fathers and sons, with nothing in common due to differing generations, found a language they both understood in baseball? Think back to the times you've been alone somewhere and yet were able to have a conversation with a complete stranger because of a mutual interest in our national pastime. Baseball has that effect; it's the great equalizer—the people's game.

BULLDOGS

George Bush
FIRST BASEMAN

The freshman who tried out for the Yale baseball team in the spring of 1947 wasn't your typical college kid. The 22-year-old just left the U.S. Navy, where he had spent the last three years on an aircraft carrier flying torpedo bombers against the Japanese. On one of his 58 combat missions, his Avenger was hit by flak. Ignoring his burning engine, he completed his bombing run before bailing out. His two other crew members killed, he floated on a raft alone for hours before a dramatic rescue by an American submarine. He earned a Distinguished Flying Cross and three Air Medals and upon his discharge he married his long-time girlfriend, Barbara, and entered Yale University.

When baseball season began, George Herbert Walker Bush was the Yale Bulldogs' varsity first baseman. From the start he caused quite a stir, because he fielded left-handed—an extreme rarity in the baseball world. By all accounts George was a flashy fielder. Yale's coach, Ethan Allen, whose major league career in the 1920s and '30s enabled him to observe up close greats like Lou Gehrig and Bill Terry, said Bush was one of the best he'd ever seen and was quoted as calling the future president "a one-handed artist at first base." Teammate Dick Tettlebach, who went on to play with the Yankees and Senators, called Bush's play at first base "absolutely superb. A real fancy Dan."

His offensive skills were another matter. In the 1947 season he is credited with a .239 average with a homer and a couple of doubles. Since first base is traditionally a spot where you put your big, slow-fielding slugger, the fact that Coach Allen left the mediocre-hitting Bush

there as a starter speaks much to his defensive skills.

Yale's record of 19-8 earned them the honor of playing in the very first college World Series, held in Kalamazoo, Michigan. The Ivy League Yale Bulldogs faced the University of California at Berkeley Bears. The Californians won the best-of-three series, sparked by their ace pitcher, Jackie Jensen, later a star outfielder for the Boston Red Sox.

It was a disappointing end to Yale's season, but as millions of baseball fans have muttered over the years, there's always next year, and the Bulldogs didn't disappoint.

In 1948, first baseman George Bush improved his hitting by more than 20 points and his fielding continued to sparkle. During one game against North Carolina State Bush went three for five with a double and a triple, accompanied by his usual first-rate defensive play. As he was walking off the field after the game, a major league scout approached and inquired about George's interest in playing professional ball. This brush with the scout was as close to the big leagues as George would get as a player, but his 1948 season would be memorable in other ways.

The greatest baseball player of all time, Babe Ruth, made the trek to Yale in the spring of that year to donate a signed copy of his autobiography to the university's library. As the baseball team's captain, George Bush had the honor of accepting the gift from the baseball legend. Years later Bush recalled his meeting with the Babe, who was ravaged by the cancer that would shortly claim his life: "He was dying. He was hoarse and could hardly talk. He kind of croaked when they set up the mike by the pitcher's mound. It was tragic. He was hollow. His whole great shape was gaunt and hollowed out."

After another loss to Berkeley in the 1948 College World Series, George Bush graduated from Yale. Though he went on to other things, baseball always remained close to his heart. Each spring he tried to make it to an Opening Day game, each year alternating between leagues. When he took office as president of the United States in 1989, in the top drawer of his desk in the Oval Office was a well-oiled first baseman's mitt, just in case.

In the top drawer was a well-oiled first baseman's mitt, just in case

HOLLYWOOD

Frank Sinatra
SECOND BASEMAN

DECATUR

George Halas
SECOND BASEMAN

HOLLYWOOD SWOONERS

Growing up in New Jersey, Frank Sinatra was a Brooklyn Dodgers fan. The crooner was often photographed taking in games at Ebbets Field, and he continued to support his Dodgers when they moved to L.A. His friendship with manager Tommy Lasorda is legendary, and he counted Joe DiMaggio as one of his pals. Sinatra starred in the hit baseball musical *Take Me Out to the Ballgame* and one of the most emotional songs he ever recorded is about Ebbets Field, called "There Used to Be a Ballpark." But what's not commonly known is that Sinatra also played the game. During the 1940s he formed his own team called the Swooners, and besides Ol' Blue Eyes holding down second base, the roster boasted a rotating lineup of celebrities, including Anthony Quinn, Robert Wagner, and Nat King Cole.

DECATUR STALEYS

While playing baseball at the University of Illinois, George Halas was signed by the New York Yankees. Going directly to the majors, Halas played 12 games for New York before being sent to the minors. While playing for the St. Paul Saints he hit .271 until a hip injury ended his playing career. He then took a job with the A. E. Staley Company of Decatur, Illinois, where he coached and played on the company's baseball and football teams. Adapting the orange and blue colors of his alma mater, Halas quickly turned both teams into high-quality clubs. The football team soon became a powerhouse of the pre-NFL era, and in 1921 Halas moved the team to Chicago where they evolved into the Chicago Bears. In a career lasting almost five decades, "Papa Bear" revolutionized the way football was played.

PITTSBURGH PLYMOUTHS

Although Jack Kerouac's baseball career never went past college, the game played a big part in his adult life. Besides following the games closely on the radio, on television, and in newspapers, one of his favorite pastimes was a fantasy baseball game of his own in which he created entire leagues and rosters of fictitious players. Not only did he keep copious statistics, but he also wrote newspaper articles, created correspondence between fictitious owners, and capped off each season with a World Series. The teams were named after automobiles—for example, the Philadelphia Pontiacs, the New York Chevies, and the Pittsburgh Plymouths, of which Kerouac penciled himself in as the teams' manager. Only a select few of his literary companions knew of his fantasy game, but he continued to play it up until his death at age 49.

PITTSBURGH

Jack Kerouac
MANAGER

7TH CAVALRY

Frederick Benteen
BASE-BALLIST

Although his name is forever tied to the Battle of Little Big Horn, Frederick Benteen has close ties to the early history of baseball. As a teen in St. Louis he embraced the new game of base ball and played with the Cyclone Club, one of the best in the area. When the Civil War broke out, Benteen joined the Union army and served honorably, organizing baseball games during lulls in the fighting. A newspaper article mentions Benteen as organizing and playing in three ballgames in one day.

After the war Captain Benteen was posted to command H Company of the Seventh Cavalry Regiment. The Seventh was led by George Armstrong Custer, and Benteen, who was older than Custer, did not like him from the get-go. The two differed in leadership style—Custer was a romantic, daydreaming of glorious cavalry charges and dashing knights of old. He liked to think of himself as a gentleman who appreciated the finer things in life, and he meticulously fussed over his image. Benteen was more of a modern man, practical when it came to envisioning warfare, and he looked not to the past, but to the present for things to inspire his men: things such as baseball.

Benteen quickly formed "Benteen's Base Ball Club," which not only satisfied the captain's baseball fix but helped create a sense of camaraderie and pride that made H Company the Seventh's best unit. The Benteens played ball regardless of their surroundings, and their captain would invite other local nines to engage his team every chance he got. There was always a small town or a group of miners who enjoyed a good game of baseball, and Benteen

and his boys prided themselves on bringing the game to the most inhospitable places in the West.

By the time the Seventh Cavalry embarked on the Sioux Expedition in the spring of 1876, the Benteens were known as a first-class ball club, and a few of its members were deemed good enough to pursue professional careers when they left the service. The Benteens' captain and starting pitcher was First Sergeant Joseph McCurry. He was regarded as the best player on the team and was due to be discharged in 1877 whereupon he was expected to pursue playing the game professionally. Second baseman "Fatty" Williams was another Benteen who was considered good enough to turn pro, and it was reported that he had signed a contract to play for Pittsburgh after his enlistment.

However, the battle at Little Big Horn would end that hope for many.

After Custer's group was wiped out to a man, Benteen led his men in a 24-hour defensive fight in which he displayed heroic leadership by commanding from the front and making calm, rational decisions under heavy fire. At two separate times when it looked as if his position was about to be overrun, he and his troopers turned the tables on the attacking Indians and charged.

Benteen and his elite H Company displayed a high degree of esprit de corps and discipline during the hilltop battle, due in part to the pride and teamwork drilled into them through their baseball team.

Even so, after the battle baseball seems to have been forgotten by the remaining troopers. The team's captain and pitcher, Joseph McCurry, was wounded in the shoulder that day and never made it to the big leagues. Likewise, "Fatty" Williams was wounded, and though he lived until 1919, he never appeared in a ballgame with Pittsburgh.

Benteen continued to be a talented and brave combat officer and was decorated for his part in the campaign against the Nez Perce Indians. He retired from the army in 1888 due to rheumatism, which he claimed was not brought on by 25 years of hard combat, but by playing his beloved game of baseball.

He looked to the present for things to inspire his men: things such as baseball

JIM THORPE

A Minor Mistake

After excelling in every sport the Carlisle Indian Industrial School had to offer, Jim Thorpe jumped at the chance to make a few bucks playing low-level minor league baseball. In the summer of 1909 Thorpe was paid $15 per game to pitch and play outfield for the Rocky Mount Railroaders of the Class D Eastern Carolina League.

Known as "Big Chief," Thorpe pitched in 44 games for last-place Rocky Mount. Despite a 9-10 record, he had his moments, including two shutouts and once pitching both ends of a doubleheader, losing the first and winning the second. In 1910 he posted a 10-10 record for another bad Rocky Mount team, but five of his losses were by one run.

The town of Rocky Mount had no love for people of color, even if they played on the town's own baseball team. "Coloreds" (which apparently included Native Americans) were expected to use a "colored road" to go from one part of town to the other, avoiding the downtown district. When Thorpe and two teammates cut through downtown on their way to the ball field they were set upon by a local cop. The officer dared to shove Thorpe, and Thorpe knocked him out cold. The ballplayers spent the night in jail and Thorpe was traded to the Fayetteville Highlanders.

After Thorpe's success in the 1912 Olympics, it was his former manager at Fayetteville, Charlie Clancy, who spilled the story that led to his medals' being taken away. Not only did he reveal that Thorpe had been paid to play baseball, which was against Olympic rules, but he added a few seamy stories about the Olympian's taste for the nightlife. Thorpe came clean about playing ball, claiming he did not know it was against Olympic rules, but the damage was done and his two gold medals were taken away.

> *His old manager spilled the story that led to his medals' being taken away*

Thorpe went on to play both major league baseball and pro football, but died from the effects of alcoholism in 1953 at the age of 64. Seventy years later the Olympic Committee reversed its decision and returned his gold medals to his children.

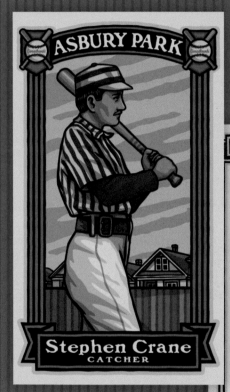

ASBURY PARK

Stephen Crane
CATCHER

ASBURY PARK

Had his dream come true, Stephen Crane would not be known as the author of one of America's greatest novels, *The Red Badge of Courage*, but as a baseball player. Crane grew up in the 1880s playing the game in Newark, New Jersey, and indulged in the sport so much that he flunked out of Lafayette College. He entered Syracuse University and garnered some interest from minor league teams. After leaving Syracuse he joined a newspaper in Asbury Park, New Jersey, and played for a local nine, but that seems to have been the end of his baseball career. After the publication of *The Red Badge of Courage*, Crane lived a short and troubled life, though he was able to recall, "But heaven was sunny blue and no rain fell on the diamond when I was playing baseball."

CAB CALLOWAY

"Dizzy" Gillespie
CATCHER

CAB CALLOWAYS

To pass time on the road between gigs, many traveling big bands of the 1930s and '40s formed baseball teams. The Woody Herman, Harry James, Louis Armstrong, and Fletcher Henderson bands all had uniformed teams, but one of the best was fielded by Cab Calloway. Fronted by the big-band leader himself, the team featured bassist Milt Hinton, saxophonist Chu Berry, and a young Dizzy Gillespie. The bebop pioneer was at the beginning of his career when he played both trumpet and baseball for the famous big-band leader. He would leave Calloway's orchestra in 1941 after stabbing "The Hi De Ho Man" with a penknife, but his love of baseball would continue throughout his life. Indeed, one of the first bebop hits recorded by Gillespie was the 1947 single entitled "Two Bass Hit," to this day a jazz standard.

NEW YORK GIANTS

As a kid in Northern California, Robert L. Ripley's life revolved around drawing and baseball. When he wasn't sketching he could be found pitching for a variety of semipro teams. He became a sportswriter and cartoonist and it was in that capacity that he accompanied the New York Giants to spring training in 1912. The young artist put his press credentials aside and impressed manager John McGraw with his curveball. The story goes that he was offered a minor league contract but shattered his arm before the season began. Ripley went on to start the famous "Ripley's Believe It or Not" newspaper series that made him world famous. He continued to be an avid sportsman, at one time the New York State handball champion, and he wrote the game's first official rule book for Spalding.

NEW YORK

Robert L. Ripley
PITCHER

DWIGHT EISENHOWER *AKA: Wilson, c.f.*

JUNCTION CITY

Dwight Eisenhower
OUTFIELDER

Fresh from winning the war in Europe, commander of all Allied forces General Dwight Eisenhower, a lifelong baseball fan, took in a Giants game at the Polo Grounds. While meeting the team in the locker room, the general told the awed players and beat reporters that at one time, he, too, was a ballplayer and had once played in the minor leagues in Kansas under the pseudonym "Wilson."

In 1911 Ike was 20 years old and living in Abilene, Kansas, very short of money and desperate to pursue a higher education. Box scores for the nearby Junction City Soldiers of the Class D Central Kansas League show that a "Wilson, c.f.," played for Junction City for just that one summer.

"Wilson" played in nine games for the Soldiers and batted .355 in 31 at-bats. As he committed no errors, his fielding percentage was a perfect 1.000. Because no first name, age, or any information, for that matter, exist for "Wilson," we will never know for sure if this was Eisenhower, but the evidence is pretty good that it was. Ike entered West Point the following year and went on to be the football team's star running back and linebacker, but curiously failed to make the baseball team. For the rest of his life Ike stated that not making the baseball team was his biggest disappointment in life.

The issue became a prickly subject after he was elected president, because to have accepted money for sports would have been a violation of the West Point Cadet Honor Code. He ordered his staff to ignore any inquiries into his baseball past, and the question remains unsolved to this day.

Despite all the stories that have been told over the years, Fidel Castro's "baseball career" lasted for exactly two innings.

On July 24, 1959, before a game between the Havana Sugar Kings, a Cincinnati Reds farm team, and the Rochester Red Wings, Fidel Castro took the mound for the aptly named Los Barbudos team (The Bearded Ones). Castro's team played a two-inning exhibition against a squad from the military police. The police pitcher, Camilo Cienfuegos, wisely joined the Barbudos team, saying, "I never oppose Fidel in anything, including baseball." Some 25,000 screaming fans watched El Jefe pitch both innings, striking out two and grounding out to shortstop in his only at-bat.

This was the extent of Castro's "baseball career," which Cuban propaganda has greatly exaggerated, turning him into one of history's greatest "what if" questions. The most common myth is that the Washington Senators were scouting the young Fidel when he was a hotshot right-handed pitcher for the University of Havana back in the 1940s. During that time the Senators gave contracts to anyone who showed even an ounce of talent, and not only were their scouts uninterested in the future dictator, but he couldn't even make the university's JV baseball team. While it's fun to think about how the fate of an entire country could have hinged on how fast a single college student could throw a little leather ball, it just isn't true. In fact, soon after coming to power, Castro, the "baseball fan," destroyed professional baseball in Cuba, ending a proud and talented league that dated back to before the turn of the century.

BARBUDOS

Fidel Castro
PITCHER

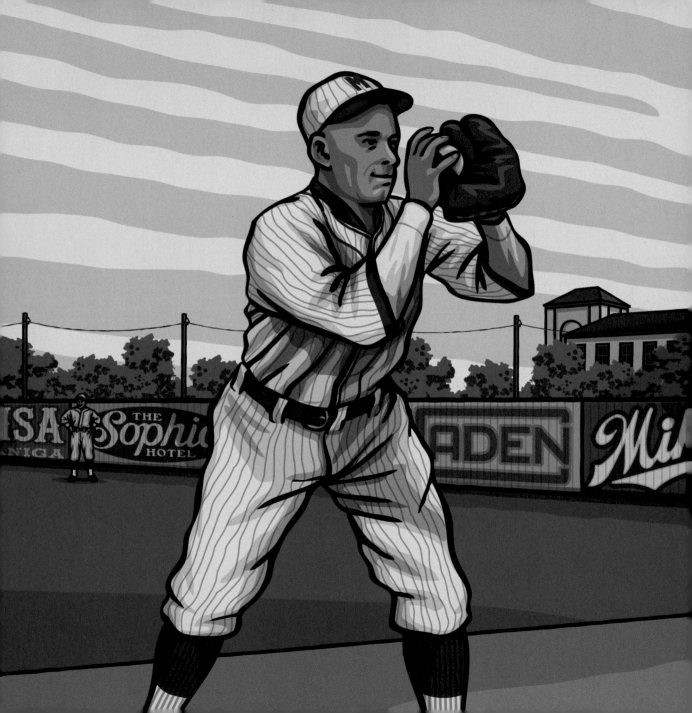

JOHN DILLINGER
Turning Double Plays and Pulling Heists

Like most red-blooded American boys of the time, young John Dillinger was an avid fan of the national pastime. He followed the Chicago Cubs and in between bullying smaller kids, petty thievery, and hard partying, Dillinger played baseball. His quick speed on his local Indiana sandlots earned him the nickname "The Jackrabbit."

After too many run-ins with the local police, Dillinger enlisted in the U.S. Navy in 1922 but deserted after a few months. He slinked home to his father's house in Martinsville, Indiana, and married a 16-year-old girl named Beryl.

By the summer of 1924 Dillinger had failed at every job he had, and his marriage to teenaged Beryl began falling apart. The only success he seemed to have was on the baseball diamond. Several local clubs would pay him to play, but his steady team was his hometown Martinsville Athletics. He was their star shortstop, and his team-high batting average earned him a $25 award from the local Old Hickory Furniture

John Dillinger's team-high batting average earned him a $25 award

Company. Behind the hitting of Johnny Dillinger, the Athletics took the 1924 league championship.

After the season ended, the former shortstop found himself in dire straits after the baseball money dried up. Instead of utilizing the connections he made to pursue honest employment, Dillinger chose to call on a fellow he met on the ball field to launch himself into professional crime.

League umpire and lowlife criminal Edgar Singleton set up John Dillinger's first armed robbery. Hopefully Singleton's arbiter skills were better than his heist planning, because their robbery of an elderly grocery store owner was so badly botched it was almost comical. Dillinger attacked the store's owner with a metal bolt wrapped in cloth, but the old man fought back. Dillinger's gun went off, hitting the old man in the foot. Singleton, the getaway driver, lost his nerve and sped off, leaving Dillinger to hoof it home on his own. To no one's surprise, both men were quickly apprehended.

Dillinger was sentenced to 10 to 20 years in prison, of which he served nine. But again, baseball played a pivotal role in his life.

While incarcerated he played on the prison baseball team, followed his Cubbies through the newspaper, and took part in baseball betting pools. However, the constant denial of his parole made him bitter and he turned his efforts to learning all he could from his fellow prisoners.

He emerged from prison in 1933 a well-educated criminal and immediately embarked on a bank-robbing tear that both shocked and fascinated the nation. Constantly on the run, he still took the time to follow the Cubs and attended more than a few ballgames at Wrigley Field.

Before one game in August 1933 the bank robber was pointed out to outfielder Babe Herman as he sat in the left-field box seats. Cubs catcher Gabby Hartnett told how the Chicago police knew about Dillinger's presence at Wrigley yet did nothing to turn him in to the Feds.

The following season he continued to attend Cubs games. In a story that made newspapers nationwide, he was in the upper deck at Wrigley the afternoon of June 26, 1934, as the Cubs defeated Brooklyn 5–2. A Robert Volk happened to have met Dillinger the year before when he witnessed him boost a car during a prison getaway. He instantly recognized the archcriminal, and much to his chagrin, Dillinger recognized him, too. He got up and sat down close to the terrified man. After sitting in awkward silence for a while, Volk mustered all his strength, turned, and said, "This is getting to be a habit," to which the country's most wanted man replied, "It certainly is." Shaking his hand, Dillinger introduced himself as "Jimmy Lawrence" and departed during the seventh-inning stretch. Apparently undaunted by the close call, he returned to Wrigley again a few days later and watched the Pirates get pounded by his Cubbies 12–3.

Constantly on the run, Dillinger still took the time to follow the Cubs

After the victory over Pittsburgh, the Cubs left on an extended road trip and were still out of town when Dillinger decided to pass the time by catching a movie at the Biograph Theater. The cops also famously caught up to Dillinger there.

Curiously, if he was a White Sox fan he might have lived a little longer—they were in town that afternoon playing a doubleheader against the Yankees . . .

CHAPTER 6
THE RACE GAME

Baseball has been both progressive and traditional, often at the same time. This is particularly true when it comes to race.

Casual baseball fans know of Jackie Robinson's role in integrating the game and of the great black ballplayers who were kept out of the majors because of their skin color. While many of the players I feature in this chapter starred in the Negro Leagues, we have to remember that African Americans were not the only race forced to play the national pastime on fields other than those found in the major leagues.

You might be surprised to find out that in the spring of 1946 as Jackie Robinson was encountering racist Jim Crow laws while training with his white teammates, a white pitcher was facing the same exact racial intolerance as he tried to take the field with his black teammates.

The anti-Semitism Hank Greenberg faced as late as the 1940s is well known, yet Lipman Pike, the first Jew to play professional baseball, caused more public outrage by accepting payment to play ball than for his religion.

Native Americans were reluctantly allowed to play professional baseball alongside whites, though virtually every one who did was saddled with the nickname of "Chief." The skin color and racial heritage of Latinos were closely scrutinized in order to be deemed acceptable to organized baseball in the United States while Americans of Asian descent were banned altogether.

The United States isn't alone when it comes to racial intolerance on the ball field. Japan has had its own issues when it came to other races breaking into its leagues. Victor Starffin, one of the greatest pitchers to ever take the mound in Japan, was hounded out of the league because he was of Russian heritage and therefore considered an outsider and probable spy.

But, as we have seen with Jackie Robinson, after initial hostility and skepticism, the game of baseball not only becomes accepting of change, it is often the force that steers the rest of the population's beliefs as well.

X-GIANTS

John P. Hill
OUTFIELDER

In 1911 Pete Hill hit safely in 115 of 116 games and won the Cuban batting title

CUBAN X-GIANTS

Pete Hill was the complete ball-player, an excellent fielder and hitter who rarely struck out. He was compared to Ty Cobb for his natural ability and fiery play. Hill played for some of the greatest early black-ball teams, including the Cuban X-Giants, Philadelphia Giants, and Leland Giants. With the Chicago American Giants in 1911 Pete hit safely in 115 of 116 games, and he won the Cuban batting title that same year with a .365 batting average. Hill was named captain of the American Giants, and Rube Foster considered him his "field general" and a second manager. He left Chicago in 1919 and took over as manager of the Detroit Stars, where he was credited with a .391 average in 1921. He finished up his career in 1925 as the player-manager of the powerful Baltimore Black Sox. Pete Hill died in Buffalo in 1953.

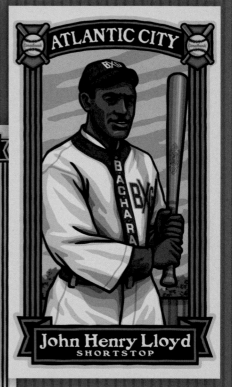

ATLANTIC CITY

John Henry Lloyd
SHORTSTOP

LEAGUES

In 1910 Joe Rogan joined the U.S. Army, where his catching, pitching, and powerful bat made the all-black 25th Infantry team the best in the service. His fastball earned him the nickname "Bullet," and in 1918 Sergeant Rogan recorded an incredible 52 wins in one season. While stationed in Hawaii he shut out the Portland Beavers of the Pacific Coast League on three hits, struck out 13, and hit a double. In 1920 Rogan and five of his army teammates formed the nucleus of the Kansas City Monarchs, one of the most powerful Negro League teams. As dominant on the mound as he was at the plate, Rogan was probably blackball's most versatile player. He was named manager of the Monarchs in 1926, and when he retired in 1936 his .338 lifetime batting average was fourth best in Negro League history.

ATLANTIC CITY BACHARACHS

No one can sum up John Henry Lloyd better than the man he was so often compared with, Hall of Fame shortstop Honus Wagner: "They called John Henry Lloyd 'The Black Wagner' and I was anxious to see him play. Well, one day I had an opportunity to go see him play, and after I saw him I felt honored they would name such a great player after me." Connie Mack was quoted as saying, "Put Lloyd and Wagner in the same bag and whichever one you pulled out, you wouldn't go wrong." Babe Ruth called Lloyd the greatest ballplayer of all time. From the start of his career in 1906 Lloyd was blackball's most sought-after attraction, and he switched teams often, stating, "Wherever the money was, that's where I was." Over a 25-year career he consistently hit around .350 and may have been the greatest player of all time.

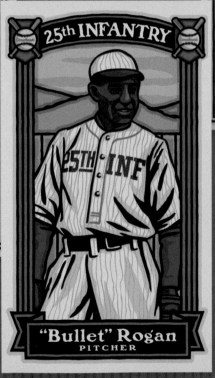

25th INFANTRY

"Bullet" Rogan
PITCHER

In 1918 Sergeant Rogan recorded an incredible 52 wins in one season

{ 151 }

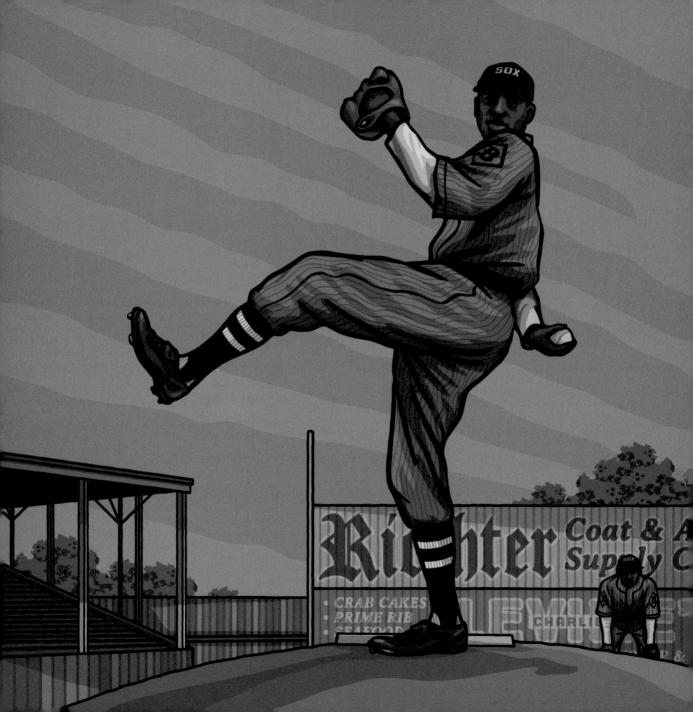

LAYMON YOKELY

The Mysterious Shadow

In 1926 ministry student Laymon Yokely was lured away to the secular world of the Negro Leagues. Yokely was a big, strapping fella, 200 pounds stretched out over a six-foot-two-inch frame. His unique windup earned him the nickname "The Mysterious Shadow." Instead of keeping his pitching hand with the ball hidden in his glove, Yokely swung the arm behind his back and then whipped it around to release the ball. Observers claimed the extra distance he added by whipping his arm all the way around from behind his back added something to the ball. His contemporaries all remarked on his velocity and the fact that his hands were so powerful that he could loosen the cover on the ball.

Yokely didn't let anything rattle him; didn't argue with umpires, didn't care if he was facing a .180 or a .350 hitter, and never let a homer break his concentration. In fact, he'd often doze off on the bench between innings and some say he probably suffered from a form of narcolepsy.

In 1929 he tossed a no-hitter and won both ends of a doubleheader twice

Yokely was particularly effective against the white major league teams that came to Baltimore every fall. His perfect 5-0 record against the likes of Jimmie Foxx, Lefty Grove, Hack Wilson, and Eddie Rommel prove his pitching was, to say the least, big league quality.

The 1929 season was Yokely's finest, as he went 19-11, threw a no-hitter, and won both ends of a doubleheader twice as the Black Sox won the pennant. The next season the Sox picked up Satchel Paige, yet it was Yokely, not the future Hall of Famer, who was the team's ace. When Baltimore took the field for the first game ever between two black teams at Yankee Stadium, it was Yokely who was handed the ball.

It was Yokely's popularity that caused his downfall. He was pitched constantly by the Black Sox to draw large crowds, and his arm was all used up by the middle of 1930. He retired to form his own ball club, Yokely's All-Stars, the team Hall of Famer Leon Day began his career with.

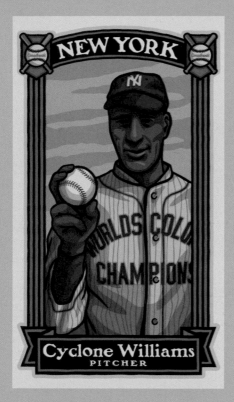

NEW YORK

WORLDS COLO

CHAMPIONS

Cyclone Williams
PITCHER

While Satchel Paige is usually referenced as the finest pitcher blackball produced, fans and sportswriters alike who witnessed both Paige and the man known as Cyclone Joe Williams pick the latter as the best. The two have much in common. Both possessed blinding speed coupled with pinpoint control and excelled when pitching against white big leaguers. Both men had careers spanning in excess of 30 years around which Paul Bunyan–esque legends have been spun. Looking at Cyclone Williams, the astonishing part is that much of it is true.

The Cyclone blew out of Texas in the early years of the 20th century, first by word of mouth spread by traveling blackball teams that encountered him. In 1910 he moved north to Chicago, where he received real news coverage pitching on quality ball clubs. From the start he was a combination of mystery and awe. He was a giant of a man, about six-four and just under 200 pounds, but lean, as you'd picture a Texas cowboy. His half-black, half–Comanche Indian heritage gave him a strikingly exotic appearance. He was quiet, didn't talk much, but exuded a confidence that his fastball backed up.

Williams threw the ball with a phenomenal speed that many guess to have been in the 100 mph range. The sheer velocity at which he unleashed a baseball was aided by the way it rolled off his inhumanly long fingers, giving the sphere an added break as it approached the plate. In the days before radar guns, the only way to gauge a pitcher's velocity was by comparison to other hurlers. Veterans say the Cyclone was often put in the same category

as contemporaries Walter Johnson and Joe Wood, white baseball's hardest and fastest throwers. As with Walter Johnson and Satchel Paige, opponents invariably commented on his pinpoint accuracy. When a man batted against the Cyclone he didn't have to be worried about getting plugged by a pitch—he just couldn't hit it.

Williams was known for his strikeouts—the Cyclone Joe legend passed down in oral histories has him repeatedly pitching games of 20 or more punch-outs. Granted, many of the feats performed by Williams, Satchel Paige, and Josh Gibson that have become part of the blackball canon were against semipro or amateur clubs. In the Cyclone's case, however, he went head-to-head against actual major league teams in 11 documented games and won an astonishing six times (plus one 1–1 tie). We're talking pitching matchups that featured Williams against the mighty New York Giants and Philadelphia Phillies when they were pennant winners, and the four games he did lose were by two runs or fewer. Against All-Star teams made up of a mixture of white major and minor leaguers, the Cyclone won 15 out of 19 games. The big Texan hung losses on Walter Johnson, Chief Bender, Waite Hoyt, and Rube Marquard, all Hall of Famers. One of the most tantalizing stories that make up the Cyclone Williams legend is a 1917 game in which he no-hit the pennant-winning New York Giants for 10 innings before losing 1–0 on an error. Though many players have claimed to have taken part and fans recalled the game, no box score or newspaper account has ever surfaced. Something tangible from that lost afternoon would be an important find, but at least we have a record of those games. You can't measure Williams's talent in any better way than that since he was denied a career in the majors.

All he ever wanted was to pitch for his favorite team, the Brooklyn Dodgers

After he walked off the mound for the last time in 1932, the Cyclone strapped on an apron and became a popular New York City bartender. Before his death in 1951, a whole new generation of Negro Leaguers had benefited from the Cyclone's career-changing advice dispensed over a few beers. The following year, 1933, the *Pittsburgh Courier* asked ballplayers and sportswriters who was the best Negro Leagues pitcher: The Cyclone beat Satchel, 20–19.

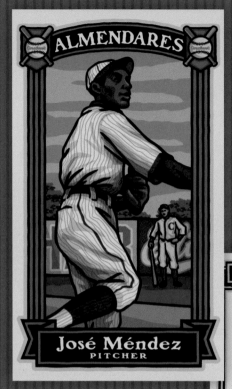

ALMENDARES

José Méndez
PITCHER

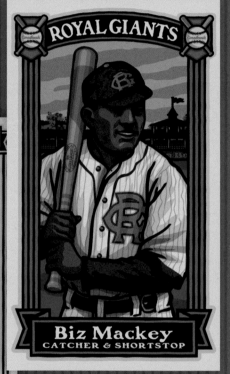

ROYAL GIANTS

Biz Mackey
CATCHER & SHORTSTOP

Among the big leaguers he bested were Mathewson, Plank, and Bender

ALMENDARES BLUES

As a rookie on the Almendares Blues, José Mendéz held the Cincinnati Reds scoreless for 25 consecutive innings over the course of three games. The five-foot-nine-inch fire-baller became known as "The Black Diamond," and his Cuban fame preceded him to the United States, where he pitched splendidly for more than 20 years, chiefly with the Kansas City Monarchs. New York Giants manager John McGraw said he would be worth $30,000, if only he were white. Méndez had long arms and long fingers, which enabled him to give his curve and fastball a better spin. Among the big leaguers he bested were Christy Mathewson, Eddie Plank, and Chief Bender. Toward the end of his career he was made manager of Kansas City and led the Monarchs to Negro National League pennants in 1924, 1925, and 1926 as well as the Colored World Championship in 1924.

LEAGUES

Oscar Charleston combined an intense desire to win with the iron discipline he learned in the army to make himself into one of blackball's greatest stars. He averaged about .350 over 25 seasons of playing ball year-round. In his prime Charleston was considered one of the game's best defensive outfielders, and he often led the league in home runs as well as stolen bases. The burly Charleston's temper was legendary—he once ripped the hood off the leader of a group of Klansmen who dared to threaten his teammates. In 1932 Charleston was named manager of the Pittsburgh Crawfords, the greatest collection of Negro League talent ever assembled. He was elected to the Hall of Fame in 1976 and is considered one of the greatest ballplayers of all time, regardless of race or color.

ROYAL GIANTS

After breaking in with the Indianapolis ABCs, Biz Mackey joined the powerhouse Hilldale club in 1923. Though a large man, Mackey played both catcher and shortstop as Hilldale won the Eastern Colored League pennant in 1923, 1924, and 1925. The big, gregarious Texan evolved into blackball's greatest catcher, winning batting crowns in 1923 and 1931. His propensity to give batters "the business" as they tried to concentrate led to his nickname, "Biz." In the winter of 1927 Mackey led the Royal Giants, a team of Negro League stars, to Japan, where he is still remembered for his kindness and generosity in teaching the American style of play to the Japanese. Mackey is most remembered as Roy Campanella's mentor when the future Hall of Famer was a teenaged catcher with the Baltimore Elite Giants.

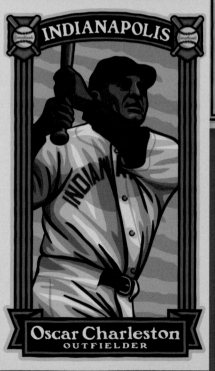

INDIANAPOLIS

Oscar Charleston
OUTFIELDER

Charleston often led the league in home runs as well as stolen bases

LEO NAJO

The Mexican Rabbit

His real name was Leonardo Alanís but he was so fast his fans called him "*conejo*," Spanish for "rabbit." With his name Americanized to "Najo," the slugger was on the fast track to becoming the first Mexican-born player in the major leagues. Though slight of build, Najo had power and twice in his career hit for the cycle, smacking a single, a double, a triple, and a home run in the same game. His speed made him one of the best outfielders in any league, once recording an amazing 12 putouts in a single game. With the Okmulgee Drillers in 1925, he hit .356 and led the Western Association with 34 homers and 195 runs scored. This brought Najo national attention and a contract from the Chicago White Sox. Though he played well enough in spring training, the White Sox sent him to the San Antonio Bears with the intention of calling him up later in the summer.

> *Only a bad break kept Najo from becoming the first Mexican big leaguer*

This is where the conspiracy nuts take over. What happened was that Najo was batting over .300 when an outfield collision with teammate Ping Bodie ended his season. The much larger Bodie broke Najo's leg between the knee and ankle, a serious injury that effectively ended his career. The tinfoil hat guys claim that Ping Bodie was instructed by the unnamed cabal that ruled baseball to run Najo down and intentionally ruin his chance at big league fame.

Fact of the matter is, Bodie had just joined the team and was unfamiliar with the outfield layout. On top of that, Bodie was about the size of an ox, and it is not surprising that once Bodie started running after a ball he couldn't stop on a dime and avoid a collision. To think that the Chicago White Sox, who were mired in the second division after losing their stars to the Black Sox scandal, would care so much about keeping a Latino from making the majors that they would destroy the most promising thing in their farm system is just insane. But it was a tragic and unintentional accident that probably did prevent Najo from being the first Mexican-born major leaguer.

DAI NIPPON

Victor Starffin
PITCHER

Victor Constantinovich Starffin is one of the most unusual players in all of baseball history. The son of czarist Russian refugees, the 18-year-old was chosen to represent Japan when the Major League All-Stars toured in 1934. Starffin was singled out as one of the Dai Nippon team's standout players. Renamed the Tokyo Giants, the team toured North America in 1935 and 1936. As Starffin was the lone Caucasian on the team, North Americans assumed he spoke English, leading to a few funny and confusing situations.

When Japan started its first professional league in 1937, Starffin became the Tokyo Giants' ace, winning an average of 30 games each season from 1937 to 1942. In 1939 he won a staggering 42 games, and in 1940 he won 38. He simply dominated the league, especially after the military draft began taking the better players from the league.

But times were turning against him. Because he was a foreigner he was placed under surveillance as a spy. To fit in to his adopted homeland he changed his name to Hiroshi Suda, but it wasn't enough. In 1944 the best pitcher in Japan was sent to a detention camp, where he contracted pleurisy. Weak and depressed after his wife left him, Starffin turned to drinking. After the war he turned down an offer from the Tokyo Giants and instead signed with the new Pacific team. He pitched until 1955 but never achieved the same dominance as before the war. Starffin compiled 303 wins, the first in Japan to do so, and died in a car accident in 1957 while driving drunk, a sad end to a truly unique player from baseball's past.

EDDIE KLEP *Robinson in Reverse*

At the same time Jackie Robinson was integrating white baseball in 1946, Eddie Klep was integrating black baseball.

Klep was a semipro pitcher from Erie, Pennsylvania, and besides being a pretty good left-hander, he was also a low-level burglar and good-time raconteur. In between short stretches in the Erie jail he put together a credible record hurling for various semipro clubs. Klep was somewhat rare for the time as he often played with all-black teams. When Klep pitched well against the Cleveland Buckeyes in an exhibition game, team owner Ernie Wright saw a unique opportunity and signed the white hurler.

The Buckeyes were the defending Negro League champs, and Klep's signing, while not as noteworthy as Robinson's, was lauded in the press as a step forward in race relations. However, when the team traveled south for spring training in 1946, Klep and the Buckeyes ran into the same Jim Crow laws that Robinson and the Dodgers were facing. In Birmingham Klep not only was forced off the field by police but wasn't allowed to even sit in the dugout. He had to watch the game from the "whites only" section. And so it went in many of the towns the Buckeyes played in that spring.

When the season began Klep pitched in two games, both in relief. His one win and one loss weren't deemed impressive, though, and the Buckeyes released him. Eddie Klep went back to the sandlots and burglaries, bouncing in and out of the joint before passing away in 1981.

DOBIE MOORE

Not All Cats Land on Their Feet

May 18, 1926. The Kansas City Monarchs won that afternoon, beating their archrivals, the Chicago American Giants, and their star shortstop, Dobie Moore, was looking to celebrate.

Known as "The Black Cat," he honed his baseball skills in the army, where he met Bullet Joe Rogan, Oscar Johnson, and Lemuel Hawkins. Upon discharge the four joined the Monarchs. The husky Moore quickly established himself as the premier shortstop in blackball, averaging .359 over seven seasons, and his .453 led the Negro National League in 1924. In 1923–24 he was with the Santa Clara Leopardos, considered the greatest Cuban team of all time, where he batted .386 and topped the winter circuit in hits and triples. On that May 18, he was batting .415, in the prime of his career, and the night was young.

Conveniently, his girlfriend, Elsie Brown, was the owner of a brothel, and naturally the Black Cat headed over there to cap off the evening. In retrospect it's not too hard

> *That night in May of 1926 Moore was batting .415, in the prime of his career*

to see how a cocky ballplayer, souped up on illegal liquor, could get into an argument with his brothel-owning girlfriend, and that's exactly what went down that night.

They engaged in a heated argument in her bedroom, and Elsie Brown told police that the big shortstop slugged her in the face three times before she managed to get hold of her pistol and shoot Moore in the leg. Fearing a second, fatal shot, Moore staggered onto the balcony and leaped into the dark alley below.

Unfortunately, not all cats land on their feet.

The impact of the two-story jump shattered Moore's already injured leg. His teammates carried him to a doctor, where it was discovered the ballplayer had no fewer than six compound fractures of both the tibia and fibula and that the bullet could not be successfully extracted. In other words, the Black Cat's career was through. His whereabouts are unconfirmed after 1926, but he is reported to have died in Detroit around 1948.

SEATTLE

Vernon Ayau
SHORTSTOP

In the decade leading up to World War I, a team of Chinese Americans called the Hawaiian Travelers toured the United States. Although the high level of play the Travelers exhibited brought considerable praise in the newspapers, no team in organized baseball was willing to give an Asian ballplayer a chance. This racist attitude is surprising, as the West Coast in particular had a high concentration of Chinese and Japanese baseball fans that had so far remained untapped.

It wasn't until 1917 that Vernon Ayau, the Travelers' shortstop, was signed by the Seattle Giants of the Northwest League. Ayau was a Hawaiian-born Chinese American whose work at shortstop had impressed even New York Giants manager John McGraw. Immediately after Seattle announced the signing of Ayau, a petition was circulated among the Northwest League players expressing their unwillingness to play with a Chinese. Despite death threats and the possibility of a players' strike, Ayau made the team, and when he took the field on Opening Day, 1917, he became the first player of Asian descent to enter organized baseball.

Though Ayau's work at shortstop was considered top-notch, his batting average barely topped the .200 mark and Seattle released him in late May. Tacoma quickly snapped him up, and he was beginning to show potential at the plate when the league collapsed midseason. Ayau served in France in World War I and then settled in New Jersey, where he played semi-pro baseball well into the 1920s.

Among the best-known traveling teams that brought quality baseball to small towns across the United States at the turn of the century was the Nebraska Indians. The Indians had a steady stream of talent recruited from the Omaha and Winnebago reservations and vocational schools in the area. Besides great baseball, the team set up an "Indian village" at the ballparks they visited, which not only entertained the fans but served as cheap lodgings for the players and circumvented racial laws, which often prevented Native Americans from sleeping in all-white hotels.

Haskell Indian Nations University graduate George Howard Johnson joined the Nebraska Indians in 1907. In his second year with the Indians he pitched 38 games, winning 32 of them. Besides grueling traveling conditions, the well-read Johnson had to endure endless racial epithets while playing with the Indians. He eventually moved up to the minor leagues and in 1913 was signed by the Cincinnati Reds. Inevitably nicknamed "Chief," as was the custom of the day, Johnson had trouble with his manager, who did not like Native Americans. The following year he jumped to Kansas City of the Federal League. While pitching in the first-ever game at Weeghman Park (now called Wrigley Field), Johnson was removed in the second inning because of a court injunction brought by the Reds, who still owned his contract. After 1915 he pitched in the Pacific Coast League and tossed a no-hitter for the Vernon Tigers in 1917. Tragically, Johnson was murdered in Des Moines in 1922 in a dispute over alcohol.

LEON DAY

Blackball's Most Complete Ballplayer

Back in 1991 I was interviewed for my work on Oriole Park at Camden Yards by TV host Dr. Bob Hieronimus. Dr. Bob and I shared a deep interest in the Negro Leagues, and he graciously introduced me to an old ballplayer named Leon Day. I spent quite a few hours in his baseball room, where he would tell me about all the great players he once shared the field with, yet he never revealed any details of his own career. It was only after some newspaper research that I realized this modest and kindly old man I called a friend was in fact blackball's most complete ballplayer!

Leon Day got his start in his hometown of Baltimore as one of Laymon Yokely's protégés. He had a screaming fastball and a sharp curve delivered from the stretch, which made him the ace of the Newark Eagles by the age of 19. In 1937 he won 13 league games without a defeat, and by the time he entered the army in 1943 his Negro National League record stood at a staggering 45-8.

The Newark Eagles boasted five future Hall of Famers, yet Leon Day was considered the team's best clutch hitter. On the days he wasn't on the mound he could be found in the outfield to take advantage of his arm or at any of the infield positions. He was known as a fast base runner and teammates all said he had the best singing voice in the league; Leon Day was as complete a ballplayer as you'd want.

In 1943 his Negro National League record stood at a staggering 45-8

While in the army he pitched his team to the 1945 European Championship and returned home in time to pitch a no-hitter on the first day of the 1946 season. Day went 13-4 and led Newark to the Negro World Championship. He played minor league ball before retiring in 1955. The seven-time All-Star holds the single-game strikeout record for the Negro National League, Puerto Rican Winter League, and the East-West All-Star Game.

My old friend Leon passed away on March 14, 1995, just days after being informed he'd been elected to the Baseball Hall of Fame.

PITTSBURGH

"Cool Papa" Bell
OUTFIELDER

*Olympic great
Jesse Owens refused
to race against
Cool Papa Bell*

PITTSBURGH CRAWFORDS

Cool Papa Bell earned his nickname as a teenaged pitcher in St. Louis, where his unflappable demeanor on the mound caused his teammates to say he was "one cool papa!" Bell soon switched to center field, where he could fully use his blinding speed to make plays that average outfielders could not. He was blackball's greatest base stealer, legendary for going from first to home on an infield bunt. During his prime, Olympic great Jesse Owens refused to race against Bell, and at one point he was said to have circled the bases in 12 seconds, though this has never been thoroughly proven. At the plate he consistently hit over .300 and played at the Negro Leagues' highest level well into his 40s. Bell's clean living enabled him to remain a star for more than 30 seasons, and his kindness helped many young ballplayers.

NEW YORK

Charlie Smith
OUTFIELDER

LEAGUES

Called "Boojum" because of the sound his line drives would make hitting the outfield wall, Jud Wilson was a fiery player, as feared for his temper as he was for his bat. Wilson played on some great clubs, but it was with the Baltimore Black Sox teams of the 1920s that his reputation was made. The Black Sox were a talented and rough outfit that would boast four future Hall of Famers. Wilson played year-round for more than 25 years, and consistently hit in the high .300s. He played third base crudely, yet effectively, getting in front of and knocking down anything that came his way. He often played through injuries, and his competitive drive fueled any team he was on. Off the field Jud was surprisingly gentle and affable, the exact opposite of the impression he liked to give when he had the uniform on.

NEW YORK LINCOLN GIANTS

Like a meteor, Charlie Smith burned hot and bright for a tragically short time. Known as "Chino" in Cuba and "Smitty" in the States, he hit Negro League pitching at a .400 clip from 1927 to 1931. He was also the man the fans loved to hate, as he would often rile up crowds and trash-talk pitchers. The more animosity he faced, the better Smith seemed to hit. He played a few winters in Cuba, averaging .340, and was continually among the league's top five hitters. In 11 games in which he faced white major league pitchers, Smith batted .405 in 37 at-bats. During the 1931 season Smith began to feel ill, and by January of 1932 he was dead of stomach and pancreatic cancer. While his career was short, he left behind many blackball veterans who swear he was one of the best three hitters in Negro League history.

BALTIMORE

"Jud" Wilson
THIRD BASEMAN

Wilson was a fiery player, as feared for his temper as he was for his bat

JIMMY CLAXTON *Not Quite First*

OAKLAND

Jimmy Claxton
PITCHER

The Canadian-born Jimmy Claxton was a pitcher for semipro teams up and down the West Coast. In 1916 he was starring for an Oakland team when he was presented to the pitching-poor Oakland Oaks.

With the Oaks assured he was a full-blooded Native American and not a Negro, Claxton made the team and on May 29, 1916, he took the mound in the first game of a doubleheader against Los Angeles. Wild and nervous, he was knocked out of the box in the third inning. He came back in the ninth inning of the second game, retiring the side, but his overall performance was weak. His totals for the day were 2⅓ innings pitched, four hits, three runs, four walks, and no strikeouts. Shortly afterward Claxton was released by the Oaks, the reason given being his poor showing, but the prevalent belief was that it was discovered that Jimmy was actually of African descent. Some say it was all a publicity stunt. Claxton was fairly well known in West Coast baseball circles as a black man and the Oaks were in desperate need of boosting attendance. No one will ever really know what the actual circumstances were.

What is unique about his short stint in white baseball is that Jimmy Claxton was the first black player to appear on an American baseball card! In the time he was with the Oaks, a photographer from the Zee-Nut candy company snapped a picture of Claxton and included it in its popular set of Pacific Coast League players. The card was withdrawn after his release, and the few examples that survived go for extravagant prices at auction.

Baltimore Orioles manager John McGraw was taking a break from whipping his boys into fighting trim in Hot Springs, Arkansas, in the spring of 1901, getting them ready for the American League's inaugural season. As he walked back to the Eastland Hotel, where his team was staying, he passed a baseball diamond adjacent to the hotel. McGraw paused to watch a team of ballplayers made up of the hotel's waiters and bellhops. As his discerning eyes scanned the field evaluating each player, his attention focused on the second baseman. This fellow fielded flawlessly, his throws were rapid and accurate, and at bat he was by far the best on the field. This man was a professional.

The only problem was he was black.

The second baseman's name was Charlie Grant and he was already a blackball star with the Columbia Giants when McGraw spotted him. McGraw and Grant's teammate Dave Wyatt came up with the idea to disguise Grant as a Native American to get him

BALTIMORE

Chief Tokohama
SECOND BASEMAN

onto the major league Baltimore Orioles. Called "Tokohama," Grant finished spring training with the team, but his cover was blown because of his popularity in the black community, who came out in droves to see him. Despite his being discovered, McGraw lobbied the American League to keep Grant on his team, but when the Orioles played in Chicago, one of Grant's old teammates and a black fan both tipped the *Chicago Tribune* that he was not Native American. Grant returned to the Negro Leagues and went on to play with some of the best early blackball teams. He was killed in a random traffic accident in 1932.

MOSE SOLOMON

The Rabbi of Swat

By the early 1920s the owners of all three of New York's major league ball clubs recognized the value in finding a Jewish star to play for their team. Jews made up a large part of New York's immigrant population, and they embraced the national pastime with an unabashed passion. Their loyalty was spread evenly among the Yankees, Giants, and Dodgers, and each owner salivated at the thought of discovering a "Babe Ruth" of the Hebrew persuasion, which would undoubtedly attract the bulk of the city's Jewish fans.

Despite winning the World Series in 1921 and 1922, manager John McGraw watched helplessly as his Giants—once undisputed as New York's favorite team—quickly lost fans to Babe Ruth's Yankees. If only he could find a ballplayer who not only packed the power and excitement of a Babe Ruth but was Jewish as well, the Giants would undoubtedly regain their place as New York's team.

So imagine the excitement the crusty

> **The owners of all three New York teams raced to find a Jewish ballplayer**

McGraw must have felt when news spread east of a Jew named Solomon playing in faraway Kansas, hitting an unheard-of 49 home runs in the summer of 1923. McGraw nearly tripped over himself dispatching his scouts to Kansas under orders to bring back this miracle man at all costs.

As the train carrying Mose Solomon from Kansas neared New York City, the expectation of a million fans had reached a crescendo. The press dubbed him "The Rabbi of Swat."

Mose Solomon was born in the epicenter of turn-of-the-century Jewish immigration, Hester Street on New York's Lower East Side. His parents moved the family west to Ohio when he was a kid. In Columbus Mose's father eked out a destitute existence as a junk dealer. Mose and his brothers grew up big and athletic, his older brother Harry becoming the boxing champ of Ohio. Mose excelled in both baseball and football and picked up good money playing for semipro teams.

For a time Mose was a ringer for Jim

Thorpe's Carlisle Indian School football team, until a sportswriter unmasked him as being Caucasian. Ohio State University offered him a full scholarship to play football, but Mose was forced to turn it down because his family desperately needed the money he made to survive.

Against his father's wishes, Mose decided to pursue a career in professional baseball. While the elder Solomon didn't mind one son making a living at boxing, for some reason he considered baseball a shameful profession.

At any rate, Mose started his professional baseball career in 1921 with the Vancouver Beavers. In the rough-and-tumble world of the low minors he made a name for himself as a man who would not put up with any anti-Semitism. Unlike many other Jews at the time, including his brother Henry, the champion boxer who called himself "Henry Sully," Mose refused to change his name to something less ethnic. It became evident in any place he played that he had no reservations about using his fists to fight back. Word soon got around the league—Mose Solomon was one tough Jew.

It was while playing for the Hutchin-son Wheat Shockers in the Southwestern League in 1923 that Mose became a legend. Out of nowhere he pounded 49 home runs, breaking the old record set way back in 1895. By September he was batting .421 and leading the league in doubles, hits, and runs scored.

Apparently he was also a bit of a character: Once he was thrown out of a game and fined $5 for arguing with an umpire, then fined an additional $10 for waving his hands. Feigning incredulity, Solomon spat back at the umps, "Don't you know I'm a Jew and have to use my hands to talk?"

Word soon got around the league—Mose Solomon was one tough Jew

News of Solomon's home run record made newspapers all over the country and that is how John McGraw became aware of what he thought would be the Giants' key to financial success.

However prodigious Mose's offensive skills were, his defensive abilities weren't up to major league standards. Though they were not as miserable as some writers have made them out to be, in 108 games he committed 31 errors—the lower end of the league average in 1923. Even so, Hutchin-son's management, who stood to benefit greatly from selling Solomon's contract,

warned the Giants about his fielding. Nonetheless, McGraw's scout Dick Kinsella purchased his contract for a reported $50,000 and put him on the next train east.

The much-heralded "Jewish Babe Ruth" rode the Giants' bench while McGraw decided what to do. At first base he had George Kelly, and the outfield was manned by Casey Stengel, Ross Youngs, and Hack Wilson—all future Hall of Famers.

Finally, in the last home game of the season, with the crowd yelling for Mose Solomon, McGraw put him in as a replacement for outfielder Ross Youngs. In the 10th inning with the score tied 3–3 and a runner on second, Solomon slammed a double to drive home the winning run. He played one more game for the Giants that year and all told went three for eight, a batting average of .375.

Although Solomon was ineligible to play and would not be paid, McGraw wanted him to stay with the team while they played the Yankees in the World Series. Mose knew his family needed money and declined the offer. The pro football season was starting and Mose needed to make a paycheck.

An insulted John McGraw sold Solomon's contract to Toledo, letting him find out about his demotion by reading about it in the newspaper.

Mose, probably a better football player than he was a first baseman, played through the winter before he was sidelined with a broken collarbone. When he joined the Toledo Mud Hens in the spring of 1924, Mose found that all the power he once had in his swing was gone. "The Rabbi of Swat" drifted around the lower levels of the minor leagues through 1929, managing to hit just eight home runs by the time he called it a day.

In the 10th, Solomon slammed a double to drive in the winning run

Baseball might have been out of the question, but football wasn't. Playing halfback and occasionally quarterback, Mose Solomon evolved into a much sought-after ringer in the days before the NFL. Through the early 1930s just the rumor of his appearing on a local team was enough to make headlines. Finally, more injuries took their toll and Mose gave up the pigskin as well. He and his wife moved to Florida and he began a long and successful career as a building contractor. John McGraw, having passed up the chance at signing Hank Greenberg, died without finding another "Rabbi of Swat."

PITTSBURGH

Josh Gibson
CATCHER

There's this famous story about a black ballplayer who hit a home run one afternoon in Pittsburgh. The blast was so tremendous that it cleared the outfield wall and disappeared from sight. The next day that same ballplayer was batting in a game hundreds of miles away in Philadelphia when a ball dropped out of the sky and into a surprised outfielder's glove. The umpire turned to the ballplayer who had hit the home run the day before and bellowed, "You're out— yesterday in Pittsburgh."

Since Josh Gibson was refused the chance to play in the major leagues, stories like the one above were related by word of mouth so many times he achieved almost a mythical status. Those fortunate enough to see Gibson play found only one way to fully describe how good he really was: "The Black Babe Ruth."

Like the Babe, Josh Gibson began dominating the game as soon as he turned pro. Playing with the Pittsburgh-based Homestead Grays in 1930, the 18-year-old catcher was reported to have hit a base-ball completely out of Yankee Stadium—even the real Babe Ruth failed to do that. Throughout the 1930s Josh Gibson was the biggest gate attraction outside the big leagues. Since black teams in Gibson's time played roughly 40 to 50 official league games in a season, most of their games were against town teams in small hamlets across the country. It was on these barnstorming trips that the legend of Josh Gibson was formed. Even today it is not uncommon to find an old fella in, say, Wheeling, West Virginia, who could gesture to some faraway point in the distance and proudly tell you how he saw "The Black Babe Ruth" hit one there in 1934.

It wasn't just small-town America that got to witness the mighty Josh Gibson; fans in Cuba, Puerto Rico, Mexico, and the Dominican Republic got to see him in action. Though he was forced to play outside the major leagues, millions were nonetheless able to experience his brand of big league–quality baseball. To people who never saw a major league baseball game, Babe Ruth seemed like a myth. Josh Gibson was their reality.

So-called "baseball experts" will tell you that because no accurate stats were kept, it's impossible to know how good a guy like Gibson was. Fortunately, if one tries just a little bit, it's easy to find traces that begin to reveal how much talent he really had.

It was on those barnstorming tours that Josh Gibson's legend was formed

Take for instance Hall of Famer and Washington Senators owner Clark Griffith. During the early 1940s Gibson's team, the Homestead Grays, played around a dozen of their home games in Griffith Stadium when the Senators were on the road. Old Man Griffith made a point of watching the Grays from his office window when his team was away and noted that during one season the big catcher hit 11 home runs into the left-field bleachers, more than all the teams in the American League hit there—*combined*!

Ted Williams often told the story about how, when he joined the Red Sox in 1939, older players would point to the distant reaches of each American League ballpark and relate how "Josh Gibson hit one there." Not Ruth, but Gibson.

It wasn't just his bat that made Gibson comparable to the Babe. Like Ruth, the catcher was a fun-loving and friendly giant. Kids surrounded him wherever he went, begging for his autograph. And like the Bambino, Gibson was supremely confident in his talent. When asked by a fan for a broken bat, Gibson famously replied, "I don't break bats—I wear them out."

Only mindless racism kept Josh Gibson from joining Babe Ruth in the record books. Instead of irrefutable black ink, all we have are word-of-mouth legends. Suitably, myth even swirls around the circumstances of Gibson's death. The story goes that the big catcher, knowing he'd never have the opportunity to show what he could do in the major leagues, died of a broken heart.

I can't tell you that it isn't true, but, as with the question of whether Babe Ruth really called his shot in the 1932 World Series—does it really matter?

Hippo Galloway
SECOND BASEMAN

Like most kids in Canada, Will Galloway played both hockey and baseball. Despite what you might visually imagine, his nickname "Hippo" derived from his middle name of Hipple and not from his girth.

When Galloway joined the Woodstock club in the Ontario Hockey Association's Central League during the winter of 1899, he became the first African American to play pro hockey. The rookie received high praise from sportswriters and fans and is credited with scoring two goals in one game. While he garnered accolades on the ice, the ball field was a different matter.

When baseball season began, Galloway joined the Woodstock Bains in the new Canadian League. When a new player objected to playing with a Negro, he was unceremoniously booted from the club. What Galloway thought about leaving the Bains is unrecorded, but a local sportswriter bemoaned, "An effort should be made to keep Hipple in town. Our hockey team needs him!" In the space of 12 months Hippo Galloway had the unbelievable distinction of being both the first black man to play professional hockey and the last black man to play organized baseball before Jackie Robinson in 1946!

Life after the Woodstock Bains wasn't bad for Galloway. In fact, it got better. He joined the Cuban X-Giants, the best blackball team around, proof that he must have had exceptional skills as a ballplayer. Unfortunately for both baseball and hockey historians, Galloway disappears after the 1907 season. However, this two-sport pioneer left behind the makings of one heck of a trivia question!

In the fall of 1920 the great Babe Ruth and the New York Giants arrived in Cuba to take on that country's best ball club, the Blues. Their star was a slugger named Carlos Torriente, and everyone wanted to see him match his skills against the Babe. Ruth put on his usual show, but his trademark long-distance shots, which would have been homers in any American park, were reined in for outs due to the monstrous dimensions of the Blues' ballpark.

After Torriente blasted three home runs, Ruth himself took the mound to face the Cuban. With bases loaded, Torriente hammered a two-run double. The Babe frowned as the crowd went hysterical. Torriente was forever after known as "The Babe Ruth of Cuba."

Described as "fun-loving," Torriente had a string of eccentricities, such as the gold bracelets he wore on his wrists, which he would jingle when he came to bat to excite the crowd. He's most known for his years on the Chicago American Giants, where he hit with power and his average was usually in the area of .350. The major leagues were very close to signing him on numerous occasions but reportedly the only thing that stood between him and stardom in the white leagues was Torriente's kinky black hair. By the mid-1920s the slugger's enjoyment of the nightlife and the hard life of outsider baseball began to take its toll on him. He bumped around from team to team and was out of baseball by 1933. The Babe Ruth of Cuba died from tuberculosis, a penniless alcoholic, in New York City in 1938. He was but 44.

MARTÍN DIHIGO

"El Maestro" of Swat

Martín Dihigo (pronounced "DEE-go") has gone down in history as the most versatile and complete baseball player of all time. Unlike many blackball stars, Martín Dihigo was watched by a resounding number of players and people in the know who have left awe-filled remembrances of him. You can't crack open *The Baseball Encyclopedia* and look up his stats, but you can listen to the guys who were there and in a position to know.

Dihigo was a huge man for the times, over six feet tall and 200 pounds. His early playing days in Cuba were spent learning every position, earning him the nickname "El Maestro"—the Master.

The big man was friendly and helpful; playing baseball seemed to fill him with joy. He mastered English just as he did all the positions on a ball field.

By the late 1920s Dihigo was posting batting averages north of .400. Used primarily as an infielder, he perfected a few hidden-ball tricks to get an edge on opponents, such as politely asking a base runner to step off the bag so he could adjust it, then tagging the red-faced victim as the crowd howled.

Dihigo loved playing the outfield, where his laser beam of an arm would catch unsuspecting runners as they tried for an extra base. After seeing what his strong and accurate arm did to runners, someone put Dihigo on the mound, and the title of pitcher was added to his résumé.

Dihigo started spending the summers in America playing with some of the best blackball clubs around, such as the Homestead Grays and Hilldale Daisies. Since most Negro League teams played the majority of their games against white semipro clubs, Dihigo was able to showcase his talents to a wide spectrum of observers. Perhaps most telling was the praise received from New York–area semipro ballplayers. Teams like the Bushwicks and Bay Parkways had the unique opportunity to play against both major league All-Star teams and Negro League teams. Their

> **By the late 1920s Dihigo was posting batting averages north of .400**

unique perspective became almost a missing link that helps baseball historians gauge the level of talent found in blackball before 1947. Many of those well-seasoned players put Dihigo down as the best they'd ever seen. That's coming from guys who faced Babe Ruth, Lou Gehrig, Dizzy Dean, and Lefty Grove, all Hall of Famers.

Johnny Mize, a four-time National League home run champ, recalled how when the two were teammates in Cuba, opposing teams would intentionally walk Dihigo to pitch to him. In Mize's major league career that spanned from the 1930s to the '50s, the Hall of Famer called Martín Dihigo the best player he ever saw.

Dihigo wasn't shy about demonstrating his versatility. He occasionally spent a game playing a different position each inning, except catcher. He didn't perform this feat as often as is alleged, but it became his trademark.

As El Maestro aged he added the title of manager to his résumé, and it's probably as a skipper that Dihigo made his most lasting impression. Seasons spent in Cuba, Mexico, and Venezuela multiplied his sphere of influence. It was on the young Hispanic players that Dihigo left his biggest impression; to future stars such as Minnie Minoso, Roberto Clemente, and Tony Perez, El Maestro was a source of pride. One of their own, denied the chance to play in the white majors, could nonetheless go down in history as one of the game's greatest players.

In the late 1950s Dihigo again demonstrated his remarkable versatility when he stepped into the broadcast booth and began calling Cuban League games on the radio. When Fidel Castro took power, Martín Dihigo became part of the new government's amateur athletic programs. When El Maestro passed away in 1971, all of Cuba mourned, and Castro himself appeared at public tributes to the island's greatest ballplayer.

Though not as well remembered today as Babe Ruth, the only other man worthy of the title "Greatest Ballplayer of All Time," he does hold one distinction that even the Babe failed to achieve: Martín Dihigo belongs to the Baseball Halls of Fame in Cuba, the United States, the Dominican Republic, Mexico, and Venezuela.

> *Well-seasoned players put Dihigo down as the best they'd ever seen*

CHAPTER 7
THE ODDBALLS

Dad and I loved to dig up the most obscure and sometimes simply hard to believe ballplayers to share. For the rest of my life I'll never forget the afternoon he called me on the phone and asked me if I knew who Victory Faust was. Where he'd heard of this guy I'll never know, but the delight he found relating the tale of who this Faust character was is one of my fondest memories of him.

Since the advent of the game, baseball has attracted a slew of oddballs and outcasts. Take a guy like Moe Berg. While most of his teammates were at best high school graduates, the Ivy League–educated catcher devoured foreign newspapers and spent the off-season attending classes at the Sorbonne in Paris. And look at the story of Eddie Bennett. Only in baseball could a poor orphan, crippled with a growth-stunting spinal condition, become a confidant of Babe Ruth and a valued member of the greatest baseball team of all time, the 1927 New York Yankees. Or Pete Gray, who didn't let the loss of his arm keep him from becoming a major leaguer.

Before television and the advent of professional football and basketball, hundreds of traveling baseball teams crisscrossed the country each summer. To set themselves apart, many teams conceived of unique gimmicks to lure fans to their games. A religious colony in Michigan called the House of David fielded no less than three separate traveling baseball teams of bearded ballplayers every year. In the summer of 1935 one could take in a game featuring the Tokyo Giants and marvel at their politeness as players bowed respectfully to the umpire before batting. That same summer of '35 you could have spent a sunny afternoon watching the Stanzak Brothers team from Chicago, which consisted entirely of 10 brothers, one of whom was an ordained Catholic priest!

These oddballs are the characters that make the game's history so rich and interesting. They are not only drawn to the greatest game on earth but have carved out their own unique niche in our national pastime.

MOE BERG
A Genuine American Hero

When Connie Mack released the list of All-Stars he was taking to Japan in 1934, none of the players selected raised an eyebrow, except for one. Grouped in with Babe Ruth, Lou Gehrig, Lefty Gomez, and Jimmie Foxx was a light-hitting, over-the-hill catcher named Moe Berg.

Berg was a star ballplayer for Princeton, where he studied French, German, Spanish, Italian, Greek, Latin, and Sanskrit, graduating magna cum laude with a BA in modern languages. Instead of embarking on a career in business or law he chose to pursue his first love, baseball.

Berg's mediocre 15-year major league career was famously summed up by teammate Ted Lyons thus: "He can speak seven languages but can't hit in any of them." Once in Japan he surprised his hosts by delivering a speech in Japanese, and his interest in the culture made him popular with the locals. Before leaving the States he purchased a 16mm Bell & Howell movie camera and used the trip to film everything

> *"He can speak seven languages but can't hit in any of them"*
> *—Ted Lyons*

that he thought would be of strategic interest in time of war. His 360-degree money shot of Tokyo taken from the roof of one of the city's tallest buildings was later put to good use when planning air raids on Tokyo in early 1942.

During the war Berg joined the OSS, the forerunner to the current CIA. He heroically parachuted into occupied Yugoslavia to evaluate resistance groups and later accurately evaluated the Nazis' atomic bomb program. After the war a grateful nation awarded him the Medal of Freedom for his valuable service, but strangely, he turned the medal down without explanation.

Eccentric and mysterious to the end, Berg never again held a steady job and after the war lived off relatives, eventually succumbing to ill health in 1972. As he lay dying in a New Jersey hospital bed, his last words were, "How did the Mets do today?" So ended the life of the strangest man to ever don a baseball uniform.

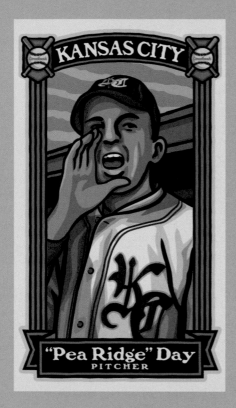

KANSAS CITY

"Pea Ridge" Day
PITCHER

Clyde "Pea Ridge" Day was just like the only decent pitch he could throw: a screwball. The strawberry farmer from Pea Ridge, Arkansas, was fun-loving and played ball with the enthusiasm of a little boy—he just wasn't all that good at it. Pea Ridge was known more for his eccentricities than for his pitching.

To make up for his lack of speed, Day began pitching both left- and right-handed. When the ambidextrous routine failed to improve his record, Day began billing himself as the strongest man in the game. To demonstrate, he would take a teammate's belt, strap it tight around his chest, and breathe in deeply, busting the belt buckle. Tired of buying new belts, one of his teammates replaced a standard belt with a heavy-duty horse harness. Pea Ridge inhaled deeply and promptly broke half his ribs.

Day recovered and managed to make it up to the St. Louis Cardinals in 1924, but a 2-2 record and a 6.30 ERA got him a ticket back down to the minors. He bounced from the Syracuse Stars and Los Angeles Angels to the Wichita Larks and Omaha Crickets. The Chicago Cubs tried to sign him but lost interest after he held out for a ridiculous amount of money.

In 1929 he turned up with the Kansas City Blues armed with a new gimmick. Back home in Arkansas Pea Ridge happened to be a champion hog caller. So now, every time the screwball pitcher struck out a batter he'd let loose a resounding call: "Yip, yip yeeee!" The fans and sportswriters ate it up and soon "The Hog Calling Pitcher" was featured in newspapers nationwide. Then Day started milking the novelty by hog calling from the dugout,

too. While his shtick undeniably bothered opposing players, it unfortunately had the same effect on his own team. Players petitioned the commissioner of the American Association to do something, but by 1932 Day's oddball routine had its desired effect: He was going back to the majors.

The Brooklyn Robins, short on talent but deep with characters, couldn't pass up a "Hog Calling Pitcher." The Robins (they'd be renamed the Dodgers in 1933) were the laughingstock of the National League and boasted such shenanigans as three runners ending up on third base at the same time, outfielders being hit in the head with fly balls, and a guy who kept lighted cigars in his pocket. Pea Ridge seemed the perfect fit.

Day was just like the only decent pitch he could throw: a screwball

Facing the Yankees in an exhibition game, Pea Ridge fanned the first two Yanks to face him, letting loose a triumphant hog call after each strikeout. The fans went wild and Babe Ruth, waiting on deck, laughed heartily as he waited his turn. Day got two quick strikes on the Babe, then Ruth launched the third pitch into the stands for a homer. Despite being popular with the Ebbets Field fans, Day failed to be more than a below-average relief pitcher and was sent back to the bush leagues.

The once fun-loving pitcher began to turn morose. He was now past 30 and his career was quickly slipping away. Though 9-8 for Minneapolis in 1932, he developed painful bone chips in his elbow. When his wife gave birth to a son, Pea Ridge began to panic.

In a last-ditch effort to save his livelihood, he spent his life savings, more than $10,000, on experimental arm surgery at the Mayo Clinic. It was unsuccessful.

In the spring of 1934 he convinced the San Francisco Seals to give him a chance. Drinking heavily and suffering from blackouts, Pea Ridge was visiting an old teammate in Missouri on his way to the coast when he checked into a hospital. Doctors told the aging pitcher to rest before continuing to California and he returned to his friend's apartment. While unpacking his suitcase he suddenly pulled out a hunting knife and slit his throat. He was dead before an ambulance arrived.

It was an unfortunate ending to one of baseball's truly unique characters.

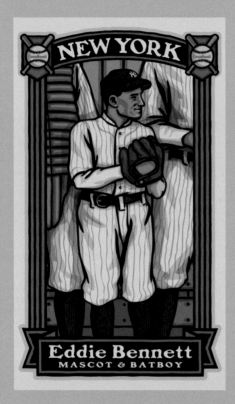

NEW YORK

Eddie Bennett
MASCOT & BATBOY

Early in life, Eddie Bennett caught one bad break after another. An accident left him with a crippling spinal condition that stunted his growth, and in 1918 he was orphaned when his parents died in the influenza epidemic. But the seemingly unlucky teen had a career ahead of him as a lucky charm.

In 1919, he was befriended by White Sox outfielder Happy Felsch, who was taken by Eddie's sweet demeanor. The Sox took the hunchbacked orphan on as a lucky mascot and went to the World Series that year. The next year Eddie hooked up with Brooklyn and they, too, went to the World Series. Eddie switched to the Yankees in 1921 and became the most famous batboy of all time.

He was a true professional at his job, performing any extra duty to make the players' lives easier, leaving them free to concentrate on the game. Babe Ruth became close to Eddie, whom he related to as a fellow orphan who had carved out his little successful niche in the world. Not one Ruthian home run went by without Eddie being the first to shake the Babe's hand when he touched home plate, and if you look at any team picture from 1921 to 1932, there's Eddie, front and center, with a big wide grin on his face, the envy of every boy in the land.

Sadly, after a decade of service to the team, Eddie was further crippled when he was hit by a car. Complications set in and Eddie took to drinking heavily to dull the pain that racked his crippled body. Eddie Bennett, professional batboy and mascot, passed away on January 16, 1935, the funeral paid for by his beloved New York Yankees.

St. Louis Browns owner Bill Veeck was desperate. His team was constantly in the bottom of the American League standings and could not compete with the Cardinals, whom they shared a stadium with. As he would throughout his career as a big league owner, Veeck tried a desperate stunt to put fans in the stands. Instead of thinking big, he thought small.

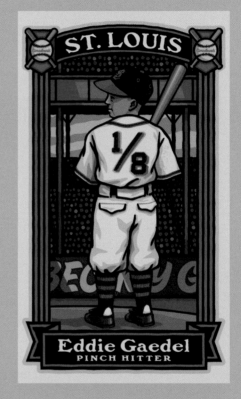

Veeck found little person Eddie Gaedel through a talent agency in Chicago. He was already a minor celebrity as Mercury Records' winged hat–wearing "Mercury Man" mascot. Gaedel was secretly signed to a major league contract, and on August 19, 1951, he popped out of a birthday cake as part of a Falstaff Beer promotion between games of a Browns-Tigers doubleheader. But that wasn't the end of Eddie Gaedel's baseball career.

Wearing a child-sized Browns uniform with the number ⅛ on the back, he was put in to pinch-hit for Frank Saucier in the second game against Detroit. Gaedel stood at the plate holding a tiny souvenir minibat. Tigers pitcher Bob Cain laughed hysterically and threw four pitches, all balls: It was nearly impossible to pitch to Gaedel's one-and-a-half-inch strike zone. Gaedel took his base and was then taken out for pinch-runner Jim Delsing.

Although he never played again, Eddie leveraged his one major league appearance all he could, appearing in advertising and television programs. He stayed close to Bill Veeck, who used him in various stunts throughout the 1950s. Eddie died at the age of 36 after being badly beaten in a robbery on Chicago's South Side.

CHARLEY "VICTORY" FAUST

Fulfilling a Prophecy

In the summer of 1911, a fortune-teller told Charley Faust he was going to pitch the New York Giants to the World's Championship, meet a woman named Lulu, and produce a long line of baseball prodigies. While others may have scoffed at the prediction, Faust was what was back then referred to as "dim-witted." Although we'll never know what exactly his deal was, it's safe to say he did not have all dozen eggs in his carton. Though apparently able to speak and write quite well, his eyes didn't seem to line up properly and he went around with a non-stop goofy smile on his face. In other words, Charley just wasn't all there.

Faust tramped to St. Louis, where the slumping Giants were playing, and talked Giants manager John McGraw into granting him a tryout.

With the rest of the team watching Charley threw his arms back and forth in a crazed windmill windup, the likes of which no one had ever seen before. One writer likened it to "a worm being chopped in three pieces."

> *He was going to pitch the New York Giants to the World's Championship*

Round and round his lanky arms went and then he unleashed his best pitch—a disappointingly average fastball with no movement on it. On a hunch, McGraw decided to keep the dim-witted fellow around as a mascot.

Coincidentally, the Giants began to win; Faust was nicknamed "Victory" and he became a minor celebrity. The cities of St. Louis and Pittsburgh awarded him medals, and McGraw signed him to an actual Giants contract. After pestering the manager to let him fulfill his prophecy of pitching the team to the championship, McGraw let Faust pitch an inning in two games.

By the end of the 1911 season, the players had tired of their eccentric mascot, and he was unconditionally released. There is no record of whether he ever met his Lulu or not, but within four years Charles "Victory" Faust, former major league baseball player, had passed away from tuberculosis in a Washington State insane asylum.

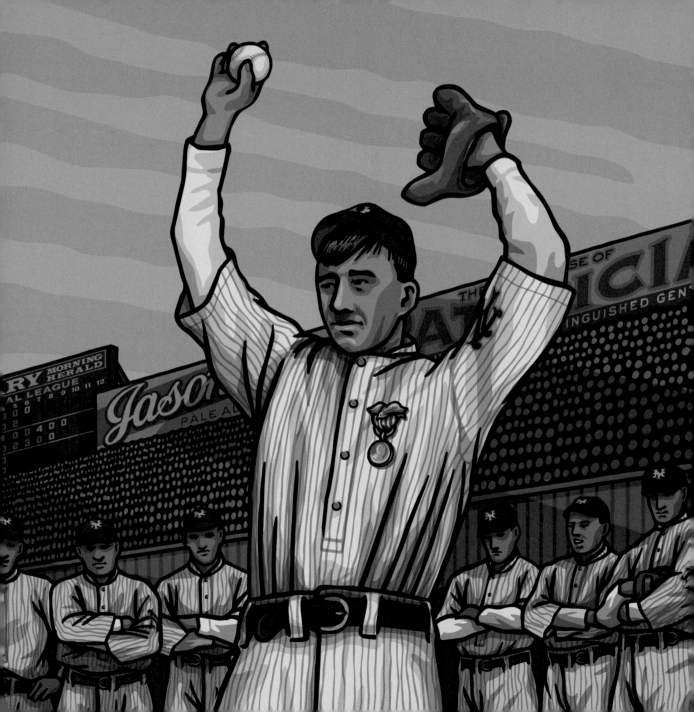

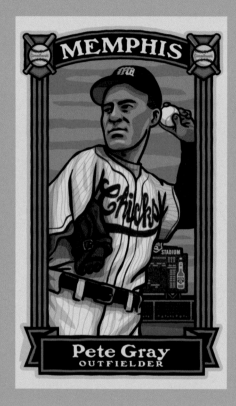

The Browns that took the field in 1945 were essentially the same team that had won the pennant the previous year. The common perception of the team was of a woeful group of misfits who stumbled their way to the pennant. None of that is true. Through the long hard summer of 1944 the Browns had been forged into a cohesive team of winners. The Browns of 1945 knew they were just as good as or better than the rest of the American League and there was no reason they couldn't repeat.

Enter Pete Gray. The whole country knew of his rise through the minors, overcoming a childhood accident that left him with a stub for a right arm. Gray taught himself to hit one-handed and field a ball flawlessly with a well-practiced motion that seemed to defy gravity.

It was one thing for the Browns to bring up a new kid fresh off an MVP season in the minors, like the one Pete Gray had with the Memphis Chicks, but in this case, a carnival atmosphere surrounded the whole thing. For a bunch of guys serious about defending their pennant this distraction was the last thing they needed. If he had just given catching and throwing exhibitions during batting practice, maybe everything would have gone well, but Gray was on the Browns for one reason: to attract fans to the ballpark. And that wasn't going to happen with him riding the pines in the dugout. The Browns needed to play the guy.

The other guys knew Pete was there as a novelty. They all knew big league curveballs would tie him in knots, and the flawless motion that he used to field his position would

add up to one thing: extra base hits for the opposing teams. On top of all this, who was going to have to take a seat while the one-armed guy made history? Mike Kreevich, that's who.

Kreevich was a former White Sox prodigy who nearly drank himself out of the game only to find redemption on the Browns. Playing every day kept him sober, and he hit just over .300 in 1944, but losing playing time to a one-armed guy sent Kreevich spinning out of control. Being platooned with Gray threw off his timing at the plate and his average plummeted. The other players looked on in shock as management appeared to sacrifice their success on the field for a modest bump in attendance. The team's cohesiveness broke down.

As infielder Ellis Clary eloquently put it: "He screwed up the whole team. If he's playing, one of them two-armed guys is sitting in the dugout pissed off."

The press, used to poking fun at the Browns' lowly status, now turned the novelty of Pete Gray against them as well. How lousy are the Browns that management has had to dig down deep and come up with a cripple to play for them? The rest of the team seethed with resentment as they tried to hold it together and win the pennant.

St. Louis put up a good fight but finished six games behind Detroit. Pete Gray played in 77 games that season and batted .218. How much better could Mike Kreevich have done had he played full-time? We'll never know, but it's not that much of a jump to assume Kreevich's bat could have been the deciding factor in winning, say, six or seven games that season. The same could be said for team spirit. How much of a difference did the media sideshow that surrounded Pete Gray make? How much did it get in the heads of the players, knowing that management seemed to be sabotaging a pennant for box-office success?

"If he's playing, one of them two-armed guys is sitting in the dugout pissed off"

But don't overlook what an accomplishment it was for Pete Gray to make it to the majors. Pete really did hit .333 at Memphis and was MVP of the Southern Association. The man could play ball—just not at the big league level. As an inspiration to people all over the world, his story is a life lesson in perseverance, but had the Browns repeated in 1945 they might not have packed up and moved to Baltimore in 1954.

JOHN
*Left Fielder
and Catcher*

BILL
*Starting Pitcher
and Left Fielder*

JOE
Second Baseman

FRANK
Shortstop

MIKE
*Third Baseman
and Pitcher*

THE STANZAK BROTHERS were one of the most unusual teams to ever play the game. In late-1920s North Chicago, Polish immigrant Martin Stanczak marshaled all 10 of his boys, aged 15 to 33, into a powerhouse semipro team. Joe, the team's second baseman and captain, was a county clerk. Third baseman Mike was a newly minted Catholic priest who'd actually skipped his own ordainment ceremony in order to play a ballgame with his brothers. The team's starting ace, Bill, had a devastating spitball propelled by a generous dose of chewing tobacco. Martin and Julius, the youngest, were still in high school.

After the team had dominated sandlots from Chicago to Milwaukee, promoter/politician Nick Keller took the reins of the Stanczak Brothers team. The new manager ordered smart new uniforms, chopping off the *c* in the family's name to make it less of a tongue twister. Proclaiming the rechristened Stanzaks the undisputed "World Brother Champions," Keller challenged any all-sibling team to dispute the title. Out West, the Marlatt Brothers thought themselves the reigning brother champs, having defeated the Skiano Brothers back in 1925. Challenge made and accepted, Keller's publicity machine organized the "Brother Championship Series." Starting in September of 1929, the best-of-seven series began on the Marlatts'

EDDIE
First Baseman

BRUNO
Center Fielder

LOUIS
Catcher

MARTIN
Right Fielder and Pitcher

JULIUS
Outfielder

home territory of Hawk Springs, Wyoming. Bill's famed spitball baffled the Marlatts and the Stanzaks took the first two games easily. Traveling across the country to the Stanzaks' home base of North Chicago, the Polish Americans continued their diamond dominance and swept the final two games. The champs commenced touring the back roads of the Depression Midwest, taking on all comers. The team pulled in large crowds, including a curious 1,200 who paid to see the Stanzaks win the Lake County Championship in 1933. Two years later the brothers received a challenge to their title. The Deikes of Fredericksburg, Texas, backed by the Nueces Coffee Company, invited the Stanzaks to Wichita to decide the title. While the Stanzaks were all full brothers, the Deikes were secretly only eight-ninths legit— their first baseman was a ringer named Lyndon Baines Johnson. However, even the presence of a future U.S. president did nothing to stop the Stanzak juggernaut, as the brothers easily defeated the Texans to defend their title. Later, Joe played some minor league ball while Louis and Martin had tryouts with the Reds. While none of the Stanzaks made it to the majors, their photograph is prominently displayed in the National Baseball Hall of Fame, proclaiming them as the 10 best brothers to ever play baseball.

TOM DEWHIRST *The Bearded Babe Ruth*

HOUSE OF DAVID

Tom Dewhirst
OUTFIELDER

Of the many traveling teams that crisscrossed the country during the Great Depression, the most unforgettable was the bearded House of David. A baseball-playing advertisement for their Michigan-based apocalyptic sect, the House had as many as three teams barnstorming the country concurrently during their heyday.

Though the House teams were billed as being almost major league quality, historian Scott Simkus's research has uncovered that the House's publicity department was considerably stronger than their baseball teams: Though billed as winning 75 percent of their games, the reality was more like 45 percent. One of their better players was the son of the House of David colony head judge H. T. Dewhirst. Tom was a husky outfielder whose power (and help from the House's publicity department) made him known throughout the country as "The Bearded Babe Ruth." Though actual statistics were never released, press releases reported Dewhirst averaged about 38 homers a year. By big league standards, 38 isn't bad at all, but the House of David's main opponents were small-town teams and low-level minor league clubs. At six-two and 220 pounds, Dewhirst must have made mincemeat out of the amateur hurlers when the House came to town. Though he was intimidating at the plate, Dewhirst made sure his team didn't run up insurmountable scores against the weak teams they played. Besides showing good sportsmanship, it was smart business, as it left small-town nines with the hope they could actually defeat the House and ensured that "The Bearded Babe Ruth" and his hirsute teammates were invited back year after year.

HARLAN PYLE *A Bad Case of Stage Fright*

Anyone who saw pitcher Harlan Pyle on the mound in 1928 knew he was destined for great things. Twice he'd pitched and won both ends of a doubleheader and his 20 wins that summer not only helped lead the McCook Generals to the 1928 Nebraska State League championship, but got him a ticket to the big leagues.

The Cincinnati Reds purchased the Nebraska native and sent him a train ticket to St. Louis, where the Reds were playing the Cardinals. Manager Jack Hendricks wanted to see what the kid had but when told to warm up, Pyle refused. Peeking out at the crowd that was filing into Sportsman's Park, he told his manager, "Hell no, I'm too scairt to pitch before this crowd." Hendricks was perplexed—any 22-year-old in the country would give anything to be in Pyle's position, but what could he do?

A week later the Reds were in Philadelphia, where the weekday crowd was a disappointing 200. After surveying the stands Pyle approached Hendricks

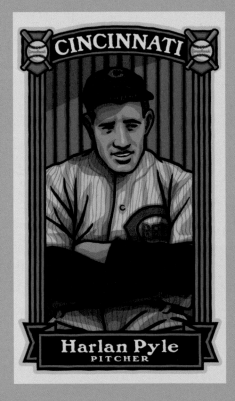

and said, "I can pitch here. This is a smaller crowd than we had in the Nebraska State League." Hendricks demurred but did let the rookie pitch the last inning of the September 21 game against Boston. Pyle retired the side in order and Hendricks decided to have him start the next day's game. It's not recorded what the attendance was, so I'm not sure it was stage fright, but Pyle got blasted off the mound. He managed to retire just one batter while giving up four walks, three hits, and three runs before he was taken out. Pyle was sent back to the minor leagues, where presumably the crowds were lighter.

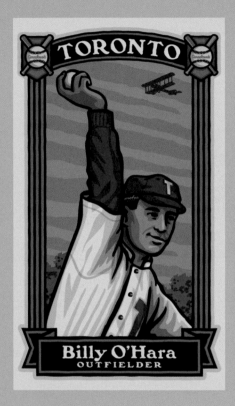

Billy O'Hara
OUTFIELDER

Toronto native Billy O'Hara started out in professional baseball with the Syracuse Stars in 1902, batting a nice .342, then spent the next couple of years bouncing around the United States, moving up the food chain of the minor leagues.

O'Hara hit in the .300 range but he was better known for his defensive abilities and his rifle arm. Runners soon learned not to test the Canadian's arm—he was as accurate as a hunting rifle. John McGraw brought him up to the majors and made him the starting left fielder for the 1909 campaign.

O'Hara's average of .236 was the lowest of all the Giants starters that year, but he made only five errors in 226 chances. Unfortunately for O'Hara, McGraw had slugger Fred Snodgrass in the wings, and he traded O'Hara to the Cardinals. In 1910 he played only nine games and was released to Toronto of the International League, right back in the hometown where he started.

O'Hara rebounded from his disappointing big league experience and gave his hometown Maple Leafs four great seasons that saw him become not only the team's star left fielder, but also one of the most popular players with the Toronto fans. He was described as "an Irishman of the true-blue type, a scrapper and also a born gentleman." A natural comedian, he mixed easily with the Broadway crowd and counted George M. Cohan as one of his many friends. In the summer of 1915 his average tapered off, and he finished with a disappointing .170, but he had other things on his mind besides throwing runners out at the plate.

Canada had joined with Great Britain and declared war on Imperial Germany. Like many men of that age, O'Hara felt the pull to become a part of the greatest adventure of his lifetime. Right beyond his position in left field was the Curtiss Aviation School, where their instructors worked round the clock to train new military aviators. An envious O'Hara watched them fly overhead every afternoon and finally took private flying lessons. When the season ended the team threw O'Hara a gala dinner party—not for his anemic batting average but because he'd joined the Royal Flying Corps. By Christmas 1915 he was commissioned a flight lieutenant and was on his way to war.

By Christmas 1915 O'Hara was a flight lieutenant and on his way to war

O'Hara was stationed beside the English Channel and flew defensive patrols until he crashed his plane in a noncombat accident. As punishment for destroying the king's property he was transferred to the balloon corps, but O'Hara had signed up for action. He requested the infantry and was promptly sent to the trenches.

Serving with the 24th Canadian Battalion, he got his first taste of combat at the Battle of Ypres, somehow emerging unscathed. During the summer of 1916 the exhausted French army pressed the British to launch an offensive to take the pressure off their own armies at Verdun. The resulting offensive, known as the Battle of the Somme, turned into the worst bloodbath the British army had ever suffered. On July 1, following a massive bombardment, the troops left their trenches and charged the German lines. In 10 minutes the British lost 60,000 men. O'Hara's battalion went over the top not once, but twice to try to dislodge the Germans. Turned back the first time, the Canadians were successful the second time, but in the process of gaining the first-line enemy trench they lost 950 out of 1,200 men. While clearing the trench O'Hara came face-to-face with a German officer and took the top of his head off with a well-placed shot from his .45 automatic.

After weeks of futile attacks, both sides once again reverted to trench warfare. After a short rest O'Hara and his men were sent back to the front lines. It was here on the Somme in October 1916 that Billy O'Hara put his baseball skills to another use.

Canadian troops were renowned for their zeal in nighttime trench raids. These typically entailed small squads of about 10 to

20 men led by a lieutenant crawling through the barbed wire of no-man's-land and slithering undetected into the German lines. Once gaining the trench they would unleash a barrage of grenades and mayhem, culminating, ideally, in their capturing a few of the enemy and returning to their own lines alive.

Billy O'Hara, the left fielder remembered for his accurate and powerful throwing arm, had found another use for the skills he had once used while manning his position in the Polo Grounds. The British No. 5 Mills Bomb was the standard-issue grenade used during O'Hara's time in the trenches. The No. 5 weighed about three times more than an official National League baseball, but its size and shape, unlike that of the cumbersome German stick grenade, enabled Canadian troops who had grown up playing baseball to throw it accurately, as opposed to lobbing it like European troops who were not accustomed to throwing anything overhand. This simple skill that North American boys take for granted earned Billy O'Hara one of the most coveted decorations the British government could bestow on one of its soldiers.

While leading a bombing party on a trench raid, Lieutenant William A. O'Hara, 24th Battalion, Canadian Expeditionary Forces, was recommended for the Military Cross "in recognition of his bravery and skill in hurling bombs."

The Military Cross was awarded only to officers and is roughly equivalent to the Silver Star in the U.S. Army.

After the Somme, O'Hara and the rest of the Canadians scored a spectacular victory at the Battle of Vimy Ridge. Vimy Ridge is to Canadians what Iwo Jima and Guadalcanal are to Americans. During the battle a shell exploded next to Lieutenant O'Hara and buried him under a mound of French soil. He woke up later in a hospital. It appears that physically O'Hara was unhurt but he was put out of action by the effects of rheumatism, brought on by too many nights in the wet trenches. Reading between the lines it can also be assumed that besides rheumatism he was suffering from severe shell shock—getting shelled and buried would do that to even the hardiest warriors. He was eventually sent back to Canada to recuperate in the spring of 1918, and he lectured extensively about the horrors as well as the lighter side of life in the trenches.

". . . in recognition of his bravery and skill in hurling bombs"

When the war ended O'Hara decided to pursue the life of a trapper in the Echo Lake region of Northern Ontario, near the town of Kapuskasing—in other words, smack dab in the middle of nowhere. His reasons for doing so are unknown—one would suspect it was his way of seeking solitude and dealing with the wholesale slaughter he had witnessed during the preceding three years. While guys like Hemingway, Fitzgerald, and Dos Passos retreated to the bright lights of Paris, others, such as O'Hara, retreated to the peace of nature. Unfortunately, his attempt to make a living as a trapper came to nothing when his traplines failed to produce much prey, but as always, Billy O'Hara was resourceful.

After the war O'Hara pursued the life of a trapper in Northern Ontario

With a nod to the knowledge learned elsewhere, O'Hara decided to apply the deadly skills he had learned in the war to help him earn a living in the wild. In 1920 he petitioned the Canadian government for permission to use surplus observation balloons to track the animals that eluded his traps and, once they had been found, to use a machine gun to mow down the unsuspecting herds of moose and deer, the same way his comrades had been mowed down on the Somme in 1916. His revolutionary ideas made the papers at the time and although there was no follow-up, I think it is safe to say that his proposal was denied.

Whatever the outcome, Billy O'Hara eventually emerged from the frozen North and in 1927 took the reins of his hometown Maple Leafs. He managed the team through 1928, when he switched over to become their business manager. He was traveling with the team on one of their road trips in June 1931 when he suffered a fainting spell in Newark, New Jersey. After being examined by doctors he was told he had a serious heart ailment and would not last the year. O'Hara continued to function as the team's business manager, and it was while on a road trip that he once again started to feel ill. He stayed with his team but by the time they arrived in Jersey City for a series against the Skeeters, he was unable to leave his bed at the Plaza Hotel.

Billy O'Hara was surrounded by friends as he passed away on June 13, 1931.

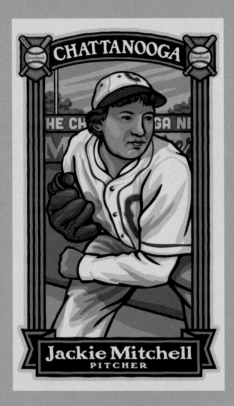

CHATTANOOGA

Jackie Mitchell
PITCHER

She came with a great story—a 17-year-old girl who learned to throw a puzzling sinker from Hall of Famer and next-door neighbor Dazzy Vance, then ascended to the minor leagues where she struck out Babe Ruth and Lou Gehrig, only to be kicked out of baseball by cruel sexism. Only problem is, it just ain't true.

Jackie Mitchell did indeed learn a sinker from Vance, and she was a serviceable pitcher against other teens in the world of sandlot ball. But when she took the mound for the Chattanooga Lookouts on April 2, 1931, it was a carefully crafted publicity stunt by the team owner, designed to boost attendance.

Facing Babe Ruth, Mitchell's first pitch was outside, but Ruth swung at the next two and missed. The Babe asked the umpire to examine the ball, which was deemed to be just fine. Mitchell then threw a sinker for a called strike three. Ruth threw his bat down and had words with the ump before stalking off to the dugout—it was great theater. Lou Gehrig promptly went down swinging on three straight pitches (Lou wasn't much fun when it came to, well, anything) as the crowd roared and the newsreel cameras captured the whole scene. Tony Lazzeri drew a walk on four pitches and Mitchell was removed from the game.

After the game Commissioner Landis voided Mitchell's contract, instantly transforming the "Girl Who Struck Out Babe Ruth and Lou Gehrig" into a feminist martyr. Research by historian Scott Simkus into Mitchell's subsequent lousy semipro pitching record reveals that the teen was no more than a publicity stunt, but a great baseball story nonetheless.

ART "THE GREAT" SHIRES *Whattaman!*

Art Shires came to the White Sox in 1928 with an ego the size of his home state of Texas. He was brash, with movie-star looks and curly locks, telling anyone who'd listen that he was the best there ever was. He told the press to call him "The Great"—they sarcastically settled on "Whattaman!" instead.

When he had four hits in his first big league game he boasted: "So this is the great American League I've heard so much about? I'll hit .400!" He finished his rookie year batting .341, and by the time the 1929 season began, he was appointed team captain. It was all downhill from there.

By the time he was kicked off the White Sox in 1930 he was 2-0 in fights with his manager, had been suspended and fined numerous times, and was under indictment for manslaughter. The charge stemmed from his minor league days, when he beaned a heckler with a ball. The man ultimately died from complications.

Though cleared of blame, he was on a downward trajectory. Shires tried to make up the salary forfeited during his suspensions by becoming a prizefighter. He padded his record by beating a couple of palookas, then began challenging ballplayers, including Hack Wilson. Commissioner Landis told the Texan to pick boxing or baseball. He chose ball, but injuries ended his major league career by 1932.

When his fights were rumored to have been fixed, the door to a boxing career was closed as well. He ran a bar in Texas, making the news one last time when he beat a friend to death in a drunken brawl. Shires was found guilty and fined $25. Whattaman.

CHICAGO

CHICAGO

"The Great" Shires
FIRST BASEMAN

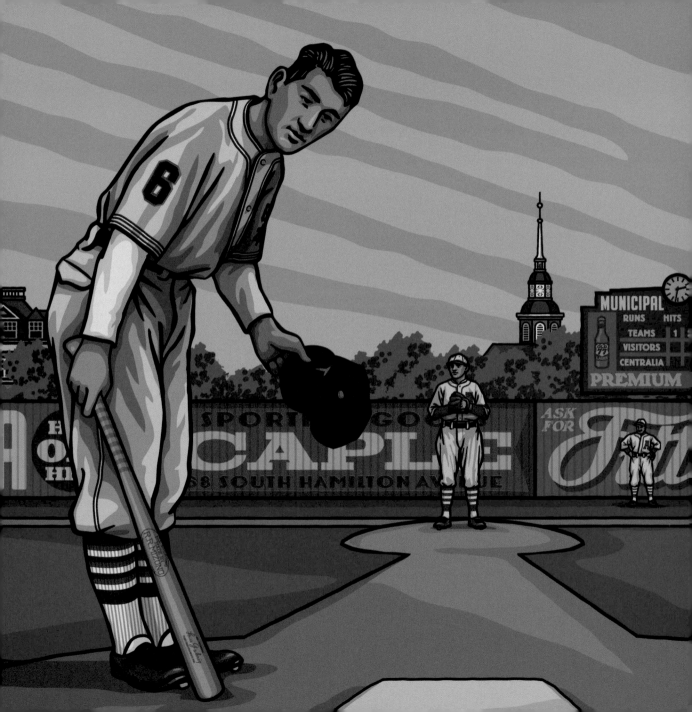

FUJIO NAGASAWA

Hats Off to the Tokyo Giants

Among the many baseball teams barnstorming around America during the 1930s, the Tokyo Giants were among the most unusual.

The Tokyo Giants were assembled to represent Japan when Babe Ruth and his All-Stars came to the island in 1934. In the spring of 1935 the team was sent to the United States to learn and play against American teams.

The team was helped by Lefty O'Doul, who had been part of the 1934 tour. He suggested the team change their cumbersome name of "Dai Nippon Tokyo Yakyu Club" to the "Tokyo Giants," which is still used today. The publicity-savvy O'Doul encouraged the Giants to capitalize on national customs that would make the team unique when they toured America. For instance, their jerseys sported the player's number on the back in traditional Japanese kanji characters and before each inning the team joined in a football-like huddle. O'Doul instructed the players to continue the tradition of tipping their caps and bowing as a group to the crowd before and after a game and to do the same before each at-bat and even after being thrown out on the basepaths. This helped differentiate the Tokyo Giants from the hundreds of other barnstorming teams, and they attracted decent-sized crowds and much newspaper publicity.

O'Doul instructed the team to continue their custom of bowing to the umpire

Fujio Nagasawa came to symbolize the team when a photograph of him tipping his cap and bowing to the umpire was featured in American newspapers coast to coast. Nagasawa had been a star collegiate athlete and was among the first players chosen to represent Japan in 1934. He accompanied the Tokyo Giants to America, where he batted .300 and as leadoff hitter for the team became the very first batter in the Japanese Baseball League when it was formed in 1936. He retired as a player in 1943, then became a successful reporter for the *Hokkaido Shimbun* newspaper, living to the age of 80.

JOHN PAPPAS *Taking One for the Team*

NEW YORK

TRI BOROUGH BRIDGE

John Pappas
PITCHER

The writers assigned to cover the new New York Mets in their first spring training were stuck. The obligatory slapstick stories about the retreads and never-will-bes trying to make the National League's newest team got old quick. Then, just when it seemed they'd run out of fresh material, John Pappas showed up.

Pappas was a 21-year-old from Queens, a hometown boy who read in the paper that the Mets needed pitching. That's what brought him to Florida. The writers were intrigued. Asked when he had pitched last, Pappas replied, "Last week in New York." The writers were perplexed—it was mid-February and New York was covered in snow. Pappas agreed—everywhere except beneath the TriBorough Bridge.

The hopeful explained that he had taught himself to pitch the previous week under the suspension bridge linking Queens and Manhattan, and now he felt he was ready to join the Mets.

Already knee-deep in sideshow characters, the Mets wanted nothing to do with Pappas. But the writers, smelling the feel-good story of 1962, convinced Mets official Johnny Murphy to give the guy a chance. Reluctantly, Murphy watched Pappas, wearing blue jeans, a T-shirt, and sneakers, throw for 20 minutes. Finally Murphy called a halt, deeming Pappas "so wild, he might hurt somebody," and walked away muttering, "I don't think he can play ball in any league." Pappas was disappointed—he hadn't gotten a chance to show off his hitting. The beat writers' prospective Cinderella story, like the upcoming Mets 1962 season, was a bust.

HUMPTY BADEL *Almost Major League*

At a time when the only way someone with a handicap could get onto a professional ball club was as a mascot, hunchback Fred Badel came surprisingly close to making the majors. He suffered from a severe curvature of the spine, which caused a hump to form on his back. In those pre–politically correct times it was inevitable he would be known as "Humpty." He could neither read nor write and sportswriters weren't shy in declaring Badel a bit on the slower side of things. One manager said he lacked common sense. Newspapers called him "odd" and "picturesque." Humpty could, however, play ball.

He was a good contact hitter and his hunchback batting stance made him hard to pitch to. Once on base his speed made him a feared base runner and he quickly rose through the minor league ranks. With the Buffalo Bisons in 1906 he was scouted by the Cincinnati Reds, who offered $5,000 for him. However, Badel committed career suicide when he deserted the Bisons midseason.

The cause of his desertion was his own team—following a long-held baseball superstition, teammates would rub Badel's hump for luck before batting. Badel was humiliated by the ritual and pleaded to the Bisons' management for relief. When none came, he quit. Badel bounced around the low minor leagues for many years and even managed the Columbia Comers in 1912. Later he surfaced with the Covington Blue Sox in the Federal League's first season in 1913. He worked as a carpenter in Ohio for a while, but after 1919 Humpty Badel simply disappears from history.

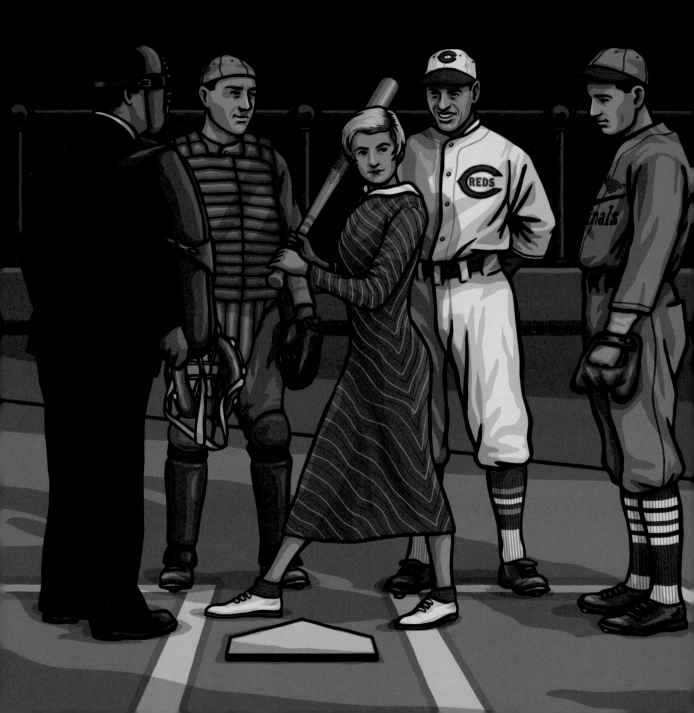

KITTY BURKE
Appearing One Night Only

In the whole history of Major League Baseball, only one woman has ever appeared in a game, and that woman was Kitty Burke.

When she's mentioned at all in baseball history books, it's usually a two-sentence entry or a footnote that goes something like: "In 1935 nightclub singer Kitty Burke emerged from the Crosley Field stands and took a bat from Reds player Babe Herman. Cardinals pitcher Paul Dean lobbed an underhand pitch to Burke, who hit it back to Dean for an out." That's it. No one seemed to know anything more about her other than that she was a singer. I wanted to know more about her and was fortunate when I tracked down Kitty's granddaughter, who shared with me the rest of her story.

She was born Virginia Georgia Murphy in Southside, West Virginia, and was just 17 when she married James Ashton. The couple had a daughter named Pauletta but the marriage failed and Virginia was left to raise her daughter alone. This being the beginning of the Depression, jobs were scarce and times were tough, especially for a single mother. To support herself and little Pauletta, Virginia changed her name to "Miss Kitty Burke" and reinvented herself as a blue-eyed, blond-haired, banjo-playing blues singer.

Kitty found work with one of the many traveling big bands that crisscrossed the country during the 1930s. Along the way she began appearing on radio shows as a featured singer, often receiving top billing above whichever band she was fronting. Kitty must have had one heck of a voice, as she was not only in demand as the featured vocalist with various traveling orchestras, but also appeared with big-name recording acts like the Mills Brothers.

By the mid-1930s she was the house singer at the Horseshoe Winter Gardens in Bellevue, Kentucky. While Bellevue might not ring a bell today, before the advent of Atlantic City and Las Vegas the Kentucky cities of Bellevue, Newport, and Covington, located just across the Ohio River from Cincinnati, were America's gambling and enter-

> *She reinvented herself as a blue-eyed, blond-haired blues singer*

tainment mecca. When Kitty graced the stage of the Horseshoe she was at the top of the entertainment world.

Being based in Cincinnati, Kitty was of course a Reds fan. Though the team had sunk to the bottom reaches of the National League, the Reds were pioneers in night baseball. The novelty became a resounding success, and when the Reds played one night game with each of the seven other league teams, they were all standing room only, and that is what set in motion Kitty Burke's major league debut.

On Wednesday, July 31, 1935, the Reds faced the Cardinals at Crosley Field. The Reds had oversold the game, and though Miss Burke had a ticket to a field box seat, the overflow crowd forced her out onto the field, where ropes were set up to keep the crowd at bay. When Cardinals outfielder Joe Medwick scored a run to put the Cards ahead, Kitty Burke was fuming mad. From her place on the field she began heckling Medwick, whose awkward gait earned him the nickname "Ducky-Wucky." Kitty called out, "Hey, Medwick, you couldn't hit the ball with an ironing board!" to which the slugger replied, "Yeah? You couldn't hit the ball with an elephant!"

"Hey, you big hick!" she cried out. "Why don't you go home and milk the cows!"

Challenge made, the tiny blond blues singer called back, "I'd like to show you sometime! I'll show you!"

Little did anyone know, Kitty Burke meant it. When Reds outfielder Babe Herman came to bat in the bottom of the seventh, Kitty burst from behind the rope and approached the startled ballplayer.

"Hey, Babe, lend me your bat," she said.

"Okay, sis," Herman replied, handing over his Spalding bat. For a minute no one knew what to do. The game was getting out of control as the crowd had now flowed into the visiting dugout as well as onto the field. The players looked to home plate umpire Bill Stewart, who shrugged, put his mask back on, and shouted, "Play ball!"

Cardinals pitcher Paul Dean walked back to the mound and looked with disbelief at the diminutive blonde in the red dress standing in the batter's box.

Kitty, an avid baseball fan, knew she was facing one of the best pitchers in the National League. Paul Dean, nicknamed "Daffy" as a bookend to his brother "Dizzy" Dean, was St. Louis's ace. Like a seasoned veteran, she knew she had to find a way to get the edge by rattling the pitcher.

"Hey, you big hick!" she cried out. "Why don't you go home and milk the cows!"

Any mercy Dean might have had for the tiny girl disappeared and he started to go into his sweeping windup. Kitty knew that Paul, just like his older brother Dizzy, possessed a blazing fastball. As she watched Dean swing his arms she found herself thinking she had made a bad mistake.

Just then third baseman Pepper Martin called out, "Take it easy, Daf!" which made the Cardinal ace grin and lob an underhand slow ball to the plate. Kitty swung the bat and hit a slow roller back to the mound. Dean fielded the ball and was waiting on first by the time Kitty ran up the line.

The crowd loved it and cried out for more. Cardinals manager Frankie Frisch ran in from second base and demanded the umpire count it as an official out, which was of course denied.

It was great theater and the publicity surrounding the whole incident helped popularize night baseball. And that's about as much information as can be commonly found on Kitty Burke's one major league appearance.

So what became of the tiny blond blues singer? The publicity she gleaned from her one plate appearance made her even more in demand as a singer. The Cincinnati Reds even gifted her with a real uniform to wear during her act as "The Only Girl to Bat in the Majors."

By 1938 Kitty had fallen in love with Harold Heintz. She left show business behind and started a new career as a nurse. The first and only woman to appear in a major league game passed away in 1964 at the age of 53.

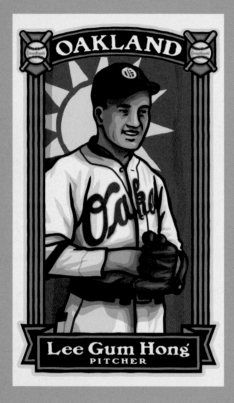

With the last home stand of the 1932 Pacific Coast League season about to start, Oakland Oaks owner Vic DeVincenzi was facing the end of yet another dismal year for his club, both in the standings and in attendance. With the Sacramento Senators coming to town, DeVincenzi knew they were sure to pitch their new attraction, Japanese-American Kenso Nushida. Nushida had so far appeared in every one of the PCL ballparks except Oakland, and his presence allowed the Senators to tap into the otherwise ignored Japanese-American fan base. The business-savvy DeVincenzi racked his brain seeking some kind of angle to match Sacramento's. Looking at the morning newspaper he saw it—Japan had recently invaded Manchuria, sparking what would be called the Sino-Japanese War. Not many Americans cared or even knew about what was happening in Manchuria, but among the Japanese and especially the Chinese communities this was a heated issue. DeVincenzi had his plan: Sacramento had their Japanese pitcher; Oakland with its large Chinese population would produce its own Chinese ballplayer and settle the Sino-Japanese War right there on a baseball diamond!

Sacramento had signed the Hawaiian-born Kenso Nushida at the tail end of the 1932 season. He was five-two and just 100 pounds, but he made up for his diminutive stature with an impressive assortment of curveballs. Well into his 30s, Nushida had played semi-pro ball in Hawaii and came to America in 1922 with the barnstorming Honolulu All-Stars. Staying in Northern California, he had become a fixture of the Japanese Nisei leagues,

where his popularity among the Japanese fans made the Sacramento owners see dollar signs.

To face Nushida the Oaks signed local pitcher Al Bowen, a former high school star and standout semi-pro hurler for the Wa Sung Athletic Club. His dominance on the mound attracted large crowds from Oakland's Chinatown, so along with a decent arm Bowen came complete with a ready-made fan base. The only problem was his name. Al Bowen didn't exactly bring to mind exotic images of the magical Far East. As long as he was appearing in an Oaks uniform Al Bowen would be known by his Chinese name—Lee Gum Hong.

The two faced each other twice, drawing large and enthusiastic crowds of Japanese and Chinese fans. In the first game Lee took the 7–5 loss after a disastrous fifth inning. In the second game, played a few days later, Lee pitched a complete one-run game over Nushida and Sacramento. The American front of the Sino-Japanese War ended in a tie, as neither Nushida nor Lee appeared in another professional ballgame.

Lee, now Al Bowen once again, organized charity efforts for Chinese refugees during the war with Japan and served in the U.S. Foreign Service overseas. He remained a fixture of the Bay Area's Chinese community for the rest of his life. Kenso Nushida tried unsuccessfully to catch on with a professional team and returned to playing in the Northern California Nisei leagues, where he was well known. He returned to his native Hawaii in 1940 to attend to his father, who was in ill health. Nushida and his family were on Oahu as the Japanese bombs dropped on December 7, 1941, and he remained in the islands until his death in 1983.

OSCAR "FARMER" DEAN

Baseball Was His Meal Ticket

Let me start out by saying that what follows is a true story—it might not read like it, but it's all taken from a wide variety of period newspapers and wire services from February to April 1935. While digging up old newspaper articles on the Tokyo Giants' games against the Pacific Coast League teams during the spring of 1935, I happened upon one of those crazy characters that only baseball seems to attract: Oscar "Farmer" Dean. The first mention was of the Great Farmer Dean being slated to pitch against the Giants. The name sounded interesting and I made a note of it. Later I noticed his name kept popping up as I read the West Coast newspapers from the spring of that year. When I found a mention of his eating capacity, I decided I had to dig deeper. Who was this guy? The truth was weirder than I ever imagined.

Out of thousands of baseball hopefuls who turned up at spring training camps

all across America trying to escape the grip of the Great Depression, "Farmer" Dean quickly set himself apart from the pack. After he wrote to every club in the Pacific Coast League bragging of his unbridled talent, the Los Angeles Angels were the quickest on the draw and invited the Farmer to camp that spring. Even before he arrived the press was abuzz with anticipation of yet another great hurler with the "Dean" moniker.

In the previous year the brother duo of Dizzy and Paul Dean devastated the National League, not only with their fastball but also with the great copy their wild bragging and colloquial quotes brought. The Deans won all four of the Cardinals' victories in the 1934 World Series and now there seemed to be yet another one of these "diamonds in the rough" out there. The aspiring pitcher who reported to the Angels camp on February 11 wasn't a spring chicken—he

claimed to be 23 but looked as if he was well into his mid-30s, six-foot-four and over 190 pounds. When not in uniform, Farmer wore an old suit of overalls complete with a sign sewn on the back declaring "I Am Farmer Dean." And just in case you failed to take notice of all that, he brought along his own agent/manager, Herb Levine, to make sure you did. The beat writers ate this stuff up.

While most of the Angels' hopefuls tried their damnedest to distinguish themselves on the field, Farmer Dean made headlines with his prodigious appe-tite. His relentless assaults on the team's hotel restaurant became legendary—eating two steaks before morning work-out became his routine. While others threw the ball around or worked on their curveball, Farmer Dean held court, giving the eager sportswriters plenty of copy for their papers.

He was fresh out of the U.S. Army, he said, where he learned how to pitch while posted at Fort Bragg in North Carolina. "My best throws are my cannon and submarine throws," the Antelope Valley resident said. While he claimed to be no blood relation to the Cardinals' two sibling superstars, Dizzy and Paul Dean, the Farmer claimed that he

He wore overalls with a sign on the back declaring "I Am Farmer Dean"

possessed the same level of ability, and while he'd never seen either one in person, from reading about them he could confi-dently state that they "haven't anything on me." Apparently the Farmer could do the Deans of St. Louis one better: He claimed he was such a good hitter he played outfield when he wasn't mowing 'em down with that fireball of his.

The Angels management didn't think the same way, because after a week Farmer Dean and his agent/manager Herb Levine were cut loose.

On February 19, sports pages across the country car-ried the UP article announc-ing Farmer Dean's signing by the Mission Reds of San Fran-cisco. The Reds sent Dean a contract and told him to travel north to Marysville, Cal-ifornia, where the Mission team was open-ing their training camp on February 25. The Reds' manager, Gabby Street, who a few years earlier was Dizzy Dean's catcher on the Cardinals, optimistically told the press: "He's just like Dizzy when he signed with the Cards," and the Farmer himself added con-fidently, "I'll win 20 games in this league."

The article also went on to list Farmer Dean's weight as 200 pounds.

Before the Reds even opened the doors to their spring training camp in Marysville, Farmer Dean was a local superstar and was even presented with the key to the city. Earlier in the month the Reds' Bay Area rivals, the Oakland Oaks, were chastised in their local newspapers for not being quick enough in responding to the Farmer's letter of introduction and letting him slip away to the Angels. Now that he had turned up in the rival Reds' camp it was even harder for the Oaks fans to take.

The reporters who covered the Reds badgered manager Gabby Street for updates on the team's prized rookie. "Well, I'll tell you. The big fella has a lot of color and is sure attracting a lot of attention. He's plenty big, says he can pitch, and certainly acts the part of a fellow looking to make good. He talks a great game and he eats like a big leaguer." Street went on to contrast the Farmer with

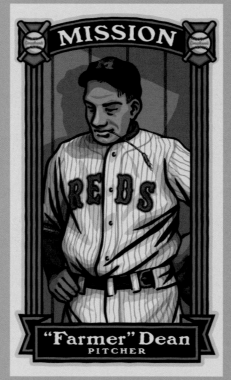

MISSION

"Farmer" Dean
PITCHER

Dizzy, saying the Farmer was more modest, because when asked how many games he planned on winning that year he said: "I guess about 20 games would be enough for the first year, eh, Sarge?"

The Sarge promised to put the Farmer through a rigorous tryout to determine the full extent of the rookie's prodigious talent. "I will find out mighty quick if this big boy has anything of value in a baseball way. What a card he will be if he can really pitch. If he can't, the Mission club will be out the price of his carfare and the meals he absorbed."

On the afternoon of Saturday, March 2, Gabby Street handed the Farmer the ball to see what he could do in a game. The Mission Reds faced the touring Tokyo Giants in the first of a series of games they scheduled against Pacific Coast League teams. The Tokyo Giants were a young team, mostly made up of college stars, and featured the

schoolboy sensation Eiji Sawamura, who made history that winter when he struck out Gehringer, Ruth, Gehrig, and Foxx in succession during an exhibition game in Japan. Before the game Dean went over the pitches he planned on unleashing that afternoon: "I got a submarine ball and a fireball, but my fireball is the best. It starts out fast and leaves a smoke screen as it curls up."

The Farmer, employing a novel submarine-style pitching motion, shut out the Tokyo Giants for two innings, but the roof caved in during the third. Slapping him around for six runs, Tokyo knocked him out of the box on the way to a 12–5 win.

Obviously choosing to focus on only the first three innings of that afternoon's game, Dean went out on the town celebrating. When he meandered into the team's hotel, the Reds' president, Joe Bearwald, confronted his star hurler about breaking training rules. An indignant Dean declared, "I am a farmer, and Saturday is farmer's night. I do not care to retire now." The two men began a heated exchange, but Bearwald had the last word: "You're fired."

The next morning as the Farmer and his agent/manager Herb Levine packed up their

> *Dean had a lot of color, the manager said, "but nothing on the ball"*

stuff, Gabby Street spoke to the shocked press: "Farmer Dean didn't have a thing as a chucker." Dean had a lot of color, he said, "but nothing on the ball."

At a rival meeting of the scribes, no doubt set up by agent/manager Levine, the Farmer gave his side of the story. "I walked out on the Missions because that old miser Joe Bearwald complained because I ate two steaks for dinner." The most famous pitcher in the Pacific Coast League was now free to take his talents elsewhere.

On March 5 he suddenly turned up in Santa Barbara and presented himself to the Seattle Indians' owner, Bill Klepper. At a press conference the following day, Dean reported that Klepper and the Indians promised him "plenty of food" and promptly proved the point by devouring two full steaks before making his way to the field for practice. The newspapers described him as "the 205-pound Dean."

Now boasting that he would win 25 games for Seattle this season, the Farmer was treated to a rigorous running regimen by the Indians' manager, Dutch Ruether. Seeing as he had put away two steaks, Ruether had Dean run around the field for three hours.

The following morning the press reported seeing the Farmer only put away one steak at breakfast. Ruether adjusted his training regimen accordingly and made Dean run for only one hour. He had yet to appear in a game, claiming the cards were not right yet. Farmer Dean, you see, consulted his horoscope before every game, and if the stars were not favorable, Dean didn't pitch.

The newspapers now all seemed to focus on the Farmer's appetite instead of his fireball. One paper claimed he ate "20 hot cakes every morning" and "carries with him a loaf of french bread and a roll of bologna sausage in a paper bag" to stave off hunger between meals. At the end of March he challenged teammate and the reigning Indians eating champ, Mike Hunt, to an eating contest. The Farmer packed in "eight pounds of hamburger steak, three plates of potatoes, and then ripped a beefsteak apart" on the way to thrashing Hunt and claiming the team title. After the crumbs settled Dean told manager Ruether that if they had a better class of steak he could really show 'em how to eat. Incredulous, Ruether called his bluff and ordered the pitcher a fresh T-bone. Ten minutes later it was gone.

"If he could play ball like he can eat he'd be worth as much as Dizzy Dean"

Indians owner Bill Klepper declared: "If he could play ball like he can eat he'd be worth as much as Dizzy Dean."

The last trace I can find of the Farmer is at the end of March, when the United Press syndicated a photograph of Dean sitting awkwardly on the ground in front of the Indians dugout eating an impressive-looking sandwich. The supplied caption notes that to construct the sandwich he was consuming "required 14 inches of bologna and a loaf of bread." He is also noted as being six-four and weighing 220 pounds.

So who was Farmer Dean? There is no other mention of him after April 2, 1935. A teammate on the Indians did say that he had known Dean under a different name back on an unnamed eastern team and that he was 35, not 23. But he never gave the man's former name. Another clue I found was a mention of his being a resident of Lancaster, California. Then I found it. In a *Los Angeles Times* article writer Bob Ray's secret contacts revealed that Oscar "Farmer" Dean's real name was West and that he once played with a team in the defunct Eastern League. Going through all the records found on Baseball-Reference .com I found no "West" who played in the

Eastern League who would fit his age group (assuming he was born between 1900 and 1905). The only close fit I could see would be a Tommy West, who played for the Lindale Pepperalls of the Georgia-Alabama League in 1930. The league collapsed following the 1930 season so it fits what was reported about Dean's being out of a job after the folding of the league he played in. And taking into consideration that before showing up on the West Coast he'd just served a four-year hitch in the army, that would fit the timeline just fine. But this is all just a wild, though educated, guess on my part.

So was this guy a real prospect or a publicity hound trying to be his own meal ticket? I'm guessing the latter, and the teams in the Pacific Coast League played along. The year 1935 was one of the worst of the Depression, and Americans grasped at any kind of distraction to keep their minds off their current predicament. If anything, Dean's romp through the PCL's spring training was beneficial to both himself and the league: The ever-hungry Dean gained in excess of 30 pounds from free food and the Coast League gained national publicity and a much-needed boost to spring training attendance because of the Farmer and his personal publicity machine. I love the history of this game!

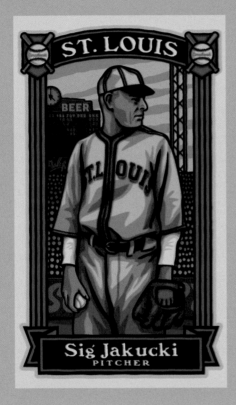

ST. LOUIS

BEER

Sig Jakucki
PITCHER

Sigmund Jakucki was six-two and a whole lot of bad news. Hailing from the rough tenements of Camden, New Jersey, he starred for his local Polish-American Citizens Club before escaping town in 1928 to join the army. Stationed in Hawaii, Sig quickly made a name for himself on the barracks baseball team. When he was discharged in 1931 he joined the semipro Honolulu Braves. Sig was such a popular player that when a scout suggested he could make the big leagues, the local fans chipped in to pay his way back to the mainland.

He made the San Francisco Seals of the Pacific Coast League, but from the beginning he was pegged as a constant brawler and big league boozer. He was bounced from team to team because of his lousy personality but somehow made it to the St. Louis Browns in 1936. He promptly had a falling-out with manager Rogers Hornsby and was sent back down to the minors. By 1937 Sig had drunk and fought his way out of the minors and found himself pitching semipro ball in the Southwest in between stints hanging wallpaper.

In 1941 he burst back into the spotlight when he pitched the Bona Allen Shoe Company to the final round of the Denver Post Tournament, the World Series of semipro baseball. When most of the good players were off serving in World War II, the Browns dusted off Sig Jakucki and brought him back to the big leagues. He rebounded to become an instrumental part in their 1944 pennant-winning season, but his old habits, fueled with a major league–sized paycheck, quickly found him plenty of trouble.

Once when he was drinking at the bar of the New Yorker Hotel in Manhattan, a low-level Mafia punk was shooting his mouth off trying to impress the woman on the next stool. One thing led to another and the hood pulled his pistol on Jakucki, who proceeded to snatch the piece from the tough guy and beat him into hamburger meat right at the bar. He then sat back down and finished his scotch before leaving to find a quieter place to finish the evening.

Another time he and a teammate went to a wrestling match. Deciding it was on the boring side, the two ballplayers invaded the ring and started going at it themselves. When the referee tried to break it up Sig knocked him out cold. As the crowd went nuts the two original wrestlers tried to take on the big ballplayer, whereupon they, too, were flattened by Jakucki. When the dust cleared Jakucki and his teammate spent the night in the local jail.

When Sig was tapped to pitch the pennant-clinching game against the Yankees, his teammates begged him to lay off the sauce. Pledging not to drink the night before the game, Sig kept his word to the letter. However, no one said anything about the morn-ing of the game, and Jakucki had a few belts to keep himself straight. Nonetheless he pitched a masterful game, giving the lowly Browns their only pennant.

Jakucki followed up his triumphant 1944 season with a disappointing 1945. He just couldn't juggle his drinking and the every-day responsibility of playing on a big league team. This was the season one-armed out-fielder Pete Gray joined the team, and it is an interaction between the two that speaks a lot about Sig's personality. Despite his handicap, Gray was able to do most anything a ballplayer needed to do, except tie his shoes. For that he needed a teammate's help before every game. One day when no one was left in the locker room except Jakucki, Pete asked him to lend a hand. Sig glared down at him and uttered the immortal phrase, "Tie your own shoe, you one-armed son of a bitch!"

He was released when he turned up at the St. Louis train station for a road trip with nothing but a bag of scotch bottles. Sig drifted back to the Southwest, where he led a marginal, transient existence, dying in 1979 after years of poor health brought on by his major league excesses.

> *"Tie your own shoe, you one-armed son of a bitch!"*
> *—Sig Jakucki*

NEW YORK CITY

SANITATION

Eddie Boland
OUTFIELDER

Eddie Boland became, along with one-armed Pete Gray, the poster boy for the sad state of the national pastime during World War II. Boland had spent eight years toiling in the minor leagues, with a short stint with the Philadelphia Phillies before calling it quits in 1938. He went home to New York City and took a job with the Department of Sanitation, playing semi-pro ball on weekends.

When the Washington Senators approached him with a contract, Boland balked—his job at the Department of Sanitation was much more steady than restarting a big league career at age 35. Eventually he agreed to play for Washington, but only during his annual vacation.

So while other garbagemen took their summer vacations at the Jersey Shore, Eddie Boland spent his roaming the outfield for the Washington Senators. In 19 games he batted a respectable .271 with four doubles and 14 RBIs. Not bad for a guy who was, as the sportswriters of the day liked to say, "literally picked off the scrap heap."

While some looked at Eddie Boland's second chance at the majors as a neat underdog story, others saw it differently. To black Americans it was a slap in the face. There were two whole leagues, the Negro National and Negro American Leagues, filled with dozens of can't-miss major leaguers, and the Senators sign up a has-been semipro garbageman? The outrage it caused helped spur the movement to get the major leagues to integrate. In the late summer of 1944, that moment was barely two years away.

In the 1920s and '30s the New York metropolitan area was the epicenter of baseball. Besides the Yankees, Giants, and Dodgers, on weekends the city boasted some of the most competitive semipro teams ever assembled. Not just amateurs, as the name "semipro" would suggest, teams like the Brooklyn Bushwicks, Bay Parkway Dukes, and Paterson Silk Sox were the equals of a high minor league club and fielded former and future major leaguers and college stars.

One of those college stars was first baseman George Sackett. After graduating from New York University, he was given a tryout with the New York Giants. Descended from an old New York family, Sackett bowed to his mother's wish for him not to play professional sports. On weekdays he was an adman at a prestigious Madison Avenue agency, but on weekends he was a baseball star. To slake his baseball thirst, Sackett played for no fewer than three semipro outfits, the best of which was the Bay Parkway Dukes. Sackett's booming home runs soon

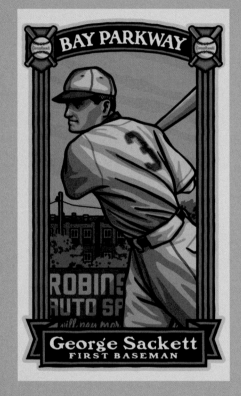

made fans forget the team's former first baseman, future Hall of Famer Hank Greenberg. Playing against other semipro clubs and the best Negro League teams in the country, Sackett batted above .450 for 1931 and 1932 and broke all local home run records. Doing all this in New York City got the scouts interested but "The Babe Ruth of the Semipros" turned down everyone, including the New York Yankees. Like many of the other metropolitan New York weekend stars, George Sackett simply made more money at his day job, and playing semipro ball let him compete against the best teams in the country without leaving home.

Mt. St. JOSEPH'S

Ford Meadows
PITCHER

I love those what-if questions in history—you know, major events in history that hinged on one minor and insignificant event or individual: What if Hitler had gotten into art school, or what would America be like now if Lee Oswald was a lousy shot? Baseball has plenty of those great what-ifs as well, and it was one of those minor turns of events that gave the game its greatest player.

In the spring of 1914, Baltimore Orioles owner and manager Jack Dunn had a problem—lack of left-handed pitching. Fortunately, Baltimore and the surrounding countryside was an untapped gold mine of amateur talent, and Jack Dunn knew exactly who he wanted.

For a year Dunn had been following a local 19-year-old Xaverian school student who was mowing down every team he pitched against. He was a big fella, and like most left-handers had a reputation for being a bit eccentric. To Dunn, a veteran judge of baseball talent, this kid was one of the greatest lefties he'd ever seen. In early February of 1914 the Orioles owner went to talk to the brothers who ran the school the young phenom attended. Brother Gilbert, the school's baseball coach and athletics director, met with Dunn apprehensively. While on one hand he wanted the young man to succeed, on the other he also wanted a winning ball club for the upcoming season, and this kid was his ace. Brother Gilbert thought about how he could keep him for just one more season and settled on the old bait and switch tactic.

"Sure, my boy is great," he said, "but this other lefty we faced last season was even bet-

ter." Dunn, intrigued, must have wondered who this unknown star was.

"Ruth from St. Mary's," was Brother Gilbert's reply.

The pitcher Jack Dunn had scouted and called one of the greatest left-handers he'd ever seen was not the young Babe Ruth, but a student at Mount St. Joseph's College named Ford Bernard Meadows.

At the time, Meadows was hands-down the best pitcher in Baltimore. In the 1913 season the kid had shut out Georgetown, Boston College, and Holy Cross—all in one week. His games were given as much coverage in the Baltimore newspapers as the Washington Senators and Orioles. There was no doubt that Meadows was a budding superstar. As far as anyone was concerned, no one had heard of this Ruth kid over at St. Mary's that Brother Gilbert had spoken of.

And in truth, the Xaverian brother and baseball coach was fibbing a bit: He'd never actually seen Ruth pitch. In all the games Mount St. Joseph's played against St. Mary's, Ruth appeared as a left-handed catcher. The big kid impressed Brother Gilbert not with his pitching but with his bat, a skill he used to eat up any pitcher Mount St. Joseph's threw at him. Because both St. Mary's and Mount St. Joseph's College were run by the Xaverian brothers, Gilbert was familiar with Ruth's coach, Brother Matthias, and through him had learned of Ruth's strong and accurate arm.

It was a brilliant tactic and Jack Dunn fell for it. Within days he'd signed the young George Herman Ruth without ever seeing him play an inning of baseball, all based on the little white lie of a Xaverian brother who was trying to keep his prized ball club intact for one more season.

In 1913 Baltimore, it was Ford Meadows everyone was measured against

But what became of Ford Meadows? Well, he continued to dominate the collegiate scene, and Dunn finally succeeded in signing him in 1915. The eccentric lefty infuriated Dunn by complaining to the press about his not being used properly. When Dunn finally put him into a game, Meadows set a new record by walking 11 batters in a single inning.

World War I interrupted his precarious career and a dislocated shoulder and an ear shot off in combat ended it. While his ball-playing career might not have lived up to the promise many expected from him, he was instrumental in launching the career of the greatest baseball player of all time.

FRANKIE ZAK

The Accidental Ballplayer

Unlike all the other boys growing up on Quincy Street in Passaic, New Jersey, Frankie Zak didn't care for baseball.

In the summer of 1941 Zak ventured south to visit his high school pal Eddie Sudol, who played ball with the Tarboro Orioles, then part of the Coastal Plain League, the bottom rung of the minors. Turning up in Tarboro, North Carolina, one hot and humid day, Zak found the team in desperate need of a shortstop. Zak, almost six feet tall, lean, and athletic, looked the part and was quickly signed to a Tarboro contract. It was only going to be temporary; Frankie didn't care for baseball.

Zak finished the season with a lean .255 average and fielded his position with a .905 percentage, right about league average. In normal times, it would be tough to say whether that first season at Tarboro would be good enough to keep him in professional baseball, but these were not normal times. After the Japanese attacked Pearl Harbor and the country was thrust into war, every

> *It was a time when men like Frankie Zak got their chance at baseball immortality*

able-bodied man who didn't rush to volunteer was scooped up by the draft. It was a time when men like Frankie Zak got their chance at baseball immortality.

Frankie's rookie season was good enough for him to be picked up by the Pirates organization, which sent the shortstop to the Class D Hornell Maples. While he didn't exactly tear up the league, he did boost his average to .271 and belt two home runs, the only ones he ever hit in his professional career.

In 1943 he was promoted to the Pirates' highest minor league team, the Toronto Maple Leafs. While it was still the minors, Zak was lauded in the press as one of the few players to ever leap from Class D to Class A in one jump.

The Maple Leafs were managed by Burleigh Grimes, the cantankerous former Brooklyn spitball pitcher. Midway through the season Grimes was crowing to the press that his shortstop Zak was better than Pee Wee Reese was when he joined the Dodgers.

By 1944 the majors were decimated by

the war, and this enabled Frankie Zak to put on a uniform with the number 14 on the back and step out onto the field as a Pittsburgh Pirate.

Zak's debut was on April 21, 1944, in Forbes Field against the Cincinnati Reds. With the Pirates losing 4–2 in the bottom of the ninth, Frankie Zak batted for veteran catcher Al Lopez. He popped out. But still, Frankie Zak, the guy from the old neighborhood who didn't care for baseball, was now a major leaguer!

Throughout the summer the young shortstop played 87 games as backup to Frank Gustine. Zak batted a hearty .300 with three doubles, a triple, and six stolen bases thrown in there for good measure. But breaking the .300 mark was not the highlight of Zak's 1944 season. Getting named to the 1944 All-Star Game was. Yes, Frankie Zak, rookie backup shortstop and occasional pinch-runner, was named to represent the National League at the 1944 All-Star Game.

Eddie Miller was picked to play in the game but became injured. Since the game was held in Pittsburgh, Frankie Zak was asked to step in. Although he didn't get into the game, he did feature in the official team portrait, mixed right in there with the best players of 1944.

Frankie Zak, the guy who didn't care for baseball, was now a major leaguer!

The next year found Zak bouncing between Kansas City and Pittsburgh, playing just 15 games with the Pirates in 1945 and 21 in 1946. But Frankie made up for lack of playing time with a couple of legendary baseball stories that are still told by old-timers.

The first one takes place in the 1944 season. The Pirates were playing the Cubs at Wrigley Field and Frankie was trying to score on a double by outfielder Jim Russell. Rounding third, Zak was shoved by nasty little third baseman Eddie Stanky, and an out-of-control Frankie tumbled all the way to the dugout. The ump waved in the run but neglected to discipline Stanky. Pirates manager Frankie Frisch vowed to even the score for Zak, and sure enough on the next play as Jim Russell came sliding into Stanky, spikes high, so did manager Frankie Frisch, sliding in spikes high from the coach's box! The ump, Hall of Famer Jocko Conlan, called Russell safe and Frisch out of the game.

Another great Frankie Zak story took place on Opening Day 1945. Pittsburgh led

the Reds 1–0 in the fifth at Crosley Field and Frankie beat out a bunt. Now there were two men on base. Reds pitcher Bucky Walters looked in to pitch to Jim Russell, and Zak, noticing his shoe was untied, called time. The first-base umpire threw his hand up, calling time out, but Walters and the home plate ump didn't hear it. Walters threw and Russell belted the ball into the right-field bleachers for a home run. Only it wasn't. The run wasn't allowed, and after much argument, Russell returned to the batter's box and Zak hung his head in shame, tying his cleats. The Pirates lost 7–6, and the next day Frankie Frisch got a telegram from Casey Stengel: "Am rushing a pair of button shoes for Zak."

The last Frankie Zak story comes from former catcher and Cleveland Indians manager Al Lopez, who tells this:

"I never like to see women in the dugout. In the first place they don't get a very good view. In the second place, they don't know how to duck. I even knew a fellow whose romance was broken up by a foul ball in the stands. His name was Frankie Zak—a short-stop when I was catching for Pittsburgh—and he fell in love with a Chicago girl. There

Frankie Frisch came sliding into third, spikes high, from the coach's box!

was only one hitch. The girl's mother didn't want her daughter to have anything to do with a professional ballplayer. Frankie thought he knew how to break down a mother's prejudice. He arranged for the girl to bring her mother to a game. We were in Wrigley Field and it was Ladies' Day—20,000 women in the park. And of all those people, who do you suppose got the foul ball in the face? That's right. The girl's mother. She was really hurt, too. And that was the end of the romance."

What happened to Frankie Zak? His contract was sold to the Yankees and he played for the Newark Bears and later in the Pacific Coast League with Portland and San Diego. He retired in 1949, ending a nine-year odyssey playing a game he never really cared for. He and his wife, Helen, returned to Frankie's hometown of Passaic, where he died of a heart attack at the age of 49.

What about the friend he went to visit in Tarboro back in 1941? Eddie Sudol never made the majors as a player, but he did make it as an umpire, working the World Series in 1965, 1971, and 1977, and it was Eddie who was behind the plate when Henry Aaron hit his 715th career home run.

NEW YORK

Joe Styborski
PITCHER

It's the official team portrait of the legendary 1927 New York Yankees and if you look closely, he's there, standing at the top right, between bearlike outfielder Ben Paschal and the diminutive trainer Doc Woods. The 1927 Yanks are the subject of countless books and articles, undoubtedly the most documented lineup in baseball history, but for some reason this one tall young man who stares straight at the camera had remained anonymous or "unknown" or just mis-identified until recently.

First of all, the young man's name is not "unknown" or "Walter Beall" or "John Stiborski." His name is Joseph Styborski. He was the eldest son of Polish immigrants and graduated from Penn State, where his impressive record caught the eye of Yankees scouts.

After signing with the Yankees in the summer of 1927, he stayed with the club for a few weeks, pitching batting practice and throwing a few innings in exhibition games. It was during this period that Styborski was captured for posterity with Babe Ruth, Lou Gehrig, Waite Hoyt, and the rest of what would be called "the greatest baseball team of all time" in the official team portrait. The pitcher was soon farmed out to the minors, where he pitched for four seasons with a combined 43-24 record.

After leaving pro ball Styborski went to dental school in St. Louis and became the first doctor in his family. While his identity remained a mystery until recently, before his death in 1993 Joe Styborski was finally acknowledged as the last remaining member of that historic 1927 team.

ACKNOWLEDGMENTS

This book wouldn't have been possible without a perfect storm of family, friends, authors, and plain lucky research.

I'll start out with my wife, Dr. Andrea Gazzaniga. I'm probably the only guy in the world who can boast having a wife who's not only smart and beautiful but also knows who Warren Spahn is and can accurately mimic his pitching motion. Her love of baseball and understanding of how important this book is to me made it all possible.

My pal Christian Boyles at Xavier University Library in Cincinnati has helped me immensely in tracking down copies of obscure texts when my own efforts came up empty. Besides being the Dennis Becker to my Rockford, his friendship to me over the years has been more important than I could ever hope to express.

Same goes for Todd Robinson, whose words of encouragement, helping hand, and unconditional friendship over the years have meant the world to me.

I must thank Dr. Bob Hieronimus, who many years ago introduced me to his circle of former Negro League players. There aren't very many people who have done as much, without any recognition, to preserve the memory of the Negro Leagues as my friend Dr. Bob.

And to my uncle Ed, aunt Mary, cousin Chris, and grandma Helen: Thank you for helping me through the loss of both my mother and father.

The one unexpected blessing that came of my original blog has been all the baseball historians, collectors, and authors I have come to know on a first-name basis. The support of giants like John Thorn, Scott Simkus, Gary Ashwill, Leslie Heaphy, Rob Fitts, Jim Caple, Mike Shannon, and Ryan Christoff has meant the world to me. Not only have their own work and collections influenced my own, but their kindness in answering my inquiries has made this book possible.

My library of baseball books is vast, and I've used hundreds in the process of writing this book. I'll list a few of the most important titles that I heartily recommend to anyone who wishes to explore more about baseball history.

For the Negro Leagues, I can't stress enough the work of John Holway, the original researcher of blackball's oral history. Without his work a whole part of American history would have been lost forever. The same can be said of the work of James A. Riley, Phil Dixon, Larry Lester, and Neil Lanctot. Any book that carries one of their names as author is a worthy addition to your library.

For Major League Baseball histories, David Alan Heller's book on the 1944 Browns, *As Good as It Got*, is a phenomenal treatment of one of baseball's most interesting teams. Peter Golenbock's *Bums* is an oral history of the Brooklyn Dodgers that reminds me of the long sessions I had listening to my grandfather go on about his beloved Dodgers. John Thorn's seminal history of the game's early years, *Baseball in the Garden of Eden*, is indispensable when trying to understand how baseball became baseball.

For anyone even mildly interested in what life was like for a minor league ballplayer in the 1920s, Jimmy Keenan's book *The Lystons* is a must-have. Eric Stone resurrected one of baseball's most bizarre and scary characters with his *Wrong Side of the Wall: The Life of Blackie Schwamb, the Greatest Prison Baseball Player of All Time*. Thomas Barthel's *The Fierce Fun of Ducky Medwick* is a superbly written biography of one of the Hall of Fame's most overlooked members, and his *Baseball's Peerless Semipros: The Brooklyn Bushwicks of Dexter Park* is a much-needed study of outsider baseball's greatest team.

For baseball outside North America, *Early Latino Ballplayers in the United States* by Nick Wilson is a standout, as is Peter C. Bjarkman and Mark Rucker's *Smoke—The Romance and Lore of Cuban Baseball*. Rob Fitts's *Banzai Babe Ruth* is not only the ultimate book on the 1934 MLB Japanese tour but at the same time reads as a spy novel, travel journal, and the early history of baseball in Japan. Tim Tzouliadis uses an old photograph of Americans playing baseball in Gorky Park to tell the story of Stalin's purges in *The Forsaken: An American Tragedy in Stalin's Russia*.

Since I pride myself on the accuracy of the uniforms I depict in my illustrations, a

stack of Marc Okkonen's books is always close at hand, especially *Baseball Uniforms of the 20th Century*, *The Federal League of 1914–1915*, *2,000 Cups of Coffee*, and all of his Baseball Memories series. Likewise, Will Arlt of the Ideal Cap Company shared his vast knowledge of obscure ball caps. Will was my first design client back in 1988 and still produces the finest ball caps in the world!

While many of the stories told in *The League of Outsider Baseball* began with mentions or footnotes in other works, I can't stress enough the importance of contemporary newspaper research. Reading firsthand about a particular event or how a ballplayer was perceived by his peers helps make the history of the game come alive again, and I believe this is one of the things that helps make my work unique. The Internet has made such research much easier than it was in the days when I would spend hours poring over microfilm in dusty libraries. My membership in the Society of American Baseball Research (SABR) has given me access to quite a few avenues that I otherwise would not have had access to. If you're not already a member of this fine organization, then you should be!

Now for the two guys who have guided my work more than any others: Scott Simkus and Gary Ashwill. Scott's book *Outsider Baseball* is what I would call the most important piece of baseball research done in the past decade. Scott's dogged research has been a major inspiration to me, and his unselfish sharing of information has been appreciated much more than he'll ever know. Gary Ashwill's website Agate Type is a gold mine of the most obscure outsider baseball tidbits you will ever find. Like Scott, Gary has tirelessly fielded all my questions and shared his work unconditionally. I am proud to say I have collaborated with both of these guys on a few different projects, most importantly the short-lived and much-missed "Outsider Baseball Bulletin."

Finally I'd like to thank my literary agent, Jake Elwell, for not only convincing me to put a proposal together, but getting it sold in record time. That brings me to my editor, Matthew Benjamin, at Simon & Schuster. For a first-time author not knowing what to expect from the publishing world, Matthew and everyone else at Simon & Schuster have made this whole project truly enjoyable for me.

And this whole book would never have come about had it not been for my mom and dad, Pattie and Gary. What can I say except I really miss you two.